Web Animation and Interactivity

The Ultimate Guide to Web Design

Christine Saucier

JAMSA
P·R·E·S·S®

...a computer user's best friend®

Published by
Jamsa Press
P.O. Box 2608
Houston, TX 77252-2608
U.S.A.

http://www.jamsapress.com

For information about the translation or distribution of any Jamsa Press book, please write to Jamsa Press at the address listed above.

Web Animation and Interactivity: The Ultimate Guide to Web Design

Printed in the United States of America.
98765432

ISBN 1-884133-60-6

Director	*Performance Manager*	*Copy Editor*
John W. Wilson	Kong Cheung	Rosemary Pasco
Composition	*Technical Editor*	*Cover Design*
Venture Media Group	Tammy Gildersleeve	Alan Giana
		Venture Media Group
Indexer	*Proofer*	
Venture Media Group	Jeanne K. Smith	

This book identifies product names and services known to be trademarks or registered trademarks of their respective companies. They are used throughout this book in an editorial fashion only. In addition, terms suspected of being trademarks or service marks have been appropriately capitalized. Jamsa Press cannot attest to the accuracy of this information. Use of a term in this book should not be regarded as affecting the validity of any trademark or service mark.

Jamsa Press is an imprint of Gulf Publishing Company:

Gulf Publishing Company
Book Division
P.O. Box 2608
Houston, TX 77252-2608
U.S.A.

http://www.gulfpub.com

T385
.S258
2000x

CONTENTS

LESSON 1

TOURING ANIMATED SITES

Welcome to *Web Animation and Interactivity: The Ultimate Guide to Web Design*. This book will introduce you to both the traditional and latest Web animation techniques you can use to make your Web pages interactive and appealing.

As you browse the Web, you will find certain Web sites grab your attention more than others. For example, a Web site could have an interactive game, a cool effect, or entertain you with a riveting multimedia presentation of animation and sound. Web animation can serve a variety of purposes, such as adding visual appeal and interactivity to a Web site, demonstrating a process or providing a presentation, and offering functional components for Web pages (such as counters, scrolling text, pop-up windows, and much more). The Web sites that most often grab your attention also use the latest Web technology to add or control Web animation, such as JavaScript, DHTML, CGI, or Java. You will learn about these technologies and much more. You will also learn how Web site statistics can help you improve your Web site as well as how to design animation and other Web components for optimal download time and various screen display sizes.

ADDING VARIOUS TYPES OF COMPONENTS

As you complete each lesson in this book, you will see many examples of how Web animation can add life to static Web sites. First, you will learn about Web page counters, simple programs that display the number of visitors to a Web page, which not only give a rough idea of a site's popularity to users as well as site owners but can also add visual appeal to a site. As shown in Figure 1.1, the counter at *www.barbecuen.com* is made up of graphics and is more interesting to look at than a plain text counter.

In Lesson 4, you will learn about the versatile GIF (Graphics Interchange Format) animations that come in many forms, including special effects, demonstrations of processes, animated banners, product slide shows, and much more. You can see a GIF animation that shows a company's product line at *www.picturetel.com*, as shown in Figure 1.2.

As you can see, the GIF animation shows that PictureTel Corporation's main focus is videoconferencing. Another similar example can be found at *www.picturephone.com*, as shown in Figure 1.3.

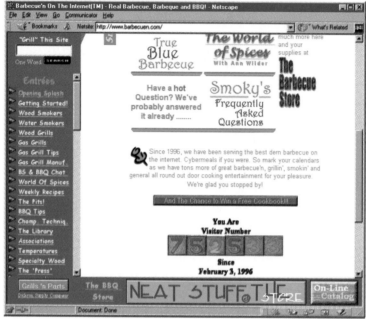

*Figure 1.1 The graphical hit counter at **www.barbecuen.com**.*

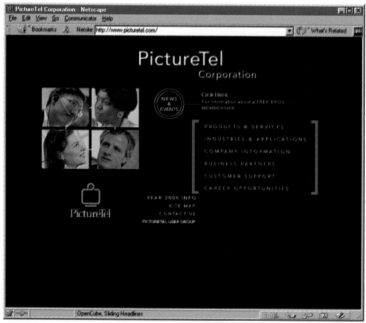

*Figure 1.2 The GIF animation at **www.picturetel.com** shows PictureTel's product line.*

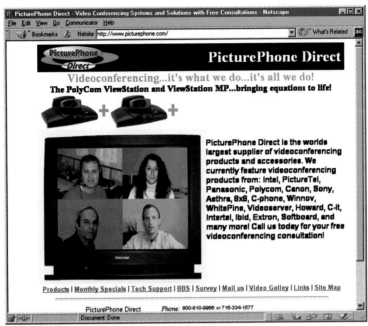

Figure 1.3 The GIF animation at ***www.picturephone.com*** *shows another company's product line.*

Animation can be subtle and still be effective, as demonstrated in the GIF animation at *www.inmedia.com,* shown in Figure 1.4.

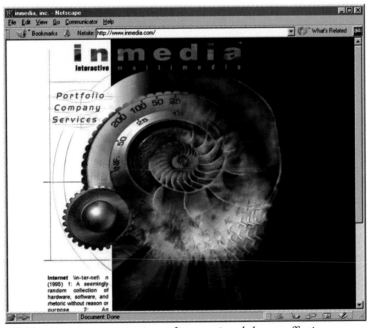

Figure 1.4 The GIF animation at ***www.inmedia.com*** *is subtle, yet effective.*

You will learn how to add a search engine to your Web site in Lesson 5. As you will learn, a search engine is a utility that lets the user enter a word or phrase to find information about a topic at a Web site. Thus, a search engine is a component that makes a Web site more user-friendly and interactive. Lesson 6 discusses ActiveX controls that let Web designers enhance and add interactivity to Web sites. For example, you can add interactivity to Web pages by embedding controls for navigation, spreadsheets, calculators, and so on. You can also add a control to perform a specific complex task, such as acquire data from a database or display a tool, such as a calendar, for a viewer to use. ActiveX controls can also enhance a site visually with animation and special effects. A site-enhancing object, such as the Advanced Clock ActiveX control at *ourworld.compuserve.com/ Homepages/frankwallwitz/*, shown in Figure 1.5, can make a Web site visually appealing.

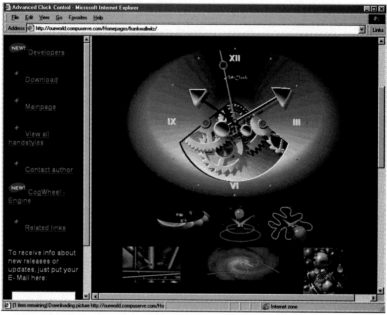

*Figure 1.5 The Advanced Clock ActiveX control at **ourworld.compuserve.com/Homepages/frankwallwitz/**.*

In Lesson 7, you will see how versatile DHTML (a combination of three main technologies known as HTML, Cascading Style Sheets (CSS), and JavaScript or other scripting language that work together to make Web pages dynamic) is and how you can use DHTML to create animations, special effects, scrolling text, interactive forms, pop-up windows, manipulate fonts and position text on a page, cookies, and much more. A good example of a DHTML animation effect is the main graphic that slides in with an image map at *www.asynch.net/kevin/*, as shown in Figure 1.6.

Lesson 8 discusses Sun Microsystems' object-oriented programming language, Java, which is currently a popular choice for Web site programming. As you will learn, many Web site designers prefer to use Java to make Web sites interactive since Java is compatible with Windows, Macintosh, and UNIX systems. You will find out how versatile Java is and how you can use Java to create animations, special effects, mouseovers, rotating ads, scrolling text, chat rooms, message boards, guestbooks, pop-up windows, search engines, counters, Web cams, and much more. To see an

example of animation with sound, go to the Java Universe animation applet at *wdvl.internet.com/ Multimedia/Java/*, as shown in Figure 1.7.

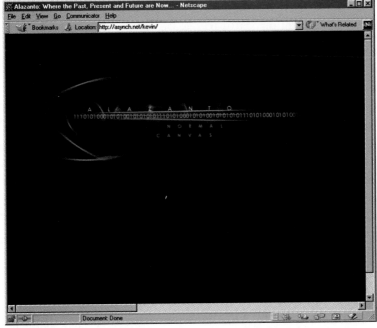

Figure 1.6 The DHTML animation effect at **www.asynch.net/kevin/**.

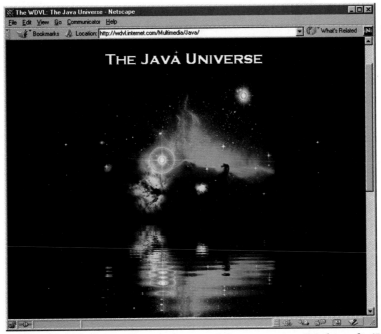

Figure 1.7 The Java Universe animation applet at **wdvl.internet.com/Multimedia/Java/**.

In Lesson 9, you will learn how to add marquees to Web pages. As you will discover, marquees can draw attention to an announcement, display current news or other information, make an otherwise static Web page more interesting, display menus, and add visual appeal to a Web page. You will find several types of marquees are available for Web pages and include the simple HTML marquee, scrolling status bar, as well as the more complex marquees accomplished with various programming technologies. The Java applet marquee, as shown earlier in Figure 1.2, at *www.picturetel.com*, displays the latest news and event items for users to click on for more information.

In Lesson 10, you will work with audio files. As you will learn, web audio files can play music, sound effects, or narration. Several formats are available for common Web audio and include WAV, AU, SND, AIFF, MP2, and MIDI. Shockwave and Flash files can include sound, too. Other formats exist for streaming audio, such as Emblaze and Real Audio. As you will find, background music is quite common at Web sites. Some music archive sites play audio interviews and let users sample music clips using Real Player or other similar technology, as well as audio chats. You will find many online game sites, such as the Picture This trivia game at *www.uproar.com/ picthis/*, as shown in Figure 1.8, now incorporate sound effects.

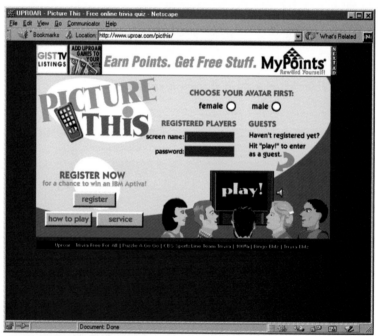

*Figure 1.8 The Picture This trivia game at **www.uproar.com/picthis/**.*

You will learn all about hot spots in Lesson 11. Hot spots, also known as rollovers, hover buttons, or mouseovers, have become a common feature on many Web sites and can add much appeal to a site if used correctly. A hot spot is a button or an image on a Web page that changes in some manner or has another image or part of the Web page change as a user passes his or her cursor over the button or image. Hot spots can be as simple as changing status line messages or more

complex to include animation or sound. As shown in Figure 1.9, the menu items display a description on the lower right at the Potlatch Paper Web site at *www.potlatchpaper.com/index2.html*.

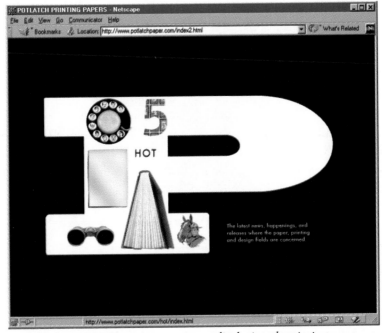

Figure 1.9 The Potlatch Paper Web site's menu items displaying descriptions.

In Lesson 12, you will learn about Virtual Reality, including panoramas and VRML, which are two technologies Web designers use to add virtual worlds to Web sites. VRML, which stands for "Virtual Reality Modeling Language," is a technology for animation and 3D modeling that lets you create 3D scenes for Web sites. A special VRML browser plug-in lets you control the viewing of VRML components on Web sites. Panoramas are another type of virtual reality component, similar in some ways to VRML in that the user needs a special plug-in to view and control the viewing of the panoramic virtual reality component. However, unlike VRML, panoramas comprise a series of photographs stitched together to create one image that you can view entirely as you move your cursor across the image. A good use for Virtual Reality is to help sell real estate. Panoramic views of both the outside and inside of homes give potential home buyers an idea of what a house looks like before going to see the house. Century 21's Virtual Tour at *www.century21.com/ctg/cgi-bin/Century21*, shown in Figure 1.10, is a good example of using panoramas to sell real estate.

As you will learn in Lesson 13, JavaScript serves several functions in Web development, including implementation and control of HTML, advanced browser capabilities, plug-ins, various Web components, as well as server-side applications. You will find JavaScript to be versatile in that you can use JavaScript to create animations, special effects, mouseovers, rotating ads, scrolling text, validated forms, pop-up windows, cookies, and much more. A JavaScript animation effect with mouseovers can be found at *www.eyeball-design.com/index3.htm,* as shown in Figure 1.11.

7

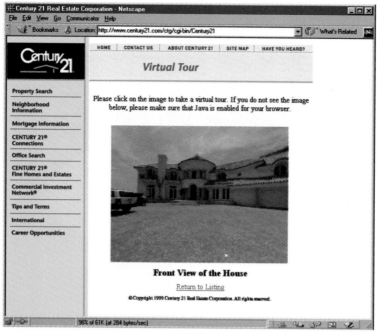

Figure 1.10 Century 21's Virtual Tour panoramas at www.century21.com/ctg/cgi-bin/Century21.

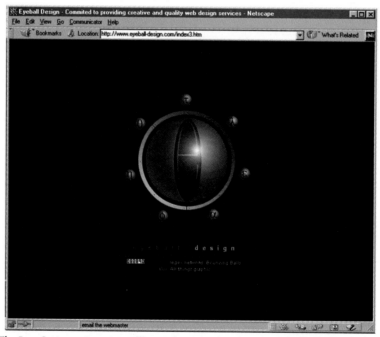

Figure 1.11 The JavaScript animation effect with mouseovers at www.eyeball-design.com/index3.htm.

As the user moves his or her cursor over a ball, the JavaScript displays the title for the link.

Lesson 14 discusses CGI, which is one of the original Web programming technologies used to enhance Web sites and make Web pages interactive and dynamic. As you will learn, CGI, which stands for Common Gateway Interface, is not a programming language. CGI is a standardized set of conventions that designates how a server communicates with a Web application, such as a reply form to acquire visitor information. Unlike other Web programming languages, such as DHTML, VRML, or VBScript that run within the browser, CGI programs run on a Web server and then quickly display results in your browser. While you can use C, C++, Java, Visual Basic, and many other programming languages to create CGI programs, Perl (Practical Extraction and Report Language) is the most popular language for creating CGI programs. Lesson 15 explains Perl in detail.

In Lesson 16, you will learn how to use cookies (a standard mechanism which scripts use to store small bits of information on a user's system as a text file for later use) to make your Web pages more user-friendly and interactive. For example, you can control the viewing of certain Web site pages, such as splash pages, with Web animation. As you will also learn, cookies serve several functions on Web pages, including storing various types of information, personalizing Web sites, tracking Web site navigation, storing information about what products users purchase, retrieving information for target marketing, and much more.

Lesson 17 will provide a foundation for Microsoft's VBScript, which is an alternative choice to using JavaScript for enhancing and adding interactivity to static Web site pages. Based on Microsoft's Visual Basic programming language, VBScript (Visual Basic Scripting Edition) is a scripting language that works with Microsoft's Internet Explorer browser. VBScript first made its appearance when Internet Explorer 3.0 was released and some Web designers continue to use VBScript today. As you will learn, current uses of VBScript include control of HTML and advanced browser capabilities, Dynamic HTML (DHTML), NT administrative tasks and applications, and Active Server Pages (ASP).

As you will learn in Lesson 18, push technology offers a way to find out about current Web site content without revisiting the Web site: push technology delivers the new content automatically to interested users who request the information. Push content is versatile and visually appealing because push content includes text, audio, video, animation, Shockwave, DHTML, software, and many other types of media. Typical push content information can be current stock quotes, software upgrades, late-breaking news, sporting event scores, and much more. As shown in Figure 1.12, the Fortune Active Channel keeps users current on financial news.

In Lesson 19, you will learn how many Web site designers take advantage of Shockwave and Flash to add multimedia effects, such as animation with sound, to their Web sites. Shockwave and Flash are two Macromedia technologies that let you add multimedia elements to Web pages. Shockwave movies are the resulting files exported from Macromedia Director that display animation, special effects, and other types of applications for the Web. Flash movies are animations and other types of interactive Web elements exported from Macromedia Flash. Shockwave and Flash make Web pages more interesting and interactive. Using Shockwave and Flash, you can add colorful navigational components, enhance a site visually with animation, multimedia, and special effects, as well as add more complex components, such as online games. To see an example of

9

using Flash effectively for hot spots, animation, and sound, see Dr. Pepper's Web site at *www.drpepper.com*, as shown in Figure 1.13.

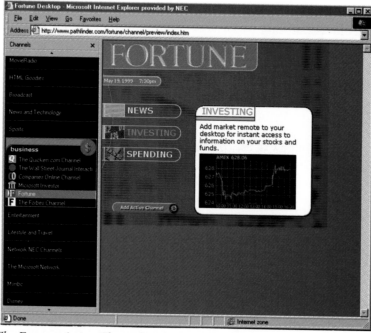

Figure 1.12 The Fortune Active Channel.

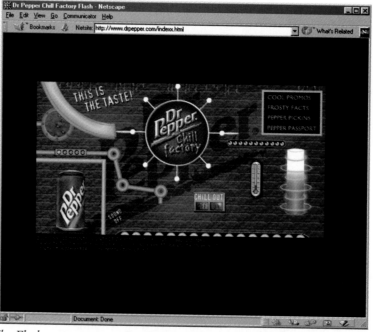

*Figure 1.13 The Flash components at Dr. Pepper Web site at **www.drpepper.com**.*

Lesson 20 will provide a background on Web video. As you will learn, Web site designers have been able to take advantage of video clips for several years but only recently has the use of video clips become more popular. The increased popularity of video is due to emergence of various streaming video options, which let video clips download quickly for viewing. You will learn how adding video clips to Web pages can greatly enhance a Web site's effectiveness, and you will learn about the various video formats and options for streaming video. Movie previews are a good way to use video clips on the Web. For example, Sony's Web site at *www.sony.com* displays many video previews in QuickTime format, as shown in Figure 1.14.

*Figure 1.14 Sony's Web site at **www.sony.com** displays many video previews in QuickTime format.*

In Lesson 21, you will learn how to use Web site statistics to find out more about users and how to use the results to improve your Web site pages and components. In the last lesson of this book, Lesson 22, you will learn about the various design considerations for animated sites, such as how to decrease the time it takes your Web site to download and how to design Web pages for various screen display sizes.

LESSON 2

THE TWO DESIGN APPROACHES

Each lesson of *Web Animation and Interactivity* teaches you how to incorporate the latest Web technologies into your own Web pages. If you are not familiar with JavaScript, DHTML, or CGI, this book will introduce you to each Web technology topic and will provide a good foundation to get you started. Although you do not need to know advanced issues regarding HTML, you should be familiar and comfortable using HTML.

The lessons in this book each contain an introduction, a reference for each Web technology topic, and exercises to introduce you to the Web technology. Each Web technology topic will include information on what the technology is, its purposes and functions, some of its uses (including samples), its advantages and disadvantages, and where to find more information about the topic.

THE TWO DESIGN APPROACHES

The lesson exercises use two design approaches. The first approach is the traditional way to add a Web technology by using actual code and components. This approach is a general solution for most platforms. The lesson exercises present a second approach, when appropriate, which is a solution using Microsoft FrontPage 2000. The latest version of FrontPage includes many ways to automatically add various Web technologies, such as counters, marquees, DHTML, ActiveX controls, and more. For example, you can quickly add a DHTML effect to your Web page with a few quick selections of settings, as shown in Figure 2.1.

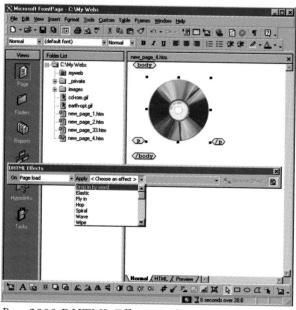

Figure 2.1 The FrontPage 2000 DHTML Effects window.

All the files you need to use for the lesson exercises will reside in the appropriate directory on the CD-ROM that accompanies this book. You will copy all of these files to a directory on your hard drive. Each lesson exercise will show a sample of how the programming code to implement each type of technology looks to give you an idea of the inner workings of the Web technology. For example, the following is a sample JavaScript code for mouseovers (indicated in bold), you will learn more about in Lesson 13:

```
<head>

<meta http-equiv="Content-Type" content="text/html; charset=iso-8859-1">

<title>Javascript Image Changer</title>

<script language="Javascript">

<!— Script by Ricke Stauffer, 1998

// Feel free to use, but please include these two lines

img1 = new Image ()

img1.src = "over1.gif"

img2 = new Image ()

img2.src = "over2.gif"

img3 = new Image ()

img3.src = "over3.gif"

img11 = new Image ()

img11.src = "click1.gif"

img21 = new Image ()

img21.src = "click2.gif"

img31 = new Image ()

img31.src = "click3.gif"

function over(Name,num)

{
```

```
"Name.src=eval("img"+num+".src")

}

function out(Name2,num2)

{

Name2.src="pic"+num2+".gif"

}

function act(Name3,num3)

{

Name3.src=eval("img"+num3+".src")

}

// —>

</script>

</head>

<body>

<p><a href="http://www.excite.com/" onMouseOver="over(document.mypic1,1)"

onMouseOut="out(document.mypic1,1)" onClick="act(document.mypic1,11)"><img
src="pic1.gif"

name="mypic1" width="100" height="75" border="0"></a><br>

<a href="http://www.htmlgoodies.com" onMouseOver="over(document.mypic2,2)"

onMouseOut="out(document.mypic2,2)" onClick="act(document.mypic2,21)"><img
src="pic2.gif"

name="mypic2" width="100" height="75" border="0"></a><br>

<a href="http://www.yahoo.com/" onMouseOver="over(document.mypic3,3)"
```

```
onMouseOut="out(document.mypic3,3)"  onClick="act(document.mypic3,31)"><img
src="pic3.gif"

name="mypic3" width="100" height="75" border="0"></a></p>

</body>

</html>
```

Each lesson's exercise shows the required code and walks you step-by-step through adding the code to a Web document. You will not have to write code for the exercises because the CD-ROM that accompanies this book contains all code for the lessons. In most cases, you will simply copy and paste the included code into an HTML document and then make minor modifications, if necessary, using Windows NotePad, as shown in Figure 2.2.

Figure 2.2 A sample of HTML code in Windows NotePad to add a DHTML effect.

The purpose of the exercises is to introduce you to the Web technology, not to teach advanced programming techniques. However, most lessons include URLs to view for more information on a Web technology as well as resources for scripts.

As you proceed through the lessons in this book, you will learn how to easily add various interactive components and effects, such as counters, DHTML, Java applets, CGI, marquees, audio, and much more. You will also feel comfortable working with the necessary code and will soon be experimenting on your own.

15

WHAT YOU MUST KNOW

Each following lesson in this book ends with a summary section that reviews the lesson's key concepts that you should know before continuing with the next lesson. In Lesson 3, "Adding a Counter to Your Web Page," you will learn about the various types of hit counters and how to add a counter to your Web site. Before you continue with Lesson 3, however, make sure you have learned the following key concepts:

✓ The lessons in this book will teach you how to incorporate the latest Web technologies into your own Web pages.

✓ The lessons in this book contain an introduction, a reference for each Web technology topic, and exercises to introduce you to the Web technology.

✓ You do not need to know advanced topics regarding HTML to use this book. However, you should be familiar and comfortable using HTML.

✓ The lesson exercises use two design approaches. The first approach is the traditional way to add a Web technology by using actual code and components. This approach is a general solution for most platforms. The lesson exercises present a second approach, when appropriate, which is an automated solution using Microsoft FrontPage 2000.

LESSON 3

ADDING A COUNTER TO YOUR WEB PAGE

Counters are a popular item that Web site designers place on Web pages. A counter is a simple program that displays a number. You can use a counter to tell how many visitors have viewed a Web page. Another name for a Web page counter is an access counter.

In this lesson, you will learn how to add a counter to your site. By the time you finish this lesson, you will understand the following key concepts:

- Web designers add counters to Web pages for two reasons: to reveal site popularity and to add visual appeal to a Web page.

- Several types of counters exist on Web pages, including simple text counters, graphical counters, site statistics display counters, invisible counters, and animated counters.

- Counters offer several advantages, such as providing Web statistics and graphical appeal. Counters have some disadvantages too, such as inaccurate and fake results.

- All access counters work in the same manner. Each time a user accesses a page, a counter program reads the counter file's current count, adds one to the count, and updates the file with the new count.

- To add a counter, you select a CGI script, set up the variables, upload the files, set file permissions, add the appropriate code to the HTML file, and upload the HTML file.

- Adding a counter to a Web page is relatively easy but you may need to adjust some special Unix server settings (for CGI scripts) and acquire some knowledge of programming concepts from outside resources (such as educational courses, reference books, technical Web sites, and other materials), depending on the type of counter you choose.

ENHANCING YOUR SITE WITH A COUNTER

Web page counters serve several functions. Counters can give a rough idea of a site's popularity to users as well as site owners. You can also use a Java applet (as you will learn in Lesson 8) or

another programming method to display not only the access count but site statistics as well. Counters can also add visual appeal to a site.

Counters come in several forms, including the simple text counter, graphical counter, site statistics display counter, invisible counter, and animated counter. The simple text counter displays a number in text format. The text counter may display the number separate from the rest of the page text or as part of a sentence, as shown in Figure 3.1. The text counter is functional but not visually appealing.

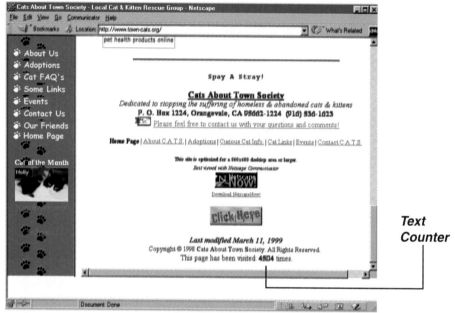

Text Counter

Figure 3.1 *This traditional text counter shows how many visitors have accessed the site.*

The invisible counter is a type of counter that works behind the scenes. As the name suggests, you do not see the invisible counter on the Web page. You should use invisible counters for Web sites that require a counter hidden from the user.

Unlike the traditional text and invisible counters, graphical counters offer functionality and visual appeal. You can, for example, use a graphical counter as an added effect for a Web page look or theme. For example, the counter at *www.andyart.com*, shown in Figure 3.2, compliments the Web page artwork.

Much artwork is available on the Internet for graphical counter digits, the individual numbers that appear within a counter. As shown in Figure 3.3, The Museum of Counter Art at *www.counterart.com/hiband/index.html* has a wide variety of colorful counter digits.

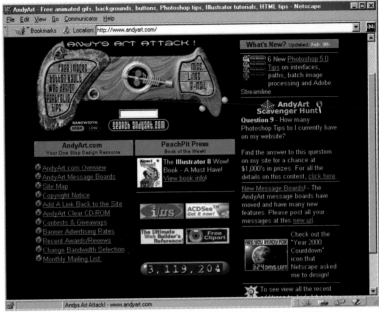

Figure 3.2 *The counter at **www.andyart.com** adds to the look of this Web page.*

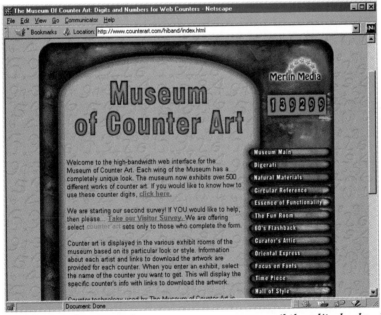

Figure 3.3 *The Museum of Counter Art at **www.counterart.com/hiband/index.html**.*

Another source for counter artwork is Digit Mania at *www.digitmania.com/fancy.html*, as shown in Figure 3.4.

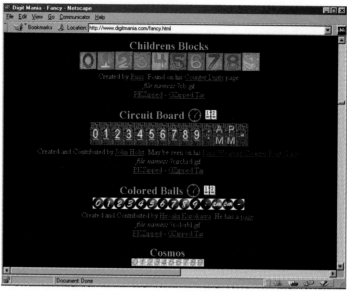

*Figure 3.4 Another source for digit artwork is Digit Mania at **www.digitmania.com/fancy.html**.*

You can also create your own digits for counters. Using an image editing program, such as PhotoShop, you simply create your own set of ten digits with your own artwork. However, you should be certain all ten images are the same size.

Some counters display more information than just the number of times users have accessed a site. For example, site statistics display counters display site statistics information, as shown in Figures 3.5 and 3.6.

Figure 3.5 A counter can display access count and site statistics.

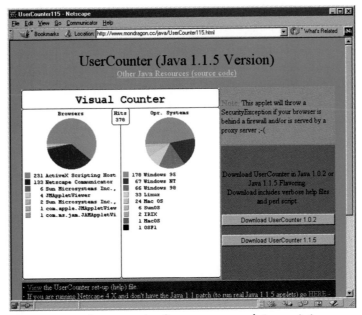

Figure 3.6 UserCounter is another example of access count and site statistics.

The Java Applet at *www.mondragon.cc/java/UserCounter115.html*, as shown in Figure 3.6, displays the number of access hits as well as browser and system information. Not all Web counters display a real access count. Some counters are just animated GIF images (as you will learn about in Lesson 4) or other types of Web animations that are just for fun and meant to look like a real counter in action. The Crazy Counter Java Applet, as shown in Figure 3.7, is an animated counter that entices the user to interact with it by making it go faster or slower.

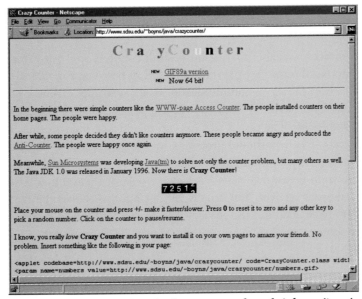

Figure 3.7 The Crazy Counter Animation Applet at *www.sdsu.edu/~boyns/java/crazycounter/*. **21**

Counters offer many advantages. For example, a counter is relatively easy to add to a Web page. In addition, you do not need special plug-in software to view a counter within your browser. Counters are generally cross platform- and browser-compatible. Download time for counters is minimal since the graphic digits are small in size. Counters also can give a rough idea of a site's popularity. You may need to adjust some special Unix server settings and acquire some knowledge of programming concepts from outside resources (such as educational courses, reference books, technical Web sites, and other materials), depending on the type of counter you choose. However, to add a counter, typically you must write only a line or two of code for Java counters and other similar Web technologies, or use a CGI script or other type of script. (You will learn about CGI in detail in Lesson 14, "Understanding CGI.") You will learn more about the requirements for adding a counter later in this lesson.

Despite their many advantages, counters have several drawbacks. For example, access counts are misleading for several reasons. Readings can register lower than their actual count due to the counter's inability to work with text-only browsers or other browsers with load graphics set to off. The counter cannot detect repeat visits because most hit counters ignore a page in the browser's cache. For example, if a user revisits a Web site a week later, the counter may not update the count because the browser loads the page in memory from the previous visit. With the increasingly popular cache proxy servers, this inability to detect cached copies results in even more inaccurate readings since cache proxy servers download a page only once and send it to other users who ask for it. Some examples of cache proxy server users include AOL and Web TV. Likewise, readings can register higher than their actual count. For example, Webmasters or Web site owners can easily change the access counts file to a higher number, resulting in fake readings. Users can also visit a page several times and they can clear the cache each time to add false hit accesses to a counter.

Adding a Counter to a Web Page

You have several options available to you for adding counters to a site. You can use counter services, CGI scripts (CGI scripts are programming scripts based on a standardized set of conventions that designate how the server communicates with a Web application, which you will learn about in Lesson 14, "Understanding CGI"), or Java applets (Java applets are small programs you embed into Web site pages). The easiest way for you to add a counter to your Web page is to use a counter service. However, you should proceed with caution regarding counter service companies because they may resell your information or bombard you with spam. Sites such as *www.bettercounter.com*, as shown in Figure 3.8, *www.TheCounter.com*, or *www.fastcounter.com*, provide free counter and site statistics services. You usually fill out a form, choose the type of counter you want, and place the given code and the service's link on your Web page. In return, in most cases, you provide the counter service company with your personal information.

You can also program your own counter script, but many freeware and shareware CGI scripts and Java applets already exist. At sites such as *www.freecode.com, www.javaboutique.com,* and *www.davecentral.com,* you will find many options for free counter scripts. Most free counters use CGI scripts but some Java applet options exist, such as the UserCounter applet discussed earlier in this lesson. No matter which option you choose, all counters work the same way. Each time a user accesses a page, a counter program reads the counter file's current count, adds one to the count, and updates the file with the new count.

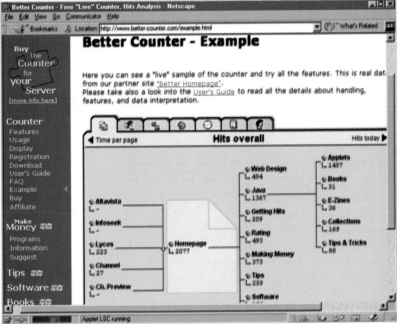

Figure 3.8 An example of Better Counter at **www.better-counter.com** */example.html.*

Now you are ready to add your first counter. In this lesson, you will add a simple text counter using the Simplehits.pl CGI script. All the files you must use for this exercise are in the LESSON3 directory on the CD-ROM that accompanies this book. Copy all of these files to a directory on your hard drive. The first step you will perform to add the counter is setting up the variables.

SETTING UP THE VARIABLES

To set up the variables for your counter, perform the following steps:

1. Click your mouse on the Start button. Windows, in turn, will display the Start menu.

2. Within the Start menu, select the Programs option and then choose Windows Notepad from the Accessories sub-menu. Windows, in turn, will open the Windows Notepad ASCII text editor.

3. Select the File menu Open option. Windows Notepad, in turn, will display directories and lists of files.

4. Within the Files of type field, use the pull-down list to select All Files (*.*).

5. Within the Look in field, use the pull-down list to select the directory where you copied the files from the CD-ROM.

6. Select the simplehits.pl file.

7. Click your mouse on the Open button. Windows Notepad, in turn, will display the script shown in Figure 3.9.

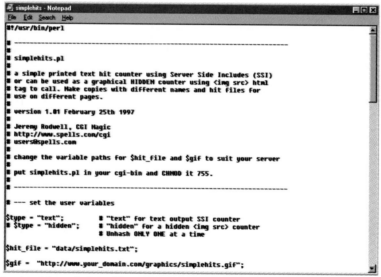

Figure 3.9 *The simplehits.pl CGI file as it appears in Windows Notepad.*

The simplehits.pl file is a CGI script file. You should first make sure that simplehits.pl file contains the correct path to your Perl Interpreter. You will find the path on the first line of the simplehits.pl file. The line looks similar to the following: #!/usr/bin/perl. If you are not sure what your path should be, contact your system administrator and ask what the correct path is. If this path is not correct, your counter will not work. The simplehits.pl CGI file has several variables that should be set correctly. For each of the settings below, you must substitute the correct server root path, as indicated in bold. To keep it simple, you will copy all the files (simplehits.pl, simplehits.txt, simplehits.shtml, and simplehits.gif in the LESSON3 directory) to your CGI-BIN directory.

```
$type = "text";   (Be sure this variable is set to "text" for a text counter)

$hit_file = " your path/cgi-bin/simplehits.txt";

$gif =          "/cgi-bin/simplehits.gif";
```

In addition to the simplehits.pl CGI script, you can use an HTML file called simplehits.shtml to test your script. It is also included in the LESSON3 directory. The line of code in SIMPLEHITS.SHTML you will use to activate the counter script looks like this:

```
<!—#exec cgi="/cgi-bin/simplehits.pl"—>
```

UPLOADING FILES AND SETTING PERMISSIONS

Your FTP software should have settings for binary and ASCII transfer. Except for the graphics files, you must upload all the project CGI files (simplehits.pl and simplehits.txt) as ASCII. You should upload only the graphics and most HTML files (simplehits.gif and simplehits.shtml) as binary. After the files are in place, you must set the permissions, as shown below, using the CHMOD command. If you are not familiar with this command, you should contact your system administrator. To upload the files to the proper location on your server, perform the following steps:

1. Connect to your server via FTP using WS-FTP or another FTP software program (if you are not sure how to do this, ask your system administrator).

2. Double-click your mouse on the CGI-BIN directory to access it. You should see some files in this directory.

3. Upload to test your script.pl and to test your script.txt to your CGI-BIN directory. (Be sure the FTP software's setting for ASCII is on.)

4. Use the CHMOD command to set the permissions to 755 for simplehits.pl and 666 for simplehits.txt.

5. Upload simplehits.gif to your CGI-BIN directory (be sure the FTP software's setting for binary is on).

6. Upload simplehits.shtml as binary to the directory where you keep your other HTML files.

You are now ready to view your text counter in your browser. The counter should appear as shown in Figure 3.10. To view the counter, use the following command (replace the bolded text with your domain name):

http://www.**your-domain-name**.com/cgi-bin/simplehits.pl

Figure 3.10 *The CGI text counter as it should appear in your browser.*

ADDING A COUNTER TO A WEB PAGE USING FRONTPAGE 2000

Adding a counter to a Web page is easy with FrontPage 2000. However, you must make sure your server has support for FrontPage Server extensions. (If you are not sure, you can ask your system administrator.) To add a counter using FrontPage 2000, perform the following steps:

1. Click your mouse on the Start button. Windows, in turn, will display the Start menu.

2. Within the Start menu, select the Programs option and then choose Microsoft FrontPage. Windows, in turn, will open the FrontPage Editor.

3. Click your mouse on the File menu Open Web option. FrontPage, in turn, will display the Open Web dialog box.

4. Enter a Folder name and click your mouse on Open.

5. Select the Insert menu Component option. Then, select the Hit Counter option. FrontPage, in turn, will display the Hit Counter Properties dialog box, as shown in Figure 3.11.

6. Within the Hit Counter Properties dialog box, select the Counter Style you want to use. Notice the Custom Picture option is available if you want to add your own GIF counter artwork file. Click your mouse on the Reset Counter to option button to start the count at a count other than zero, as shown in Figure 3.11.

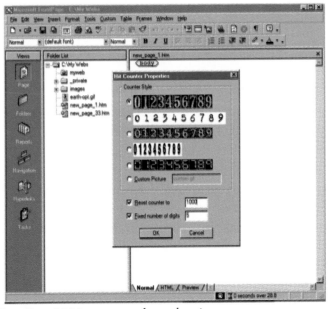

Figure 3.11 *The FrontPage 2000 counter styles and options.*

7. Click your mouse on the Fixed number of digits option button to control the number of counter digits, as shown in Figure 3.11.

8. Click your mouse on the OK button. The FrontPage editor will place the counter as a tag on your page as shown in Figure 3.12. (Various FrontPage 2000 view settings may result in some variation in appearance.)

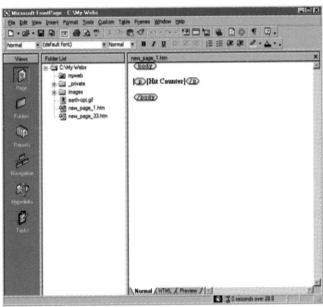

Figure 3.12 *The counter on the page after inserting it into FrontPage 2000.*

9. Click your mouse on the Save button to save your file.

10. Click your mouse on the File menu Publish Web option and upload your page to your server. FrontPage 2000, in turn, will display the Publish Web dialog box.

11. Enter a location to which you want to publish your file. If you are not sure where to publish your files, check with your system administrator.

12. Connect to the Internet as you normally would.

13. Click your mouse on the Publish button. FrontPage 2000, in turn, will display a dialog box requesting a name and password.

14. Enter your username and password. If you are not sure what username and password to use, check with your system administrator.

15. Click your mouse on OK. FrontPage 2000, in turn, will display a message that indicates your file has been uploaded successfully and will provide a link to view the file.

16. Click on the link to view your counter in a browser. FrontPage 2000, in turn, will display the counter, as shown in Figure 3.13.

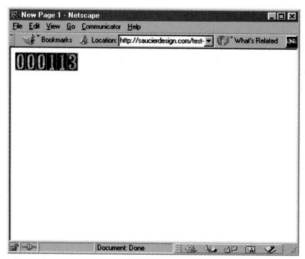

Figure 3.13 *The FrontPage 2000 counter as it appears on the page in Netscape.*

WHAT YOU MUST KNOW

As you have learned, the counter is easy to create and can enhance your Web site if you use it effectively. However, before you can add a counter, you should first understand some basic concepts, such as counter types and the advantages and disadvantages of their use. In Lesson 4, "Creating Animated GIFs," you will find out how easy it is to add interesting GIF animations to your Web pages. Before you continue with Lesson 4, however, make sure you understand the following key concepts:

✓ Counters can give a rough idea about site popularity as well as add visual appeal to a page.

✓ Several types of counters include the simple text counter, graphical counter, site statistics display counter, invisible counter, and animated counter.

✓ Counters offer several advantages, such as providing Web statistics and graphical appeal. Some disadvantages include inaccurate and fake results.

✓ All access counters work in the same manner. Each time a user accesses a page, a counter program reads the counter file's current count, adds one to the count, and updates the file with the new count.

✓ To add a counter, you select a CGI script, set up the variables, upload the files, set file permissions, add the appropriate code to the HTML file, and upload the HTML file.

✓ Adding a counter to a Web page is relatively easy but some special settings and some knowledge of programming concepts may be required, depending on the type of counter you choose.

LESSON 4

CREATING ANIMATED GIFs

Over the past few years, Web designers have used GIF animations to make Web sites more interesting and appealing. GIF animations are simply a series of frames displaying movement or change in appearance to create a visual effect. You can easily create GIF animations using the GIF animation software programs on the market today.

In this lesson, you will learn how to effectively use and add GIF animations to your Web site. By the time you finish this lesson, you will understand the following key concepts:

- A GIF (Graphics Interchange Format) animation should have a purpose for being on a page, such as to attract attention to a page item.

- GIF animations are versatile and come in many forms, including special effects, demonstrations of processes, animated banners, product slide shows, and much more.

- GIF animations have several advantages over other types of Web animation. For example, GIF animations offer cross-platform viewing and GIF animations do not require a plug-in (a special utility that lets the browser display various types of Web elements) for you to view them.

- Although GIF animations offer many advantages, the animated GIF does have some disadvantages, such as color limitations and lack of support for older browsers.

- Many GIF animation software programs are on the market and include options for special effects and optimization, as well as many other features.

- It is important to keep your GIF animations small in file size for fast-loading time. Many options exist for reducing the size of animations. Use of tables, color reduction, and special compression software and services can help reduce a GIF animation's loading time.

- To create a GIF animation, you will create the animation frames, create and apply a superpalette to all frames, using GIF animation software to generate the animation, and optimize the resulting animation.

- Adding an animation to a Web page is as simple as adding a graphic. You need no special settings.

ENHANCING YOUR WEB SITE WITH ANIMATED GIFs

Using GIF animations, you can greatly enhance a Web site's visual appeal. You can, for example, use a GIF animation to add an animated banner to a page, as shown in Figure 4.1.

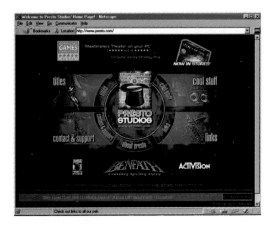

Figure 4.1 *Using an animated banner to focus the user's attention on the Presto Web site at* ***www.presto.com***.

By attracting the user's attention, the animated banner may entice the user to click the mouse on the link to get more information. You might also, as shown in Figure 4.2, use animations to emphasize some item or idea on your page.

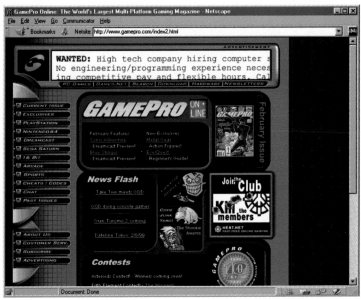

Figure 4.2 *The animation at* ***www.gamepro.com*** *draws the user's attention to various products.*

Other uses of animations include eye-catching splash pages, slide shows, demonstration of a series of steps or an action, and special effects, such as lighting, transitions, scrolling, and many other types. Before you place an animated GIF image on a page, make sure the image serves a purpose. As you will learn, GIF animations often create large files that increase download time. Likewise, keep in mind that your goal in using a GIF animation is to focus the user's attention on an item on the page. If you place too many animated GIF images on the same page, your Web site will appear cluttered and visually distracting. Too many animated buttons and backgrounds can be a reason users quickly leave a page.

Many Web site designers use a variety of GIF animations to enhance a Web site's look and feel. For example, you can create short slide shows to display different company products or services, as shown in Figure 4.3.

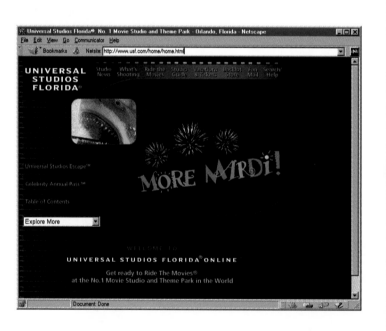

*Figure 4.3 The slide show animation at **www.usf.com** displays the products and services of Universal Studios Florida.*

A splash page with an animation makes a Web site inviting, as shown in Figures 4.4 and 4.5.

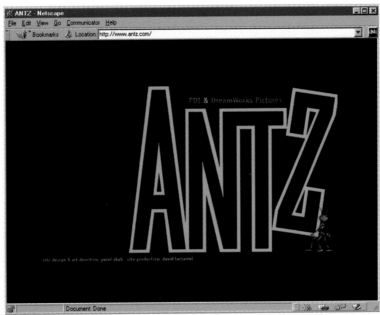

Figure 4.4 *The splash page animation at **www.antz.com** invites a user to find out more information about the movie.*

Figure 4.5 *The animation on the splash page at **www.art.net/studios/visual/Alfredo/** entices the user to access the PhotoALF site's home page.*

You can also use GIF animations to demonstrate a process or action. For example, a GIF animation could show how DNA replicates. Another popular type of animation you can create is the sequence animation, which shows an object that changes from one form to another. GIF animations do not have to be only 2D. You can also create 3D GIF animations. After you export the frames of a 3D animation using your favorite 3D software, you can import them to a GIF

animation program to create a 3D GIF animation. You can also use a GIF animation as a special effect. For example, you can add special effects to a logo or other graphic, as shown in Figure 4.6.

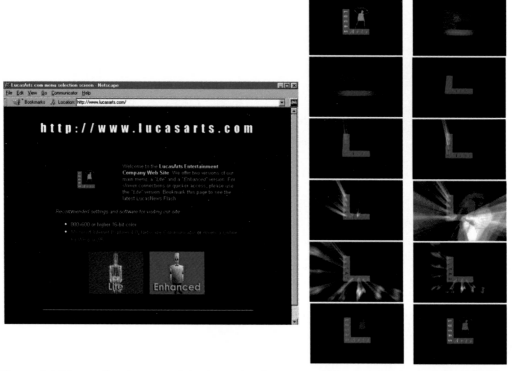

Figure 4.6 *The small animation of the Lucas Arts logo at* **www.lucasarts.com** *uses fade and lighting special effects.*

Some GIF animation programs, such as *Ulead's GIF Animator 3.0*, let you automatically add special effects to an image as well as provide other options. Another type of GIF animation is the animated banner ad that entices the user to get more information about the banner ad's topic. You can convert video clips to GIF animation. Using programs like *Ulead GIF Animator 3.0*, you can take a short AVI video clip (the popular Windows video format), reduce the number of frames, and export it as a GIF animation, as shown in Figure 4.7.

Animated buttons can add life to a Web site but should not distract the user's attention. An animated background, as shown in Figure 4.8, is another type of GIF animation.

GIF animations have many advantages over other types of Web animations. For example, you do not need special plug-in software to view an animated GIF within your browser. Animated GIFs also normally require smaller file sizes than other types of animations, which result in faster downloads. In addition, by using GIF editing software, you may be able to further optimize an animated GIF's file format, compressing the animation into yet a smaller file. GIF animations offer cross-platform viewing and are compatible with most browsers. Even non-compatible browsers will display one frame of the animation instead of an error message or plug-in required alert. Animated GIF images are easy to

create compared to other Web animations. Versatility is yet another advantage of GIF animations. Since GIF animations are simple in design and small in size compared to other types of Web animations, GIF animations place less of a burden on the network servers to which you upload your files.

Figure 4.7 An animation at ***www.sundancechannel.com*** *displays frames from a video clip converted to a GIF animation.*

Figure 4.8 The animated background at ***www.gameworld.com*** *is not too distracting for the user.*

However, some disadvantages exist too. The 256-color limit of GIFs establishes optimization as a must for best performance of the animation. You will learn about palette reduction and optimization later in this lesson. Certain browsers may distort a GIF animation's appearance. For example, some of the older Netscape and Internet Explorer versions have problems with disposal method settings (settings that let the first animation frame be full-size and include only the parts that change in the other frames). Another disadvantage of GIFs is that other graphics can interfere with the animation's playback. Unlike other Web animations (such as Shockwave or Flash), users can easily save a copy of your animation and later use it on another Web site.

USING PALETTES AND OPTIMIZATION

To create effective fast-loading animations, you must optimize your GIF animation files. No matter how appealing an animation is, most users will not wait three or four minutes to see it. Generally, all elements on one page should not add up to more than 100KB. However, there will be times when this simply is not possible due to, for example, project constraints and bandwidth considerations.

Several options available for reducing the size of animations include:

- Using tables to put graphics together. Tables can greatly reduce the size of a GIF animation since only part of the graphic is an animation, instead of the entire image.

- Color reduction.

- Special compression software/services, such as Ulead's GIF Animator 3.0, GIF Wizard, and GIF Cruncher, can greatly reduce the overall size of an animation while retaining adequate quality.

Tables have become popular in laying out Web pages. Depending on what your animation is like, tables can help reduce its overall file size. For example, you may have an image you want to animate, but only a small part of the image will actually be the animation. You can manually cut up the image into different pieces using a program like PhotoShop, or automatically, using a special utility like Ulead SmartSaver Pro. If you use PhotoShop, you must put the resulting graphics back together in your HTML Editor using table cells, which are the individual divided segments that make up a table. Programs like Ulead SmartSaver Pro create the HTML file with the graphics already in the table cells. The result is a fast-loading animated graphic, as shown in Figures 4.9 and 4.10.

By slicing up your image into sections, the actual animated part of the image will now be in a table cell by itself. The rest of the image in the other table cells does not become part of the actual animation file, thus reducing file size. You can also use tables to contain an image with multiple animations with varying delay times. For example, you can slice up an image where instead of one animating part, two or more parts of the image animate at different times.

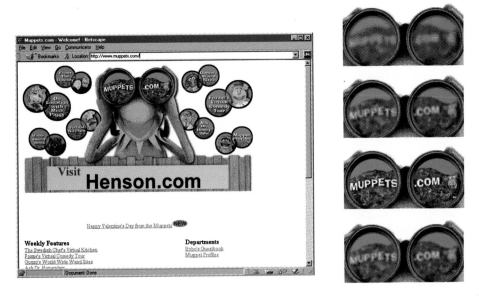

Figure 4.9 *Only part of the image is an animation at* **www.muppets.com**. *The designer uses tables to layout this image and reduce the animation's file size.*

Figure 4.10 *Another example of using tables to reduce the animation's file size can be found at* **www.cry-sys.com**.

Another way to reduce the size of a GIF animation is to reduce the color palette. For example, if you have a 256-color image and decrease its colors to 64, then the size of the animation will be significantly smaller. However, too much color reduction may have an effect on image quality. As you can see, some complexities exist for animated GIF creation. Fortunately, several software options are available that help with palette and overall GIF animation optimization.

Initially, two options exist for selecting a palette (the set of colors that make up a graphic). One option is the browser-safe palette (for example, Netscape's 216-color palette). However, the results for colorful photographic images are not always the best with the browser-safe palette. Also, there is no safe palette that will not dither (use of colors from the available palette to adjust for colors not found in the palette) on all platforms. However, one safe palette that will not dither on most platforms is the adaptive palette, which uses 256 colors. Color reduction with an adaptive palette will result in an image that keeps many of its original colors. For example, PhotoShop creates a histogram of the image's most common colors to make the resulting image look as much like the original as possible. Using an adaptive palette with diffusion dithering (a type of dithering that changes pixel colors to mix colors of an image) is a better option for viewing on systems with different display settings. The browser remaps the colors for displays set at 256 colors and the resulting images are usually adequate.

With adaptive palettes, it is usually a good idea to create a global optimized palette or superpalette for all your animation frames. A superpalette is a common color palette a group of images share. Instead of a superpalette, you could create several animation frames with the first frame set as the global palette and the other frames set for local palettes. While the resulting animation will work using most newer browser versions, it will flicker in Netscape 3. Therefore, a superpalette for all frames would work best. You should try to include many browser-safe colors in your palette, if possible. Various software options are available to create a superpalette. If you want to assign a palette to all your frames, PhotoShop will let you create a custom palette which shares common colors for your images. However, for complex images, you will find more flexibility and options in programs like Equilibrium's Debabilizer or Digital Frontier's HVS ColorGIF. GIF animation programs like Ulead's GIF Animator automatically create a superpalette for you.

Special compression software services can greatly reduce the overall size of an animation while retaining adequate quality. GIF Wizard and GIF Cruncher offer online GIF optimizing services. Many GIF animation programs like Ulead's GIF Animator also offer optimization and compression for your animations.

OPTIMIZING FRAMES

Software Programs optimize individual GIF animation frames using one or more of three methods. These methods include the minimum bounding rectangle method, frame differencing, and LZW optimization. Software programs that use one or several of these methods include GIF Wizard, Ulead SmartSaver, Macromedia's Fireworks, Ulead's GIF Animator 3.0, and BoxTop

Software's GIFMation. The minimum bounding rectangle method is an optimization method where the first animation frame is full-size and other frames include only the parts that change. Figure 4.1 shows an animation that uses this method. Frame differencing is similar to the minimum bounding rectangle method except it saves only the pixels that change in the animation frames. LZW optimization is a type of lossless compression for GIF and TIFF images. It removes unnecessary image details and color changes your eyes cannot see.

OTHER TIPS FOR OPTIMIZING

Other options are available to ensure a GIF animation's small file size and fast download time. You should always be sure your image's resolution is 72 dpi. You also should not create images that will be too large for GIF animations. (Reduce the image's dimensions or cut them into smaller pieces for tables.) You should always specify height and width in your HTML code for your animated GIF images. Reusing images, if possible, is another way to decrease download time since browsers download and place images in the PC's cache. You should also try to use images that have large areas of solid colors as opposed to gradations.

USING GIF ANIMATION SOFTWARE

Many easy-to-use GIF animation programs exist on the market today, including Ulead's GIF Animator 3.0, Microsoft GIF Animator, GIF Construction Set, GifBuilder, and BoxTop's GIFMation. Table 4 shows where to get more information on the GIF animation software products. No matter which software program you choose, most have options for setting delays (a setting for the time between the display of animation frames), looping (a setting to control how many times the user views the animation), palettes, transparency, and removal methods (the setting that controls how one animation frame changes to the next). Some programs offer options for special effects and optimization.

GIF Animation Program	Platform	For More Information
Ulead's GIF Animator 3.0	PC	*www.webutilities.com*
Microsoft GIF Animator	PC	*www.microsoft.com/ima gecomposer/ gifanimator /gifanin.htm*
MindWorkshop's GIF struction Set	PC	*www.mindworkshop.co m/alchemy/Con- gifcon.html*
GIFBuilder	Mac	*iawww.epfl.ch/Staff/Yve s.Piguet/ clip2gif- home/GIFBuilder.html*
BoxTop's GIFMation	PC/Mac	*www.boxtopsoft.com*

Table 4 GIF animation software products.

CREATING A *GIF* ANIMATION

Now you are ready to create your first GIF animation. The first step for any animation is to create the frames. Animation frames should be the same size and display some type of change whether it be movement, an increase in size, or change in appearance. You can use scanned images, illustrations, photos, or clip media. Some image files to use for this exercise are included in the LESSON4 directory on the CD-ROM that accompanies this book. Copy all of these files to a new directory on your hard drive. For the purposes of this lesson, you will use Ulead's GIF Animator 3.0 to create your GIF animation. You can obtain a demo copy of GIF Animator 3.0 at *http://www.webutilities.com/ga/ga_down.htm.*

To create a GIF animation with *Ulead's GIF Animator 3.0,* perform the following steps:

1. Click your mouse on the Start button. Windows, in turn, will display the Start menu.

2. Within the Start menu, select the Programs option and then choose Ulead GIF Animator. Windows, in turn, will cascade the Ulead GIF Animator sub-menu.

3. Within the Ulead GIF Animator submenu, click your mouse on the GIF Animator option. Windows, in turn, will open the GIF Animator Startup Wizard window.

4. Select the Blank Animation option.

5. Click your mouse on the Edit button for the Global Palette below the top menu bar. GIF Animator, in turn, will display the Global Palette dialog box.

6. Click your mouse on the Load button on the right to change the palette for the GIF animation. GIF Animator, in turn, will display the Choose a palette file dialog box, with directories and lists of files.

7. For the purposes of this lesson, you can use the superpalette included in the LESSON4 directory called earth.pal. Use the Control button in the Choose a palette file dialog box to change to the directory where you copied the LESSON4 files. Select earth.pal and click your mouse on the Open button. GIF Animator, in turn, will prompt you with a message about adding or replacing colors.

8. Click your mouse on the No button. GIF Animator, in turn, will return you to the Global Palette dialog box.

9. Click your mouse on OK. GIF Animator, in turn, will close the Global Palette dialog box and will put the new palette in place.

10. Select the Layer menu Add Images option. GIF Animator, in turn, will display the Add Images dialog box, as shown in Figure 4.11, with directories and lists of files.

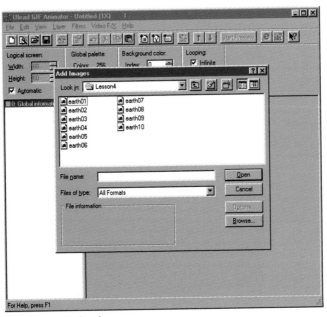

Figure 4.11 The Add Images dialog box.

11. Click your mouse on the first filename and then hold down the SHIFT key while you click your mouse on the last filename to select all 10 animation frames for importing (earth01.bmp through earth01.bmp).

12. Click your mouse on Open. GIF Animator, in turn, will display the frames as shown in Figure 4.12.

Figure 4.12 A list of frames appears to the left of the currently displayed animation frame.

13. Select the appropriate settings (delay, removal method, and other GIF animation settings) for each frame.

As shown in Figure 4.13, GIF animation programs have settings for palette, transparency, removal method, and delay.

Figure 4.13 *The various GIF animation program settings for palette, transparency, removal method, and delay are indicated by the blue box.*

In the program's settings area, you will see a local palette checkbox on the left. You can uncheck the local palette box for each frame to convert these images to the superpalette. Place a checkmark in the transparent index box to set the transparency. You can then pick the color to be transparent so that the image's background will be transparent against the Web page's background. You may have to experiment with the delay speed (a setting for the time between the display of animation frames) to get the right timing. The removal method (the setting that controls how one animation frame changes to the next) includes four options: Do Not Remove, Web Browser Decides, To Background Color, or To Previous State. Having the browser decide is not a good idea since browsers handle animations in many different ways. If an image will remain for the entire animation with other images appearing on top of it, then Do Not Remove is the best option. The To Background Color option removes the image and changes it to the Web page background color. Choose To Previous State to display the animation frame shown before when the contents of your entire frames change. Additional settings for the animation let you edit the superpalette, crop images, set the number of loops, or add special effects.

After you select all the appropriate settings, click on the Start Preview button to preview your animation. Continue to experiment with the settings until you are happy with the results. Then,

select the File menu Save option to save the animation. Name the file *earth.gif*. Next, click on Save. Select the File menu Optimization Wizard to reduce the size of the animated GIF. GIF Animator, in turn, will display the Optimization Wizard window, as shown in Figure 4.14.

Figure 4.14 The Optimization Wizard window.

You will be prompted to set options. Use the settings below as a guideline for this lesson:

Use Global Palette: Yes

Number of Colors: 100

Dithering: Yes

Remove Redundant Pixels: Yes

Remove Comment Blocks: Yes

Then, click your mouse on Finish to optimize your GIF animation using GIF Animator's Optimization Wizard. GIF Animator, in turn, will display a window with information about the optimization that just took place. Save the file as *earth-opt.gif*.

ADDING AN ANIMATION TO A WEB PAGE

Adding your GIF animation to a Web page is as simple as adding any graphic. The HTML source code is the same code you use to add graphics to your Web page, as shown below:

```
<IMG SRC="filename.gifz">
```

You do not need any special requirements, server settings, or unusual tags for GIF animations. You should be sure your GIF animation includes the height and width attributes, as with any graphic, to be sure it displays properly.

To add a GIF animation using FrontPage 2000, perform the following steps:

1. Click your mouse on the Start button. Windows, in turn, will display the Start menu.
2. Within the Start menu, select the Programs option and then choose Microsoft FrontPage. Windows, in turn, will open the FrontPage Editor.
3. Select Insert menu Picture option. FrontPage, in turn, will cascade the Picture sub-menu.
4. Within the Picture submenu, click your mouse on the From File option. FrontPage, in turn, will open the Select File window.
5. Select the resulting GIF animation called *earth-opt.gif.*
6. Click your mouse on OK. Windows, in turn, will display the GIF animation as it should appear on your page, as shown in Figure 4.15.

Figure 4.15 The GIF animation on the page after importing it into FrontPage 2000.

7. Save your file.

8. Select File menu Preview in browser option to view your animation in a browser, as shown in Figure 4.16.

Figure 4.16 *The animated GIF appears on the page in Netscape.*

WHAT YOU MUST KNOW

GIF animations offer versatility that can greatly enhance a Web page. However, before you can create a GIF animation, you should first understand some basic concepts, such as GIF animation types, the importance of GIF animations having a purpose, and options for optimization. This lesson introduced GIF animations. In Lesson 5, "Implementing a Search Engine," you will find out how easy it is to add a simple search engine to a Web site. Before you continue with Lesson 5, however, make sure you understand the following key concepts:

✓ A GIF animation should have a purpose for being on a page, such as to attract attention to a page item.

✓ GIF animations are versatile and come in many forms, including special effects, demonstrations of processes, animated banners, product slide shows, and much more.

✓ GIF animations have several advantages over other types of Web animation as well as some disadvantages.

✓ GIF animation software programs let you easily create animated GIFs and include options for special effects, optimization, and much more.

✓ Optimization to reduce the GIF animation's file size is important for fast-loading time. Some methods to reduce the GIF animation's loading time include use of tables, color reduction, and special compression software and services, such as Ulead's GIF Animator 3.0, GIF Wizard, and GIF Cruncher.

✓ To create a GIF animation, you create the animation frames, create and apply a superpalette to all frames, using GIF animation software to generate the animation, and optimize the resulting animation.

✓ Adding an animation to a Web page is as simple as adding a graphic. You need no special settings.

LESSON 5

IMPLEMENTING A SEARCH ENGINE

As a Web site gets larger with additional information, a Web site designer may decide to add a search engine. A search engine is a utility that lets the user enter a word or phrase to find information about a topic at a Web site. Thus, a search engine is a component that makes a Web site more user-friendly and interactive.

In this lesson, you will learn how to add a search engine to your site. By the time you finish this lesson, you will understand the following key concepts:

♦ Search engines serve several functions on a Web site, such as making a Web site more functional and interactive and providing an additional way other than using navigational bars to find site information.

♦ Several types of Web site search engines exist on Web sites and include search engines that perform simple text site search capabilities, more complex site search engines with advanced features, and search engines that search the entire Internet.

♦ Search engines offer many advantages, such as adding Web site functionality and interactivity, ease of implementation, no special plug-in required for viewing, minimal download time, and cross-platform and browser compatibility. A disadvantage is user frustration due to inadequate programming or the use of vague terms.

♦ To add a search engine to your Web site, you must determine your needs and what type of search engine would be best. Some factors to consider are the size of your Web site and the type of information your Web site includes, who is your audience, search engine program compatibility, and your budget.

♦ Several freeware or shareware search engine options are available for both simple and advanced search engines and include the Home Page Search Applet, the Simple Search script from Matt's Script Archive, ht://Dig, ICE, Excite for Web Servers, and Glimpse.

♦ To add a search engine, you must select a search engine program or script, add the appropriate code to the HTML file, and upload the HTML file and all other required files to your server.

♦ Adding a search engine to a Web page is relatively easy but you may need some special settings and some knowledge of programming concepts, depending on the type of search engine you choose.

ENHANCING YOUR SITE WITH A SEARCH ENGINE

Search engines play a vital role in the use of the Internet. Users rely on search engines to help them find information. Web site owners rely on search engines to bring more users to their Web sites. Some search engines, such as Excite at *www.excite.com*, as shown in Figure 5.1, have become a household name, while many exist that few users have heard of.

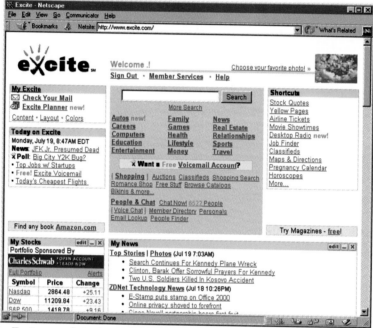

Figure 5.1 *The Excite search engine at* ***www.excite.com***.

Some search engines search for all types of information on the Internet. Other search engines, such as Switchboard.com at *www.switchboard.com*, as shown in Figure 5.2, have a more narrow focus and search for phone numbers, addresses, and e-mail addresses, as well as other specific types of information.

Companies include search engines on their Web sites to search the entire Internet or just local to their own Web sites. For example, NetZero, as shown in Figure 5.3, offers free Internet access and e-mail to users and includes a search engine to search the entire Internet as a benefit to users visiting their Web site at *netzero.looksmart.com*.

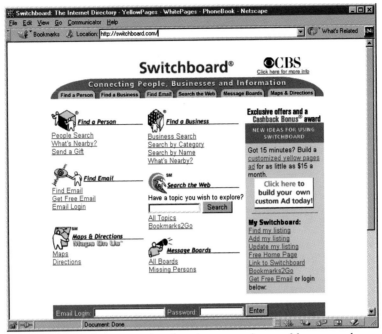

Figure 5.2 www.switchboard.com searches for phone numbers, addresses, and e-mail addresses of both businesses and people.

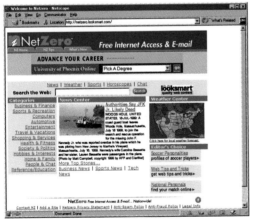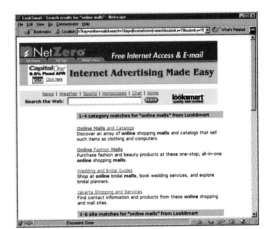

Figure 5.3 NetZero with a search engine.

Some Web sites, such as the Henry Ford Health System's Web site at *www.henryfordhealth.org/sea/ index.html*, include both Internet and local Web site search capabilities, as shown in Figure 5.4.

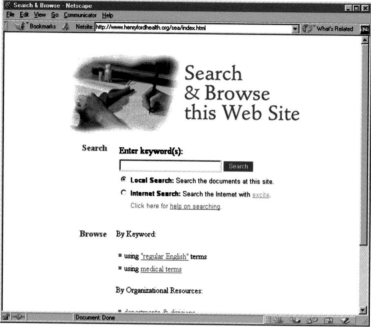

Figure 5.4 The Henry Ford Health System's Web site .

For medium to large-sized Web sites with multiple pages of information, you should consider adding site search capabilities. Search engines serve several functions on a Web site, such as making a Web site more functional and interactive and providing an additional way other than using navigational bars to find site information. A Web site with a search engine provides users with an additional way to find the information the user seeks. You cannot include all site topics for large Web sites in navigational bars. Therefore, site search capabilities make sense for Web sites containing much information. If users have a difficult time finding information at your Web site, they probably will not return for another visit.

Several types of Web site search engines exist on Web sites and include search engines that perform simple text site search capabilities, more complex site search engines with advanced features, and search engines that search the entire Internet. The simplest type of Web site search engine searches a Web site's HTML files and finds all matching words or phrases that a user requests. For example, the Java applet at *www.babbage.demon.co.uk/HomePageSearch.html* performs a search of HTML files for the phrase "search applet" and retrieves a list of pages the phrase is found on, as shown in Figure 5.5.

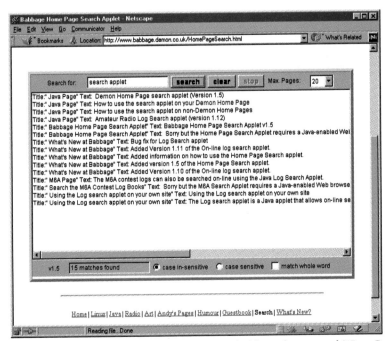

Figure 5.5 Sample search results of the Java applet at www.babbage.demon.co.uk/HomePageSearch.html.

You can then double-click your mouse on an entry to access the Web page with the information. Simple search engines are fine for some small to medium-sized sites, but for many complex Web sites containing vast amounts of information a search engine with advanced features is a better choice. Search engines with advanced features perform more than simple text searches. For example, some search engine programs take the user's input and search for the past tense, plural, and other variations of the word or phrase, they provide results on other related information, use a thesaurus to find more information from similar terms, automatically omit unlinked Web pages on servers, and search other types of documents besides HTML files (such as spreadsheets). However, what differentiates the advanced featured search engines from the simple text search engines is the use of a large index that the search program generates or one you generate manually. The index contains information about your Web site pages, such as all the Web site's HTML files and other types of files as well as pointers to the Web pages' indexed words. The advantage of using an advanced featured search program is more accurate results for the user. The advanced search programs generally display query results as a link and description or just a link to access the information. An example of an advanced featured search program is the search engine at the Chef Talk Web site at *www.cheftalk.com*, as shown in Figure 5.6.

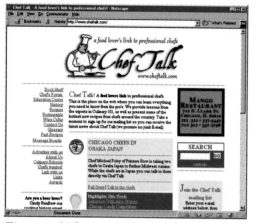

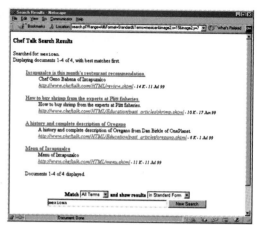

Figure 5.6 *The sample search using the advanced search engine at the Chef Talk Web site.*

A search for the word "mexican" results in several entries with a brief description and link. The Chef Talk Web site's search engine also incorporates the look of the Web site for both the search entry box and the results. You should be sure to have your search engine appear like the rest of your Web site for a uniform look. Advanced searches can include choices for categories to narrow down the search for information. For example, IBM's Web site at *www.ibm.com* offers the user a choice to search the entire site or just certain areas, as shown in Figure 5.7.

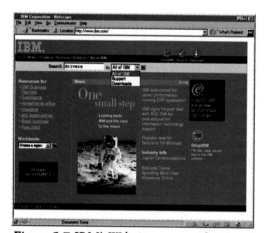

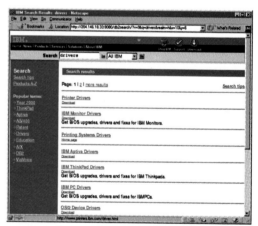

Figure 5.7 *IBM's Web site at* **www.ibm.com** *lets users search the entire site or just certain areas.*

As you can see, the result for "drivers" is a rather long list. The results may be more accurate if searching only the Download or Support areas. IBM's Web site is also another example of how the look of the search program matches the look of the rest of the Web site. Some search engines let you limit the search by more than one category. For example, the ThinkQuest Library of Entries Web site at *library.advanced.org/library/advanced.html* lets the user narrow down the search for information by selecting documents pertaining to a specific country, language, and type, as well as how to list the results, as shown in Figure 5.8

Figure 5.8 *The ThinkQuest Library of Entries Web site at **library.advanced.org/library/advanced.html***.

You can use search engines with other components on Web sites to make your search engine more effective. For example, you can give the user a choice of using a search engine or choosing a general topic from a pull-down menu to access information. Webreview.com's search engine at *www.webreview.com/wr/pub/* includes the added option of accessing information from a pull-down menu of jump to links, as shown in Figure 5.9.

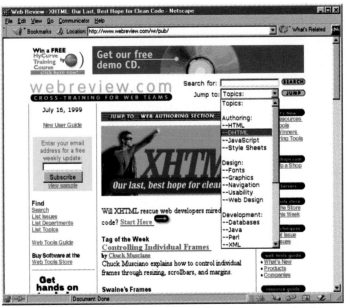

Figure 5.9 *Webreview.com's search engine at **www.webreview.com/wr/pub/***.

You can also give the user options to browse information by category in addition to using the search engine. For example, the Learner Online Web site at *www.learner.org/info/search/* lets the user browse by title, subject/discipline, primary audience, and primary purpose, as shown in Figure 5.10.

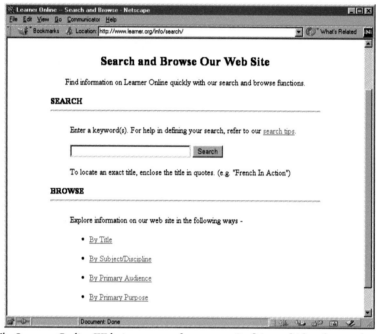

*Figure 5.10 The Learner Online Web site at **www.learner.org/info/search/** lets the user browse by category.*

Sometimes users can have difficulties using search engines. Therefore, you should, if possible, also include some tips and guidelines on how to use the search engine on your Web site for best results. Some Web sites that offer search tips for users include the Henry Ford Health System's Web site, as shown in Figure 5.4, and the Chef Talk Web site, as shown in Figure 5.6. Useful information to include in search tips is how the particular search engine works, types and examples of queries users can enter for more advanced searches, any information on advanced options the search engine supports, and tips on how to handle situations of inadequate results.

Search engines offer many advantages. For example, search engines make a Web site more functional and interactive. A search engine is also relatively easy to add to a Web page. Depending on the type of search engine you choose, you may need some special settings and knowledge of programming concepts. However, typically you just need to modify the parameters of a Java applet or set up a CGI script (you will learn about Java in Lesson 8, "Understanding and Working with Java," and about CGI in Lesson 14, "Understanding CGI") or other Web programming technology to add search capabilities. In addition, you do not need a special plug-in to view a search engine within your browser. Search engines are generally cross platform- and browser-compatible. Download time for search engines is minimal in most cases.

Despite the many advantages, search engines offer some disadvantages. For example, sometimes search engines can frustrate users because search engine programs can display too many results due to inadequate programming or the use of vague terms. Some simple search engines can also provide irrelevant results since the simple search engine does not have any advanced features.

ADDING A SEARCH ENGINE TO A WEB PAGE

To add a search engine to your Web site, you must determine your needs and what type of search engine would be best. Some factors to consider are the size of your Web site and the type of information your Web site includes, who is your audience, search engine program compatibility, and your budget. For small to medium-sized Web sites, you may be able to use a simple text search engine. However, if you feel that the type of words or phrases users will enter may result in too many links then you may want to consider a search engine with advanced features. Likewise, if you feel your audience may expect an elaborate search engine with many options for searching, a simple text search engine would not be adequate. You should also be sure your choice for a search engine is compatible with the operating system of your server. Cost is another factor. Several freeware or shareware search engine options are available for both simple and more advanced search engines. Two freeware simple search engines are the Java applet at *www.babbage.demon.co.uk/HomePageSearch.html* and the Simple Search script from Matt's Script Archive at *www.worldwidemart.com/scripts/search.shtml.* Some more advanced freeware and shareware search engine programs include ht://Dig (*www.htdig.org*), ICE (*www.objectweaver.de/ice/*), Excite for Web Servers (*www.excite.com/navigate/*), and Glimpse (*glimpse.cs.arizona.edu*). New search engine programs are developed periodically. Other resources for shareware and freeware search engine programs and scripts include Website Abstraction at *www.wsabstract.com*, Web Developer's JavaScript resources at *www.webdeveloper.com/javascript*, The Web Design Resource at *www.pageresource.com*, The Script Vault at *www.iw.com/daily/scripts/*, The JavaScript Tip of the Week archive at *www.WebReference.com/javascript/*, The JavaScript Source at *www.Javascriptsource.com*, WebCoder Scriptorium at *www.webcoder.com/scriptorium*, *www.freecode.com*, *www.javaboutique.com*, and *www.davecentral.com*.

Now you are ready to add your first search engine to your Web page. In this lesson, you will add a simple freeware text search engine Java applet called Home Page Search. For more information on the Home Page Search Applet, refer to *www.babbage.demon.co.uk/java.html*. All the files you need to use for this exercise are in the LESSON5 directory on the CD-ROM that accompanies this book. Copy all of these files to a directory on your hard drive. The first step in adding a search engine to your Web page is to add the code to your HTML file. For the purposes of this lesson, the code to embed the Home Page Search Applet is provided for you. An example of how that code looks is shown below:

```
<APPLET CODE="HomePageSearch.class" WIDTH="650" HEIGHT="400">

<PARAM NAME="server" VALUE=" http://www.yourhomepage.com ">
```

```
<PARAM NAME="indexName" VALUE="homepage.htm">

<EM>Sorry but the search applet requires a java aware browser.</EM>

</APPLET>
```

As you can see, the first line of code sets the width and height of the applet as well as specifies such items as the Java applet class file to load. Java applets usually have several lines of parameter settings for various applet options. In this case, you will set two parameter settings, as indicated in bold, the URL of your home page, and the name of your index file for your Web site. To add the code to your HTML document, perform the following steps:

1. Click your mouse on the Start button. Windows, in turn, will display the Start menu.

2. Within the Start menu, select the Programs option and then choose Windows NotePad from Accessories. Windows, in turn, will open the Windows NotePad ASCII text editor.

3. Select the File menu Open option. Windows NotePad, in turn, will display directories and lists of files.

4. Select the search-code.txt file.

5. Click your mouse on the Open button.

6. Select all the code in the search-code.txt file.

7. Select the Edit menu Copy option.

8. Select the File menu Open option. Windows NotePad, in turn, will display directories and lists of files.

9. Select the search-test.htm file.

10. Click your mouse on the Open button.

11. Position your cursor between the <BODY> tags, then select the Edit menu Paste option to paste all the code from the search-code.txt file. Windows NotePad, in turn, will display the code, as shown in Figure 5.11.

12. Enter the URL of your home page for the first parameter and the name of your Web site's index file for the second parameter.

13. Save your file.

14. Connect to your server via FTP using WS-FTP or other FTP software program. (If you are not sure how to do this, ask your system administrator.)

15. Upload all files in the LESSON5 directory as you normally would to the directory on your server where you keep your other HTML and graphic files.

Figure 5.11 The search-test.htm file with the code as it appears in Windows NotePad.

16. Open the uploaded search-test.htm file on your server in Netscape or Internet Explorer. Windows Notepad, in turn, will display the Home Page Search Applet, as shown in Figure 5.12.

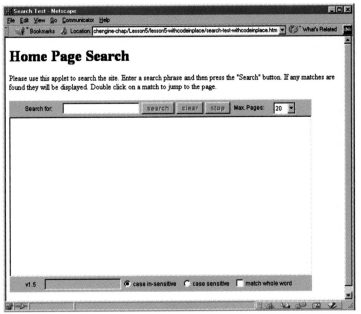

Figure 5.12 The Home Page Search Applet as it appears in your browser.

ADDING A SEARCH ENGINE TO A WEB PAGE USING FRONTPAGE 2000

Adding a search engine to a Web page is easy with FrontPage 2000. To add a search engine using FrontPage 2000, perform the following steps:

1. Click your mouse on the Start button. Windows, in turn, will display the Start menu.

2. Within the Start menu, select the Programs option and then choose Microsoft FrontPage. Windows, in turn, will open the FrontPage Editor.

3. Click your mouse on the File menu Open Web option. FrontPage, in turn, will display the Open Web dialog box.

4. Enter a Folder name and click your mouse on Open.

5. Select the Insert menu Component option and then select Search Form from options. FrontPage, in turn, will display the Search Form Properties window, as shown in Figure 5.13.

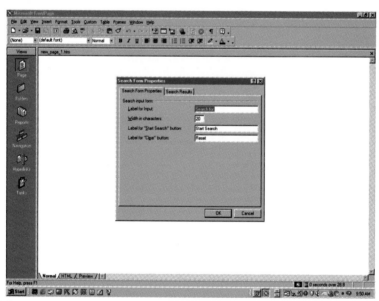

Figure 5.13 The FrontPage 2000 Search Form Properties window.

6. Keep default settings for the search form.

7. Click your mouse on the OK button. FrontPage, in turn, will display the search form as a tag on your page, as shown in Figure 5.14.

8. Publish and upload your page to your server.

9. Select the File menu Preview in browser option to view your search form in a browser, as shown in Figure 5.15.

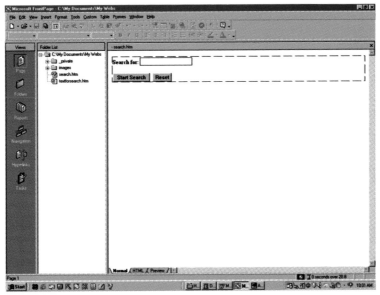

Figure 5.14 The search form on the page after inserting it into FrontPage 2000.

Figure 5.15 The FrontPage 2000 search form as it appears on the page in Netscape.

WHAT YOU MUST KNOW

As you have learned, a search engine is easy to add to a Web site and can enhance Web site functionality and interactivity. However, before you can add a search engine, you should first understand some basic concepts, such as search engine types and the advantages and disadvantages of their use. This lesson introduced you to search engines. In Lesson 6, "Adding an ActiveX Control to your Web Page," you will find out how easy it is to add ActiveX Objects to your Web pages. Before you continue with Lesson 6, however, make sure you understand the following key concepts:

✓ Search engines serve several functions on a Web site, such as making a Web site more functional and interactive and providing an additional way other than using navigational bars to find site information.

✓ Several types of Web site search engines exist on Web sites and include search engines that perform simple text site search capabilities, more complex site search engines with advanced features, and search engines that search the entire Internet.

✓ Search engines offer many advantages, such as adding Web site functionality and interactivity, ease of implementation, no special plug-in required for viewing, minimal download time, and cross-platform and browser compatibility. A disadvantage is user frustration due to inadequate programming or the use of vague terms.

✓ Some factors to consider when adding a search engine are the size of your Web site and the type of information your Web site includes, who is your audience, search engine program compatibility, and your budget.

✓ Several freeware or shareware search engine options are available for both simple and advanced search engines, such as the Home Page Search Applet, the Simple Search script from Matt's Script Archive, ht://Dig, ICE, Excite for Web Servers, and Glimpse.

✓ To add a search engine, you must select a search engine program or script, add the appropriate code to the HTML file, and upload the HTML file and all other required files to your server.

✓ Adding a search engine to a Web page is relatively easy but you may need some special settings and some knowledge of programming concepts, depending on the type of search engine you choose.

LESSON 6

ADDING AN ACTIVEX CONTROL TO YOUR WEB PAGE

A few years ago, Microsoft introduced ActiveX controls that let Web designers enhance and add interactivity to Web sites. An ActiveX control, once known as an OLE or OCX control to Windows users, is a small program you can insert into a Web page that a Web browser downloads and executes. Programmers write ActiveX controls in several languages, including Visual Basic, Java, Delphi, C and C++.

In this lesson, you will learn how to add an ActiveX control to your site. By the time you finish this lesson, you will understand the following key concepts:

◆ Web designers add ActiveX controls to Web pages for several reasons, such as enhancing a site and adding interactivity to Web pages.

◆ Several methods to incorporate ActiveX components on Web pages exist, including using ActiveX controls, ActiveX documents, and ActiveX scripting.

◆ Several types of ActiveX controls exist on Web pages, including site-enhancing objects, controls for other programs and technologies, and stand alone applications.

◆ ActiveX controls offer several advantages. ActiveX controls are easier to develop and have more power than Java applets. ActiveX controls have a large library of pre-built objects. ActiveX controls have some disadvantages too, such as cross-platform and cross-browser incompatibility and potential security risks.

◆ To add an ActiveX control, you must select a control, collect all its associated files, add the appropriate code to your HTML file, and upload the HTML file along with the ActiveX control's files to your server.

◆ Adding an ActiveX control to a Web page is easy. You do not need special settings or knowledge of complex programming concepts.

ENHANCING YOUR SITE WITH AN ACTIVEX CONTROL

ActiveX Controls serve several functions. You can add interactivity to Web pages by embedding controls for navigation, spreadsheets, calculators, and the like. You can also add a control to perform specific complex tasks, such as acquire data from a database, or display a tool, such as a calendar, for a viewer to use. ActiveX controls can also enhance a site visually with animation and special effects.

61

Several technologies to incorporate ActiveX components on Web pages are available, including using ActiveX controls, ActiveX documents, and ActiveX scripting. ActiveX controls range from simple buttons or gadgets to complex database retrieval application. You can also use ActiveX documents to enhance your Web pages. ActiveX documents are navigable documents you can view in Internet Explorer 3.0 and edit online as well. Another component, ActiveX scripting, lets you use scripting languages, such as VBScript and JavaScript, to coordinate ActiveX controls' actions.

Several types of ActiveX controls are available for Web pages. Site-enhancing objects are popular on Web sites today. For example, you can add an ActiveX control that displays an HTML slide show like the one at *www.quiksoft.com/htmlshow/samples/sample1.asp*, as shown in Figure 6.1.

Figure 6.1 *An ActiveX control that displays a HTML slide show.*

Site-enhancing objects can be very simple. Fot example, see the NewsTicker ActiveX control at *www.devpower.com*, as shown in Figure 6.2.

A site-enhancing object, such as the Advanced Clock ActiveX control at *ourworld.compuserve.com/ Homepages/frankwallwitz/*, shown in Figure 6.3, can make a Web site visually appealing.

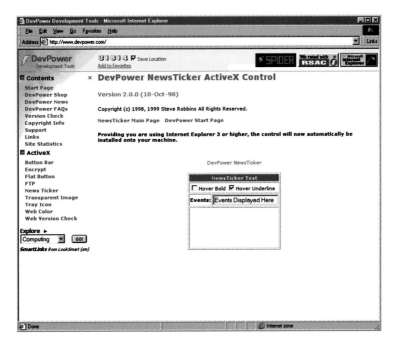

Figure 6.2 *The NewsTicker ActiveX control at **www.devpower.com**.*

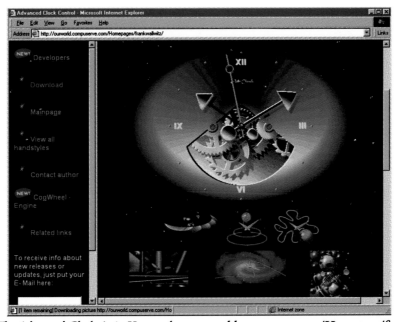

Figure 6.3 *The Advanced Clock ActiveX control at **ourworld.compuserve.com/Homepages/frankwallwitz/**.*

Another example of a site-enhancing object is a navigational bar. See *www.cyberdesign.net/sitemenu/* as shown in Figure 6.4.

Figure 6.4 *An ActiveX control for a site navigational bar at **www.cyberdesign.net/sitemenu/**.*

You can see a variation of a more complex navigational bar at *www.solidworks.com/html/gallery.htm*, as shown in Figure 6.5.

Figure 6.5 *A more complex variation of a navigational bar at **www.solidworks.com/html/gallery.htm**.*

You can also use ActiveX controls to display advertisements on your Web page. For example, the Billboard 97 ActiveX control at *www.xtratek.com/index_demo1.htm* offers multiple rotating advertisement banners, as shown in Figure 6.6.

Figure 6.6 *The Billboard 97 ActiveX control at **www.xtratek.com/index_demo1.htm**.*

Other examples of site-enhancing objects are tools, such as the Calendar ActiveX control at *www.kwery.com*, shown in Figure 6.7.

Figure 6.7 *The Calendar ActiveX control at **www.kwery.com**.*

An ActiveX control can also act as a control for other programs and technologies. For example, ActiveX components exist for displaying Shockwave and Flash (two Macromedia technologies that let you add multimedia elements to Web pages), as well as various types of video and presentations on the Web. An example of a Shockwave and Flash player ActiveX control is at *www.macromedia.com/shockwave/download/director/completion.html*. ActiveX controls can also be standalone applications, such as spreadsheet applications or database reporting tools. You can find an example of a spreadsheet ActiveX control at *www.download.com/pc/software/0,332,0-62319-s,1000.html*.

Many ActiveX controls are available for you to incorporate into your Web pages. Some ActiveX controls are free, while other controls are either shareware or part of commercial software packages. As shown in Figure 6.8, CNet has an ActiveX Control Library at *www.download.com/PC/Activex/*.

Figure 6.8 *CNet has an ActiveX Control Library at **www.download.com/PC/Activex/**.*

Two other excellent sources for ActiveX controls are *browserwatch.internet.com/activex.html* and *www.developer.com/directories/pages/dir.activex.html*.

ActiveX controls offer many advantages. For example, ActiveX controls are easier to develop with programming languages, such as Visual C++ or Visual Basic, than Java applets. (You will learn about Java applets in detail in Lesson 8.) ActiveX controls also offer a large library of pre-built objects. Another advantage concerns download time. After you download an ActiveX control, it stays in your browser's cache so you will not have to download it again the next time you visit the same site. In contrast, you download the same Java applets each time you visit the same site. In addition, ActiveX controls are more powerful than Java applets because ActiveX controls work with the Windows operating system. Therefore, ActiveX controls can access your hard drives, start an application for you, and much more. Java applets cannot

perform tasks like these. However, ActiveX controls' power is also a disadvantage because it can pose a potential security risk. Some malicious controls can damage your system's software or data. Microsoft has developed ways to reduce the risk of harmful ActiveX controls. First, Internet Explorer includes setting options for several levels of security regarding the download of ActiveX controls. Second, when you download an ActiveX control, your browser identifies the author of the control with Microsoft's Authenticode system. You will see a window appear with a warning with your default security settings set to moderate security. The security warning, as shown in Figure 6.9, will identify the author of the control and includes a link to view the Certificate Properties, as shown in Figure 6.10.

Figure 6.9 *The ActiveX control security warning identifies the control's author and includes a link to view the Certificate Properties.*

Figure 6.10 *ActiveX control Certificate Properties.*

In addition to the potential security risks, ActiveX controls have another major drawback. Cross-platform and cross-browser incompatibility poses a real disadvantage to using ActiveX controls. Unlike Java applets that work on most browsers and platforms, ActiveX controls only work in the Windows operating system and with Microsoft Internet Explorer. ActiveX controls will not work with Netscape unless you use Ncompass' special plug-in called ScriptActive.

ADDING AN ACTIVEX CONTROL TO A WEB PAGE

Now you are ready to add your first ActiveX control. In this lesson, you will add a freeware ActiveX control called LEDSign. For more information on this control, go to *www2.nsknet.or.jp/ ~jogoshi/JavaS/ActX/*. All the files you need to use for this exercise are in the LESSON6 directory on the CD-ROM that accompanies this book. Copy all of these files to a directory on your hard drive. The first step in adding the ActiveX control is to add the code to your HTML file. Sometimes an ActiveX control will include the code you should use. If not, you can use Microsoft's ActiveX Control Pad, downloadable from *www.microsoft.com*, to generate the HTML code you will need to run a control. For purposes of this lesson, the ActiveX control includes the code you should use. An example of how the code looks that you will add to your HTML document to embed the LEDSign ActiveX control is shown below:

```
<OBJECT ID="Iledx1" WIDTH=413 HEIGHT=111

CLASSID="CLSID:8FC70C91-C2D2-11D1-B13D-0000F803EC35"

CODEBASE="Iledx.CAB#version=1,0,0,1">

<PARAM NAME="_ExtentX" VALUE="10927">

<PARAM NAME="_ExtentY" VALUE="2910">

<PARAM NAME="JUMPURL" VALUE="http://www.yahoo.com">

<PARAM NAME="URL" VALUE="URL FOR PROJECT FILES">

<PARAM NAME="TEXT" VALUE="ActiveX Test!">

<PARAM NAME="SPEED" VALUE="300">

</OBJECT>
```

As you can see, the LEDSign control has an ID value and a CLASSID value. All ActiveX controls have ID and CLASSID values. Some ActiveX controls have values for CODEBASE and parameters, as does the LEDSign control. To add the code to your HTML document, perform the following steps:

1. Click your mouse on the Start button. Windows, in turn, will display the Start menu.

2. Within the Start menu, select the Programs option and then choose Windows NotePad from Accessories. Windows, in turn, will open the Windows NotePad ASCII text editor.

3. Select the File menu Open option. Windows Notepad, in turn, will display the Open dialog box.

4. Use the controls in the Open dialog box to select the ACTIVEX-CODE.TXT file you copied to your hard drive from the CD.

5. Click your mouse on the Open button.

6. Select all the code in the ACTIVEX-CODE.TXT file.

7. Select the Edit menu Copy option.

8. Select the File menu Open option. Windows NotePad, in turn, will display the Open dialog box.

9. Use the controls in the Open dialog box to select the ACTIVEX-TEST.HTM file you copied to your hard drive from the CD.

10. Click your mouse on the Open button.

11. Position your cursor between the <BODY> tags, then select the Edit menu Paste option to paste all the code from the ACTIVEX-CODE.TXT file. Windows NotePad, in turn, will display the HTML code, as shown in Figure 6.11.

```
activex-test - Notepad
File  Edit  Search  Help
<HTML>
<HEAD>
<TITLE>New Page</TITLE>
</HEAD>
<BODY>

<OBJECT ID="Iledx1" WIDTH=413 HEIGHT=111
 CLASSID="CLSID:8FC70C91-C2D2-11D1-B13D-0000F803EC35"
 CODEBASE="Iledx.CAB#version=1,0,0,1">
    <PARAM NAME="_ExtentX" VALUE="10927">
    <PARAM NAME="_ExtentY" VALUE="2910">
    <PARAM NAME="JUMPURL" VALUE="http://www.yahoo.com">
    <PARAM NAME="URL" VALUE="URL FOR PROJECT FILES">
    <PARAM NAME="TEXT" VALUE="ActiveX Test!">
    <PARAM NAME="SPEED" VALUE="300">
</OBJECT>

</BODY>
</HTML>
```

Figure 6.11 The ACTIVEX-TEST.HTM file with the ActiveX control code.

12. Change the parameter for the URL where you plan to upload your files to on your server (as indicated in the bolded text in the above code).

13. Save the ACTIVEX-TEST.HTM file.

69

14. Click your mouse on the Close button to close NotePad.

15. Connect to your server via FTP using WS-FTP or other FTP software program. (If you are not sure how to do this, ask your system administrator.)

16. Upload ACTIVEX-TEST.HTM file and all the ActiveX control project files as you normally would to the directory where you keep your other HTML and graphic files.

You can now open Internet Explorer and call up your Web page to view your ActiveX control. Internet Explorer, in turn, will display the control, as shown in Figure 6.12.

Figure 6.12 The ActiveX control as it appears in your browser.

ADDING AN ACTIVEX CONTROL TO A WEB PAGE USING FRONTPAGE 2000

Adding an ActiveX control to a Web page is simple with FrontPage 2000. To add a control using FrontPage 2000, perform the following steps:

1. Click your mouse on the Start button. Windows, in turn, will display the Start menu.

2. Within the Start menu, select the Programs option and then choose Microsoft FrontPage. Windows, in turn, will open the FrontPage Editor.

3. Click your mouse on the File menu Open Web option. FrontPage, in turn, will display the Open Web dialog box.

4. Enter a Folder name and click your mouse on Open.

5. Select the Insert menu Advanced option, then select the ActiveX Control. FrontPage 2000, in turn, will display a list of the many ActiveX controls it offers, as shown in Figure 6.13.

Figure 6.13 *The FrontPage 2000 ActiveX control options.*

6. Select the Calendar control from the options listed.

7. Click your mouse on the OK button. FrontPage 2000, in turn, will display the calendar control on your page, as shown in Figure 6.14.

Figure 6.14 *The ActiveX control on the page after inserting it into FrontPage 2000.*

8. Publish and upload your page to your server.

9. Select the File menu Preview in browser option to view your ActiveX control in a browser, as shown in Figure 6.15.

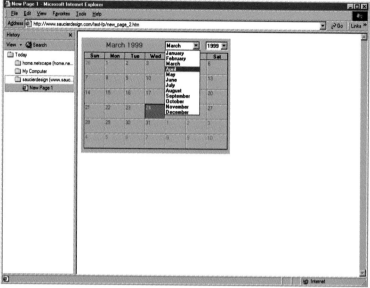

Figure 6.15 The FrontPage 2000 ActiveX control as it appears on the page in Internet Explorer.

WHAT YOU MUST KNOW

As you have learned, the ActiveX control is easy to add to a Web site and can enhance and add interactivity to your Web site. However, before you can add a control, you should first understand some basic concepts, such as ActiveX control types, methods to incorporate, where to find ActiveX controls, and their strengths and weaknesses. This lesson introduced you to ActiveX controls. In Lesson 7, "Understanding and Working with Dynamic HTML," you will find out how easy it is to create dynamic Web pages. Before you continue with Lesson 7, however, make sure you understand the following key concepts:

✓ Web designers add ActiveX controls to Web pages for several reasons, such as to enhance a site and add interactivity to Web pages.

✓ Several methods to incorporate ActiveX components on Web pages are available. The methods include using ActiveX controls, ActiveX documents, and ActiveX scripting.

✓ Several types of ActiveX controls are found on Web pages, including site-enhancing objects, controls for other programs and technologies, and standalone applications.

✓ ActiveX controls offer several advantages. They are easier to develop and have more power than Java applets. ActiveX controls also have a large library of pre-built objects. ActiveX controls have drawbacks, too, such as cross-platform/cross-browser incompatibility and potential security risks.

✓ To add an ActiveX control, you must select a control, collect all its associated files, add the appropriate code to the HTML file, and upload the HTML file with the ActiveX control's files to your server.

✓ Adding an ActiveX control to a Web page is easy. You do not need special settings or knowledge of complex programming concepts.

LESSON 7

UNDERSTANDING AND WORKING WITH DYNAMIC HTML

Although Dynamic HTML is still in development in some areas, many Web designers are now taking advantage of Dynamic HTML to add life to the traditional static Web site pages. HTML is the standard markup language for creating Web hypertext documents. Dynamic HTML, or DHTML, as it is often called, is a combination of three main technologies, including HTML, Cascading Style Sheets (CSS), and JavaScript (or other scripting language, such as VBScript or CGI) that work together to make Web pages dynamic.

In this lesson, you will learn how to effectively use and add DHTML to your Web site. By the time you finish this lesson, you will understand the following key concepts:

- ◆ The three types of DHTML are dynamic style sheets, dynamic positioning, and dynamic content.

- ◆ DHTML is versatile and you can use it to create animations, special effects, scrolling text, interactive forms, pop-up windows, to manipulate fonts and position text on a page, cookies, and much more.

- ◆ DHTML offers several advantages over other types of Web technologies. For example, DHTML offers versatility, fast downloads, cross-browser and cross-platform viewing (with some exceptions), and you do not need a special plug-in to view a DHTML Web page. Although DHTML offers many advantages, the technology does have some disadvantages, such as some cross-browser and cross-platform inconsistencies as well as lack of support for older browsers.

- ◆ Many of the popular HTML editors on the market include some options for DHTML.

- ◆ To add DHTML to your Web page, you will add the appropriate code to the HTML file, modify other settings, if necessary, and upload the HTML file, along with any scripts and graphics files, to your server, or view in your browser offline.

- ◆ Adding DHTML to a Web page is as simple as adding a few lines of code in many cases. You need no special complex settings.

ENHANCING YOUR WEB SITE WITH DHTML

The three types of DHTML are dynamic style sheets, dynamic positioning, and dynamic content. Dynamic style sheets, also known as Cascading Style Sheets, let you manipulate fonts and position text on HTML pages. For example, you can assign a font style to a page, a whole site, or just one paragraph using attribute tags, such as <STYLE> or <CLASS>. You can also assign a particular font size and color and have it change to a different size and color as the cursor moves over it. Dynamic positioning not only lets you place text and graphics where you want on a Web page, but also makes it possible for objects to move on the fly. Three positioning attributes for objects are top, left, and z-index. The z-index designates how far forward or back an image is from another image. Scripting languages like JavaScript or VBScript make it possible to move images to a different position on a Web page. Therefore, you could have an image or GIF animation move in the background behind the text on a Web page. Dynamic content lets you have content that is invisible until a user requests it. For example, a user can click on a button and the invisible text will be visible on the same Web page.

You can make a Web site interesting and interactive using DHTML. You can, for example, have a user enter information into a form and select various display options for a text box on the Web page. Not only will the new information appear in the text box, but color and other selected changes appear automatically as well. The DHTML Guestbook at *www.bratta.com/guestarea.html*, as shown in Figure 7.1, lets the user first move the text box to a new position on the page and update the text box's information and appearance.

*Figure 7.1 . The DHTML Guestbook at **www.bratta.com/guestarea.html**.*

You might also, as shown in Figure 7.2, use DHTML to make a Web page's background color change as the user's cursor passes over certain items on the Web page.

Figure 7.2 The background color at www.select-plan.com/casa.htm changes.

Another popular use of DHTML is to create interactive online games and puzzles. For example, a user can play arcade games, such as the space arcade game at *www.quick-silver.demon.co.uk/ dhtml/galaxian/,* as shown in Figure 7.3, or the Mr. Patrol game at *developer.electrografix.com/ mrtpatrol,* as shown in Figure 7.4.

Figure 7.3 The space arcade game at www.quick-silver.demon.co.uk/dhtml/galaxian.

You can also use DHTML to create interactive puzzles similar to the puzzle at *www.webreference.com/dhtml/column10/,* shown in Figure 7.5, or an interactive kid's toy like the Build Your Own Hero toy at *www.hbo4kids.com/kids/wu/super/,* as shown in Figure 7.6.

*Figure 7.4 The Mr. Patrol game at **developer.electrografix.com/mrtpatrol.***

*Figure 7.5 An interactive puzzle as seen at **www.webreference.com/dhtml/column10/.***

77

*Figure 7.6 The Build Your Own Hero toy at **www.hbo4kids.com/kids/wu/super.***

Many Web site designers use DHTML to create animations and special effects. One common effect DHTML can provide is movement of text or graphics. For example, the introductory Web pages at *www.bratta.com/dhtml/* display a moving spotlight that gets the user involved, as shown in Figure 7.7. As the user initially moves his or her cursor around the Web page, a spotlight also moves with the cursor. As the spotlight moves around the page, it reveals instructions on how to proceed, asks a question about DHTML, and makes a suggestion to bookmark the site in the background, inviting the user to click to continue.

*Figure 7.7 The introductory Web pages at **www.bratta.com/dhtml/** display a variety of animated effects.*

You can also use DHTML to make text move or animate in various ways on a Web Page. For example, at *http://www.vispo.com/animisms/enigman/enigman.htm*, as shown in Figure 7.8, the word "meaning" animates in several different ways on a Web page.

Figure 7.8 *The word "meaning" animates in various ways on the Web page.*

You also have the option of letting buttons control the movement of an object. For example, the arrow buttons in the lower left corner control The Liquid Hompage title's movement around the page at *www.quick-silver.demon.co.uk/dhtml/,* as shown in Figure 7.9.

Figure 7.9 *The arrow buttons in the lower left corner control The Liquid Hompage title's movement.* **79**

Another example of movement is mouseovers or hotspots. Mouseovers are buttons that either change in appearance or display an item on another area of the Web page as the cursor moves over them. (You will learn about mouseovers or hot spots in Lesson 11, "Taking Advantage of Hot Spots.") A good example of mouseovers can be seen at *www.CorvusCorax.Org/~jnugent/indexNN.php3*, as shown in Figure 7.10.

Figure 7.10 An example of the mouseovers at www.CorvusCorax.Org/~jnugent/indexNN.php3.

As the user passes his or her cursor over each green button, the button lights up in yellow. Another example of mouseovers is the Dynamic HTML Zone at *www.dhtmlzone.com*. You can see a variation of mouseovers at *www.electrografix.com* using Netscape 4.0, as shown in Figure 7.11.

Figure 7.11 A nice variation of mouseovers can be seen at www.electrografix.com using Netscape 4.0.

As the user passes his or her cursor over each button, the titles slide in and out from the sides of the screen. Mouseover buttons can also animate as the cursor passes over them, such as the mouseovers at *www.papermedia.com*, as shown Figure 7.12.

Figure 7.12 *Mouseover buttons animate as the cursor passes over them at **www.papermedia.com**.*

The introductory Web pages at *www.bratta.com/dhtml/* also display some interesting mouseovers. You can also use DHTML to create animated effects for splash pages, such as the photos that slide in from the right, seen at *www.prulite.com*, as shown in Figure 7.13.

Figure 7.13 *The splash page at **www.prulite.com**.*

When you combine special effects on a page, you will get varied results. For example, on the home page at *www.wddg.com*, as shown in Figure 7.14, a cluster of animated cursors move randomly as you move your cursor around the page.

Figure 7.14 The cluster of animated cursors moving randomly is a combination of effects.

Another type of movement is the use of transitions to reveal new pages or another image on the same page. For example, if you click your mouse on the spotlight on the introductory Web pages at *www.bratta.com/dhtml/*, as shown in Figure 7.7, a transition reveals a new site page. However, Netscape does not support these particular types of transition effects. Only Internet Explorer 4.0 and above supports the transitions code. However, you can use layers, which is Netscape's method of DHTML positioning, to achieve limited transition effects while viewing a Web page with Netscape.

Scrolling text is another type of movement possible with DHTML. The scrolling text at *www.CorvusCorax.Org/~jnugent/indexNN.php3*, as shown in Figure 7.15, lets the user scroll up or down using the arrow buttons.

An animated background, such as the background at *www.stephelo.com/anne/*, as shown in Figure 7.16, is a further example of movement using DHTML.

Figure 7.15 *The scrolling text lets the user scroll up or down using the arrow buttons.*

Figure 7.16 *The background at www.stephelo.com/anne/ is another example of movement using DHTML.*

You can also use DHTML to retrieve a user's system information and display it for him or her to see. As shown in Figure 7.17, the Web page at *www.papermedia.com/dynSi/* displays information about the user's browser, plug-ins, and more.

***Figure 7.17** The Web page at **www.papermedia.com/dynSi/** displays information.*

DHTML makes it possible to control sound as well. You can control the audio and the animation at *developer.netscape.com/devcon/jun97/contest/freefall/index.html*, as shown in Figure 7.18.

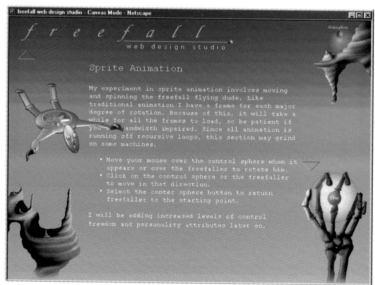

***Figure 7.18** You can control the audio and the animation at developer.netscape.com/devcon/jun97/ contest/freefall/index.html.*

DHTML provides many other possibilities for bringing Web pages to life. Besides transitions, Internet Explorer 4.0 supports many visual filters or special effects, such as a glow around text or images similar to what you could create with special plug-ins using an image editing program, such as PhotoShop. Other uses include pop-up windows, manipulating fonts, and positioning text on a page, cookies, and much more.

DHTML offers many advantages over other types of Web technologies. For example, you do not need special plug-in software to view a page with DHTML effects and components within your browser. DHTML requires less complex code than ActiveX or Java. (You will learn about Java applets in detail in Lesson 8.) DHTML also requires less download time for scripts than ActiveX or Java. The user does not have to load a new page to get more information. That decreases download time as well. In addition, DHTML, with some exceptions, offers cross-platform viewing and is compatible with Netscape and Internet Explorer 4.0 and higher browsers. Non-compatible browsers will display regular static pages instead of an error message. Versatility is yet another advantage of DHTML. DHTML places less of a burden on the network servers to which you upload your files because the code is less complex than Java or ActiveX.

However, some disadvantages exist, too. DHTML does not support Netscape and Internet Explorer 3.0 browsers. Another disadvantage is some incompatibilities of Netscape and Internet Explorer 4.0 browsers regarding certain DHTML functions. For example, Netscape uses the <LAYER> tag to position objects while Internet Explorer requires the <DIV> and tags. You can view only some DHTML features, such as transitions and visual filters, with Internet Explorer 4.0 and higher. Some cross-platform incompatibilities also exist. Therefore, you should test using the Windows and Macintosh versions of the two browsers.

How DHTML Works

DHTML requires a browser, such as Netscape or Internet Explorer 4.0 or higher, that supports the Document Object Model (DOM), which is a model based on turning Web page elements into modifiable objects. In other words, Standard HTML is made up of tags for various types of Web page elements. DHTML takes the tags and makes them objects. Thus, you can modify the way your browser displays Web page elements, such as head, title, bgcolor, and the like, by manipulating the tag objects. For example, the following is a sample script that will change the background color from red to blue when the cursor passes over it in Netscape 4.0:

```
<HTML>

<HEAD>

<TITLE></TITLE>

</HEAD>

<BODY>
```

```
<LAYER NAME="MyLayer" BGCOLOR="blue" TOP="50" LEFT="50"

 ONMOUSEOVER="colorlayer('red')" ONMOUSEOUT="colorlayer('blue')">

<H1>Test Page</H1>

<SCRIPT LANGUAGE="JavaScript1.2">

        function colorlayer(changeto)

                { bgColor=changeto }

                </SCRIPT>

</LAYER>

</BODY>

</HTML>
```

Many resources for free DHTML code are available on the Internet. Some excellent resources include The Dynamic Duo Cross-Browser Dynamic HTML at *www.dansteinman.com/dynduo/*, WebCoder at *www.webcoder.com/scriptorium/index.html,* Netscape's DHTML resources at *developer.netscape.com/docs/examples/index.html?content=dynhtml.html*, and Inside DHTML's code libraries at *www.insidedhtml.com/writeonce/writeonce.asp*. If you need code for Internet Explorer's filters, try the CSS Filters Wizard at *msdn.microsoft.com/workshop/samples/author/dhtml/filtwizard/ filtwzrd.htm*. The CSS Filters Wizard automatically generates the code for certain filters for you.

If you do not want to look for DHTML code or write your own, some popular HTML editors now offer support for DHTML. Some programs available include Microsoft FrontPage, Softquad's HotMetal Pro, Macromedia's Dreamweaver, Elemental Software's Drumbeat, Astound Dynamite, and NetObjects' Fusion.

ADDING A *DHTML* EFFECT TO A WEB PAGE

You can now add your first DHTML effect to your Web page. In this lesson, you will add a few lines of DHTML code to animate an image of a CD-ROM. All the files you need to use for this exercise are in the LESSON7 directory on the CD-ROM that accompanies this book. Copy all of these files to a directory on your hard drive. The first step in adding DHTML to your Web page is to add the code to your HTML file. For the purposes of this lesson, the DHTML code is provided for you. An example of how that code looks is shown below:

```
<SPAN ID="YOUR GRAPHIC'S ID" STYLE="position:absolute; width:150; height:148;">

<IMG SRC="YOUR GRAPHIC" WIDTH="150" HEIGHT="148">
```

```
</SPAN>
<SCRIPT TYPE="text/javascript" LANGUAGE="JavaScript"><!—
if (document.all) {
    document.all('YOUR GRAPHIC'S ID=').style.posLeft = 50;
    document.all('YOUR GRAPHIC'S ID').style.posTop = 50;
}
else if (document.layers) {
    document.layers['YOUR GRAPHIC'S ID'].left = 50;
    document.layers['YOUR GRAPHIC'S ID'].top = 50;
}
var xInc=12, yInc=12;
var xOld=xMin=50, yOld=yMin=50;
var xMax=350, yMax=250;
function moveit() {
    if ((xOld + xInc) >= (xMax-43) || (xOld + xInc) < xMin) xInc
*= -1;
    if ((yOld + yInc) >= (yMax-43) || (yOld + yInc) < yMin) yInc
*= -1;
    if (document.all) {
    document.all('YOUR GRAPHIC'S ID').style.posLeft = xOld += xInc;
    document.all('YOUR GRAPHIC'S ID').style.posTop = yOld += yInc;
}
    else if (document.layers) {
        document.layers['YOUR GRAPHIC'S ID'].left = xOld += xInc;
        document.layers['YOUR GRAPHIC'S ID'].top = yOld += yInc;
```

```
    }

    setTimeout("moveit()",5);

}

if (document.all || document.layers)

    setTimeout("moveit()",1000);

//—></SCRIPT>
```

As you can see, certain lines require you to add in the name and ID of your graphic file, as indicated in bold text. To add the code to your HTML document, perform the following steps:

1. Click your mouse on the Start button. Windows, in turn, will display the Start menu.

2. Within the Start menu, select the Programs option and then choose Windows NotePad from Accessories. Windows, in turn, will open the Windows NotePad ASCII text editor.

3. Select the File menu Open option. Windows NotePad, in turn, will display directories and lists of files.

4. Select the DHTML-MOVEMENT-CODE.TXT file.

5. Select all the code in the DHTML-MOVEMENT-CODE.TXT file.

6. Select the Edit menu Copy option.

7. Select the File menu Open option. Windows NotePad, in turn, will display directories and lists of files.

8. Select the DHTML-TEST.HTM file.

9. Click your mouse on the Open button.

10. Position your cursor between the <BODY> tags, then select the Edit menu Paste option. Windows Notepad, in turn, will display the code with the name and ID of the graphic file already in place for you, as shown in Figure 7.19.

11. Save and close the DHTML-TEST.HTM file.

12. Open the DHTML-TEST.HTM file in Netscape or Internet Explorer 4.0 or higher. The CD-ROM image will move and appear, as shown in Figure 7.20.

```
dhtml-test-with-code - Notepad
File  Edit  Search  Help
<HTML>

<HEAD>
<TITLE></TITLE>
</HEAD>

<BODY>
<SPAN ID="cd-rom-div" STYLE="position:absolute; width:43; height:43;">
<IMG SRC="cd-rom.gif" WIDTH="43" HEIGHT="43">
</SPAN>

<SCRIPT TYPE="text/javascript" LANGUAGE="JavaScript"><!--
if (document.all) {
    document.all('cd-rom-div').style.posLeft = 50;
    document.all('cd-rom-div').style.posTop = 50;
}
else if (document.layers) {
    document.layers['cd-rom-div'].left = 50;
     document.layers['cd-rom-div'].top = 50;
}

var xInc=12, yInc=12;
var xOld=xMin=50, yOld=yMin=50;
var xMax=350, yMax=250;

Function moveit() {
    if ((xOld + xInc) >= (xMax-43) || (xOld + xInc) < xMin) xInc
*= -1;
    if ((yOld + yInc) >= (yMax-43) || (yOld + yInc) < yMin) yInc
*= -1;

    if (document.all) {
```

Figure 7.19 The DHTML-TEST.HTM file with the code as it appears in Windows NotePad.

Figure 7.20 The DHTML CD-ROM movement effect as it appears in your browser.

89

ADDING DHTML EFFECTS TO A WEB PAGE USING FRONTPAGE 2000

Adding DHTML effects to a Web page is easy with FrontPage 2000. However, you must make sure your server has support for FrontPage Server Extensions. (If you are not sure, you can ask your system administrator.) To add DHTML effects using FrontPage 2000, perform the following steps:

1. Click your mouse on the Start button. Windows, in turn, will display the Start menu.
2. Within the Start menu, select the Programs option and then choose Microsoft FrontPage. Windows, in turn, will open the FrontPage Editor.
3. Click your mouse on the File menu Open Web option. FrontPage, in turn, will display the Open Web dialog box.
4. Enter a Folder name and click your mouse on Open.
5. Select the Insert menu Picture option, then select the From File option. FrontPage 2000, in turn, will display a list of directories and files.
6. Select CD-ROM.GIF.
7. Click your mouse on Open. The CD-ROM image should now appear on the page.
8. Select the CD-ROM image.
9. Select the Format menu Dynamic HTML Effects option. FrontPage 2000, in turn, will display the DHTML Effect Toolbar with the <Choose an effect> field, as shown in Figure 7.21.
10. Click your mouse on the down arrow to the right of the <Choose an effect> field to display the event drop-down list. Within the drop-down list, click your mouse on the Page Load option. FrontPage, in turn, will activate the <Choose an effect> field.
11. Click your mouse on the down arrow to the right of the <Choose an effect> field to display the effect drop-down list. Within the drop-down list, click your mouse on the Fly In option. FrontPage, in turn, will activate the <Choose Settings> field.
12. Click your mouse on the down arrow to the right of the <Choose Settings> field to display the Settings drop-down list. Within the drop-down list, click your mouse on the From right option.
13. Close the DHTML Effect Toolbar. FrontPage 2000, in turn, will display the CD-ROM image, as shown in Figure 7.22.

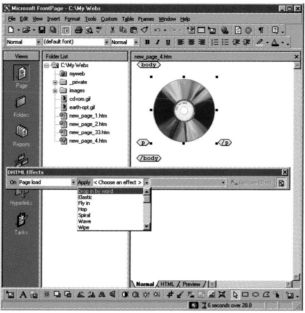

Figure 7.21 *The FrontPage 2000 DHTML Effect Toolbar with the <Choose an effect> field.*

Figure 7.22 *The CD-ROM image after applying the DHTML effect using FrontPage 2000's DHTML Effect Toolbar.*

14. Publish and upload your page to your server.

15. Select the File menu Preview in browser option to view your DHTML effect. Your browser, in turn, will display the CD moving across the screen from the right and ending up on the left side of the screen, as shown in Figure 7.23.

Figure 7.23 *The FrontPage 2000 DHTML CD-ROM movement effect as it appears on the page in Internet Explorer.*

WHAT YOU MUST KNOW

DHTML offers versatility that can greatly enhance a Web page and make it interactive. However, before you can start using DHTML, you should first understand some basic concepts, such as the types of DHTML and the many ways DHTML can bring life to otherwise static Web pages. This lesson introduced you to DHTML. In Lesson 8, "Understanding and Working with Java," you will find out how easy it is to add a Java applet to a Web site. Before you continue with Lesson 8, however, make sure you understand the following key concepts:

✓ The three types of DHTML are dynamic style sheets, dynamic positioning, and dynamic content.

✓ DHTML is versatile and you can use it to create animations, special effects, scrolling text, interactive forms, pop-up windows, to manipulate fonts and positioning text on a page, cookies, and much more.

✓ DHTML offers several advantages over other types of Web technologies. For example, DHTML offers versatility, fast downloads, cross-browser and cross-platform viewing (with some exceptions), and you do not need a special plug-in to view a DHTML Web page. Although DHTML offers many advantages, the technology does have some disadvantages, such as some cross-browser and cross-platform inconsistencies as well as lack of support for older browsers.

✓ Several popular HTML editors on the market include some options for DHTML.

✓ To add DHTML to your Web page, you will add the appropriate code to the HTML file, modify other settings, if necessary, and upload the HTML file, along with any graphics files, to your server, or view offline.

✓ Adding DHTML to a Web page is as simple as adding a few lines of code in many cases. You need no special complex settings.

LESSON 8

UNDERSTANDING AND WORKING WITH JAVA

Sun Microsystems' object-oriented programming language, Java, first made its appearance on Web sites in 1995 and still remains a popular choice for Web site programming today. Many Web site designers prefer to use Java to make Web sites interactive since Java is compatible with Windows, Macintosh, and Unix systems. Java programs are either full applications for execution outside of a Web browser or small programs for embedding into Web site pages, known as applets, which you can view with a Java-enabled Web browser.

In this lesson, you will learn how to effectively use Java and add an applet to your Web site. By the time you finish this lesson, you will understand the following key concepts:

- Java applets serve several functions. They add interactivity and functionality to Web pages for navigation, guestbooks, calculators, and other Web components, provide server-side functions for chat rooms, message boards, database applications, and the like, and enhance a site visually with animation, multimedia, and special effects.

- Many users assume JavaScript is related to Java; however, the two programming languages are not really related with the exception of similar names.

- Java is versatile. You can use Java to create animations, special effects, mouseovers, rotating ads, scrolling text, chat rooms, message boards, guestbooks, pop-up windows, search engines, counters, Web cams, and much more.

- Java offers Web site designers many advantages, including no need of special plug-in software for viewing, ease of development and implementation, provision of greater security, cross-platform viewing, general compatibility with browsers, and less of a burden placed on network servers. One main disadvantage is some Java applets load slowly compared to other Web technologies.

- To add Java to your Web page, you must add the appropriate code to the HTML file, modify parameter settings, if necessary, and upload the HTML file, along with any applet and graphics files, to your server. You can view it offline in your browser.

- Adding Java to a Web page can be as easy as adding a few lines of code. You generally need no special complex settings or plug-ins.

ENHANCING YOUR WEB SITE WITH JAVA

Java applets serve several functions. First, you can embed applets to add interactivity and functionality to Web pages for navigation, guestbooks, calculators, and other Web components. Certain server-side functions (chat rooms, message boards, database applications, and the like), previously possible only with CGI programming (you will learn about CGI in Lesson 14, "Understanding CGI"), are now possible with Java servlets, the special types of applets that perform server-side functions. You can also use Java applets to enhance a site visually with animation, multimedia, and special effects.

You can use Java to add interactivity and functionality to your Web site in many ways. For example, you can add a Java applet to a Web site to make navigation easier. The applet lets the user access information by using pull-down menus or by displaying a scrolling marquee of menu options, such as the menu marquees at the That's Entertainment Innit? Web site at *www.innit.com/cgi-bin/home.cgi*, the Discovery Web site at *www.discovery.com*, or the 4 Guys Interactive Web site at *www.4guys.com*, as shown in Figures 8.1, 8.2, and 8.3.

Figure 8.1 *The marquee menu at the That's Entertainment Innit? Web site.*

Figure 8.2 The marquee menu at the Discovery Web site at *www.discovery.com*.

Figure 8.3 The marquee menu at the 4 Guys Interactive Web site at *www.4guys.com*.

You can also add a chat room to promote interactivity, such as the MultiChat applet at *javaboutique.internet.com/MultiChat/*, as shown in Figure 8.4.

Another popular use of Java is for hot spots or mouseovers, which are buttons or images on a Web page that change in some manner or have other images or parts of the Web page change as the user passes his or her cursor over the buttons or images. (You will learn more about hot spots in Lesson 11, "Taking Advantage of Hot Spots.") For example, Charlie Morey's Resume Thing at

home.earthlink.net/~cmorey/ (click on the Java/Javascript-enhanced version link to view the pop-up window), as shown in Figure 8.5, includes hot spots for easier navigation.

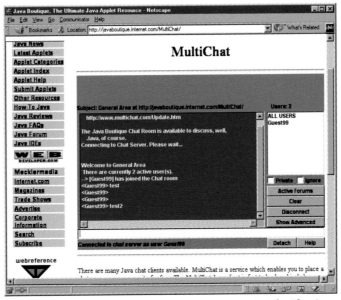

*Figure 8.4 The MultiChat applet at **javaboutique.internet.com/MultiChat/**.*

*Figure 8.5 Charlie Morey's Resume Thing at **home.earthlink.net/~cmorey/**.*

You can also use Java applets to incorporate popular Web components, such as counters, Web cams, search engines, and more. For example, the Better Counter Java applet at *www.better-counter.com/ example.html*, as shown in Figure 8.6, displays the number of hits as well as hits analysis.

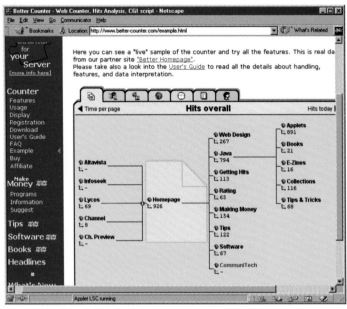

Figure 8.6 The Better Counter Java applet at ***www.better-counter.com/example.html*** *displays the number of hits as well as hits analysis.*

You can also use a Java applet to set up a Web cam, which is a special component to view live video or a series of regularly updated photos on your Web page. To see a Web cam applet, go to the Anfy Cam Web applet at *www.anfyjava.com/anj/anfycam/anfycam.html*, as shown in Figure 8.7.

Figure 8.7 The Anfy Cam Web applet at ***www.anfyjava.com/anj/anfycam/anfycam.html*** *lets you add a Web cam to your Web page.*

Search engine applets are also common components on Web sites. For example, the Home Page Search applet, available at *www.babbage.demon.co.uk/HomePageSearch.html*, as shown in Figure 8.8, is an easy way to set up a search applet that will search an entire Web site for terms or phrases the user enters.

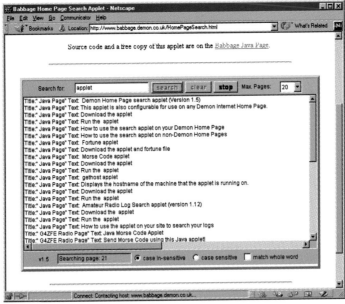

Figure 8.8 The Home Page Search applet available at www.babbage.demon.co.uk/HomePageSearch.html.

As discussed earlier, the server-side applet, known as servlet, is a new technology that is an alternative to using CGI for generating dynamic content, adding many types of Web components, and performing other Web functions. While applets run within your Web browser, the servlet runs on your Web server. Some advantages servlets have over CGI include ease of development and implementation, cross-platform compatibility, efficiency in operation, and better security. You can use Java servlets to add many types of components to make your Web site interactive. For example, you can add a multiuser chat program with several features, like the JavaTalk client/server chat applet at *www.mike95.com/java/javatalk/*, as shown in Figure 8.9.

Dynamic content is also possible with servlets. For example, Money.com at *www.pathfinder.com/money/markets/index.html*, as shown in Figure 8.10, offers many charts with current financial data.

Servlets do require that your server runs the Java Virtual Machine (JVM), just as your browser does for applets. In addition, your server must support Java Servlet API, which controls communication between the servlet and the server. If you want to create your own servlets, you will need the Java Servlet Development Kit, available at Sun Microsystems' Web site (*www.sun.com*). Sun Microsystems' Web site also has more information on servlets and how to incorporate servlets into Web sites. Another useful resource is the java.sun.com Web site at *www.javasoft.com*.

Figure 8.9 The JavaTalk client/server chat applet at www.mike95.com/java/javatalk/.

Figure 8.10 Money.com at www.pathfinder.com/money/markets/index.html offers many charts with current financial data.

Java applets can also enhance a site visually with animation, multimedia, and special effects. For example, you can use applets to play a sound file as a Web page opens or to let the user select music to play. An example of using Java technology to play music is the WebRadio Web site at *www.webradio.com,* as shown in Figure 8.11.

*Figure 8.11 The WebRadio Web site at **www.webradio.com** uses an Emblaze Audio Java applet.*

The WebRadio Web site lets the user select a radio station to listen to from a category of music preferences. An Emblaze Audio Java applet broadcasts the radio station via the Internet. Special effects and animation applets are also common on Web sites. For example, the faded text applet on the introductory page of the Vietnam War Web site at *dialspace.dial.pipex.com/town/road/ gbk06/nam/* provides a nice effect, as shown in Figure 8.12.

Figure 8.12 The faded text applet on the introductory page of the Vietnam War Web site.

An excellent example of animation with music is the Java Universe animation applet, which plays the well-known 2001 theme, at *wdvl.internet.com/Multimedia/Java/*, as shown in Figure 8.13.

*Figure 8.13 The Java Universe animation applet at **wdvl.internet.com/Multimedia/Java/**.*

Another popular use for Java applets is rotating banners. For example, the rotating banner on the Virtual TradeWinds Web site's Extraordinary EMC Virtual Trade Show page at *www.virtualtradewinds.com/EMC/index.html*, as shown in Figure 8.14, not only displays multiple banners but also adds some transition and wipe effects between each banner.

Figure 8.14 Multiple banners displayed with some transition and wipe effects.

Many users assume Java is related to JavaScript. However, the two programming languages are not related, with the exception of similar names and some of JavaScript's syntax being vaguely based on Java. JavaScript is a simple scripting language you can use for controlling Web page browsers and content. Java is a more complex programming language used to develop advanced applications for outside browsers or applets for viewing with browsers only. Java lets you perform more complex tasks, such as networking, but does not control browsers like JavaScript. However, you can use JavaScript to control Java applets on Web pages for more advanced Web applications.

Java offers Web site designers many advantages. For example, you do not need special plug-in software to view a page with a Java applet within your browser. Java's code is less complex and easier to develop than CGI, and does not require the special server settings CGI needs. Applets are easy to add to your Web site pages. The Java programming language also provides greater security compared to some poorly written server-side CGI scripts, which can pose a risk. In addition, most Java offers cross-platform viewing and is compatible with both Netscape and Internet Explorer browsers. Versatility is yet another advantage of Java, especially with the use of servlets. Java applets also place less of a burden on Web servers since applets run within your browser. However, Java's major disadvantage is speed. For example, compared to some other Web technologies, such as DHTML or JavaScript, some Java applets load slowly due to higher memory demands for running certain applets.

How Java Applets Work

You must have a Java-enabled Web browser for a Java applet to work, which means the browser must support what is known as the Java Virtual Machine. Today most browsers, such as Netscape and Internet Explorer, are Java-enabled Web browsers and you can view Java applets without a problem. As a user enters a Web page with an embedded Java applet, the browser downloads the applet to the user's system where it executes and the user views it in his or her browser.

A Java applet generally includes several files. First, you may notice a file with a .java extension. A java file contains the actual source code for the applet. Some applets include a java file while some will not. You will also see one or more files with a .class extension. The class file stores the compiled source code for the applet and is the file that you add to your applet tag to run the applet. You must be sure not to change the filename or the case for the filename since Unix is case-sensitive. If you do accidentally change the name or the case, the applet will not run.

Adding A Java Applet To A Web Page

Several options exist for obtaining Java applets for Web sites. First, you can use specialized software or utilities to create applets. Many software programs, such as *Ulead's Animation.Applet or Lotus BeanMachine*, automatically create applets for you based on your selections. If you want to create your own applets, you should download the latest Java Developer's Kit (JDK) from Sun Microsystems' Web site (*www.sun.com*). The Java Developer's Kit includes a manual, compiler, tools, samples, and other items for applet creation. Many online resources are available for freeware and shareware applets. Some resources you can use for a references and for applets include **103**

JavaShareware.com at *www.javashareware.com*, the Free Java Applets Web site at *www.bodo.com/Applets/index.html*, Gamelan at *www.gamelan.com*, the Java Boutique at *www.javaboutique.internet.com*, FreeCode at *www.freecode.com*, and Dave Central at *www.davecentral.com*.

Now you are ready to add your first Java applet to your Web page. In this lesson, you will add a simple freeware rotating banner applet called J-Ads. For more information on the J-Ads applet, refer to *javazoom.hypermart.net/applets/jads10/jads10.html*. All the files you need to use for this exercise are in the LESSON8 directory on the CD-ROM that accompanies this book. Copy all of these files to a directory on your hard drive. The first step in adding an applet to your Web page is to add the code to your HTML file. For the purposes of this lesson, the code to embed the J-Ads applet is provided for you. An example of how the code looks that you will add to your HTML document is shown below:

```
<APPLET CODE="jads.class" CODEBASE="./" ALIGN="BASELINE" WIDTH="468"
HEIGHT="60">

    <!— Banners Parameters —>

    <PARAM NAME="image_0" VALUE="banner1.gif">

    <PARAM NAME="alink_0" VALUE="http://www.yahoo.com">

    <PARAM NAME="image_1" VALUE="banner2.gif">

    <PARAM NAME="alink_1" VALUE="http://www.yahoo.com">

<PARAM NAME="image_2" VALUE="banner3.gif">

    <PARAM NAME="alink_2" VALUE="http://www.yahoo.com">

    <PARAM NAME="wait" VALUE="10">

    <!— Extra Parameters —>

</APPLET>
```

Java-enabled browsers run applets for you. As the Web page loads, the browser will detect the <APPLET> tag and the browser will run the applet. All information necessary to run the applet is between the <APPLET> tags. As you can see, the first line of code sets the width and

height of the applet and specifies items, such as the Java applet class file, to load. The CODEBASE attribute specifies the URL or location of the CLASS file to run the applet. The ALIGN attribute specifies the alignment for the applet on the Web page. Java applets also usually have several lines of parameter settings for various applet options. The parameters let you customize the applet to your needs. Most applets you download from the Web include some type of documentation with descriptions for each parameter. Once in place, the applet parameters will be in effect when your browser runs the applet. For the J-Ads applet, the parameter option includes the images to use, the links for each image, and the time between transitions. Extra parameter options include type of transitions, target frames, and refresh rate. For the purposes of this lesson, you will only be using the regular parameters. You can refer to *javazoom.hypermart.net/applets/jads10/jads10.html* for more information on how to incorporate the extra parameter options. To add the code to your HTML document, perform the following steps:

1. Click your mouse on the Start button. Windows, in turn, will display the Start menu.

2. Within the Start menu, select the Programs option and then choose Windows NotePad from Accessories. Windows, in turn, will open the Windows NotePad ASCII text editor.

3. Select the File menu Open optzion. Windows NotePad, in turn, will display directories and lists of files.

4. Select the JAVA-APPLET-CODE.TXT file.

5. Click your mouse on the Open button.

6. Select all the code in the JAVA-APPLET-CODE.TXT file.

7. Select the Edit menu Copy option.

8. Select the File menu Open option. Windows NotePad, in turn, will display directories and lists of files.

9. Select the JAVA-APPLET-TEST.HTM file.

10. Click your mouse on the Open button.

11. Position your cursor between the <BODY> tags. Select the Edit menu Paste option to paste all the code from the JAVA-APPLET-CODE.TXT file between the <BODY> tags. Windows NotePad, in turn, will display the code, as shown in Figure 8.15.

12. Save your file.

13. Open the JAVA-APPLET-TEST.HTM file in Netscape or Internet Explorer. Your browser, in turn, will display the J-Ads applet, as shown in Figure 8.16.

105

```
java-applet-test-withcodeinplace - Notepad
File   Edit   Search   Help
K!DOCTYPE HTML PUBLIC "-//SoftQuad Software//DTD HoTMetaL PRO
5.0::19981217::extensions to HTML 4.0//EN" "hmpro5.dtd">

<HTML>

<HEAD>
<TITLE>Java Applet Test </TITLE>
</HEAD>

<BODY>
<APPLET CODE="jads.class" CODEBASE="./" ALIGN="BASELINE" WIDTH="468"
 HEIGHT="60">

        <!-- Banners Parameters -->
<PARAM NAME="image_0" VALUE="banner1.gif">

<PARAM NAME="alink_0" VALUE="http://www.yahoo.com">

<PARAM NAME="image_1" VALUE="banner2.gif">

<PARAM NAME="alink_1" VALUE="http://www.yahoo.com">

<PARAM NAME="image_2" VALUE="banner3.gif">

<PARAM NAME="alink_2" VALUE="http://www.yahoo.com">

<PARAM NAME="wait" VALUE="10">

        <!-- Extra Parameters -->

</APPLET>

</BODY>
</HTML>
```

Figure 8.15 The JAVA-APPLET-TEST.HTM file with the code as it appears in Windows NotePad.

Figure 8.16 The J-Ads Applet as it will appear in your browser.

WHAT YOU MUST KNOW

Java offers versatility that can greatly enhance a Web page and its functionality. However, before you can start using Java, you should first understand some basic concepts, such as its functions in Web development and the many ways Java can add both interactivity and functionality to Web pages. This lesson introduced you to Java. In Lesson 9, "Implementing a Scrolling Marquee Banner," you will learn how marquee banners can enhance a Web site. Before you continue with Lesson 9, however, make sure you have learned the following key concepts:

- ✓ Java applets serve several functions. They add interactivity and functionality to Web pages, provide server-side functions, and enhance a site visually.

- ✓ JavaScript is not related to Java, with the exception of similar names.

- ✓ Java is versatile. You can use Java to create animations, special effects, mouseovers, rotating ads, scrolling text, chat rooms, message boards, guestbooks, pop-up windows, search engines, counters, Web cams, and much more.

- ✓ Java offers Web site designers many advantages, including no need of special plug-in software for viewing, ease of development and implementation, provision of greater security, cross-platform viewing, general compatibility with browsers, and less of a burden placed on network servers. One main disadvantage is some Java applets load slowly compared to other Web technologies.

- ✓ To add Java to your Web page, you must add the appropriate code to the HTML file, modify parameter settings, if necessary, and upload the HTML file, along with any applet and graphics files, to your server, or view in your browser offline.

- ✓ Adding Java to a Web page is as easy as adding a few lines of code in many cases. You generally need no special complex settings or plug-ins.

LESSON 9

IMPLEMENTING A SCROLLING MARQUEE BANNER

Web designers have been using scrolling marquee banners to enhance their Web sites for many years. A marquee is a vertical or horizontal scrolling message appearing on a Web page, usually within a square or rectangular-shaped object. Marquees range from a simple HTML marquee to the more complex marquee Java applets (or other programming technology).

In this lesson, you will learn how to add a marquee to your site. By the time you finish this lesson, you will understand the following key concepts:

- ◆ Web designers add marquees to Web pages for several reasons, including to draw attention to an announcement or to display current news or other information, to make an otherwise static Web page more interesting, to display menus, and to add visual appeal to a Web page.

- ◆ Web designers have several types of marquees available for their use, including the simple HTML marquee, scrolling status bar, as well as the more complex marquees accomplished with various programming technologies.

- ◆ Marquees offer many advantages, such as ease of implementation, no special plug-in software required (except for a Shockwave marquee), cross-browser and cross-platform compatibility (except for some DHTML and ActiveX marquees), and fast download time for most marquees. Some disadvantages exist as well. For example, marquees can annoy and distract users, some marquees require a plug-in, some have existing browser and platform incompatibilities, and some marquee Java applets load slowly.

- ◆ Many software programs, such as Ulead's GIF Animator or the Web Marquee Wizard freeware program, automatically create marquees for you.

- ◆ To add a marquee, you will select a marquee, add the appropriate code to your HTML file, and upload the HTML file and any other files to your server.

- ◆ Adding a marquee to a Web page is relatively easy but you may need some special settings and some knowledge of programming concepts, depending on the type of marquee you select.

ENHANCING YOUR SITE WITH A MARQUEE

As you explore the Web, you will see several types of marquees, such as the simple HTML marquee and scrolling status bar, as well as the more complex marquees Web designers accomplish with various programming technologies. The HTML marquee is a simple text marquee with text scrolling horizontally across the page. You can place an HTML marquee anywhere on a Web page in seconds using the <MARQUEE> tag. Scrolling status bar marquees require a few lines of JavaScript (or other scripting language) to implement on a Web page and appear in the status bar, as illustrated with the Web site shown in Figure 9.1.

Figure 9.1 *The status bar displays a message that scrolls continuously as the user views the Web page.*

As you can see, the status bar displays a message that scrolls continuously as the user views the Web page at *www.cancergenetics.org.* You can enhance and add interactivity to your Web sites with some of the more complex marquees developed with DHTML, JavaScript, Java, Shockwave, ActiveX, and other programming languages that are available at various online resources. The more complex marquees not only scroll in various directions, as demonstrated in Figure 9.2, but can also display an interesting look or animation, let the user click on an item for more information, as well as offer many other possibilities.

Figure 9.2 The DHTMLLib Auto-Scrolling Viewpoint Demo at www.insidedhtml.com/dhtmllib/demos/marquee/page1.asp.

You can enhance your Web site in several ways with a scrolling marquee. For example, you can use a scrolling marquee to draw attention to an announcement or to display current news or other information. The DHTML marquee at the Liquid Home Page Web site's marquee at *www.quick-silver.demon.co.uk/dhtml*, as shown in Figure 9.3, displays the date of last update as well as other information.

Figure 9.3 The Liquid Home Page Web site's marquee at www.quick-silver.demon.co.uk/dhtml.

The marquee at *www.scorecard.org*, shown in Figure 9.4, displays the top 10 U.S. counties with TRI Chemicals.

Figure 9.4 *The marquee at **www.scorecard.org** displays the Top 10 U.S. counties with TRI Chemicals.*

The Maximov Online Web site at *www.maximov.com* displays the latest news, as shown in Figure 9.5.

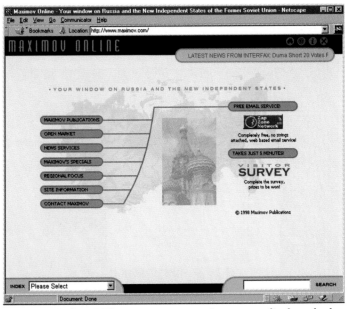

Figure 9.5 *The Maximov Online Web site at **www.maximov.com** displays the latest news.*

The Superman Web site's marquee at *www.fxstation.com/heroes/superman/*, as shown in Figure 9.6, contains the well-known Superman introduction.

Figure 9.6 *The Superman Web site's marquee at **www.fxstation.com/heroes/superman/**.*

You can also use a marquee to make an otherwise static Web page more interesting. For example, you can use a vertical scrolling text marquee as part of a presentation of information on a Web page. A marquee that presents information is Charlie Morey's Resume Thing at *home.earthlink.net/ ~cmorey/*, as shown in Figure 9.7.

Figure 9.7 *Charlie Morey's Resume Thing at **home.earthlink.net/~cmorey**.*

A Java applet produces the scrolling text marquee, shown in Figure 9.8, available at *wdvl.internet.com/Multimedia/Design/*.

Figure 9.8 *A Java applet produces the scrolling text marquee available at **wdvl.internet.com/Multimedia/Design/**.*

You can incorporate marquees into your Web sites to add visual appeal, as shown in Figures 9.3 and 9.5. You can use a vertical scrolling marquee to offer viewers a menu of choices. As shown in Figure 9.9, the marquee at *www.innit.com/cgi-bin/home.cgi* offers the user a vertical scrolling menu of items from which to choose more information.

Figure 9.9 *The marquee at **www.innit.com/cgi-bin/home.cgi**.*

Another vertical scrolling menu marquee that a JAVA applet produces can be seen at the Discovery Channel Online Web site at *www.discovery.com/online.html*, as shown in Figure 9.10.

Figure 9.10 The Discovery Channel Online Web site's scrolling menu marquee Java applet.

You can also create a horizontal scrolling menu. The Spin Web site at *www.spin.com*, as shown in Figure 9.11, not only has a horizontal scrolling marquee menu but the marquee Java applet also provides mouseovers (you will learn about mouseovers or hot spots in Lesson 11, "Taking Advantage of Hot Spots") for the menu items, resulting in an interesting effect.

Figure 9.11 The Java applet at The Spin Web site at www.spin.com.

As the user passes his or her cursor over the items, each item lights up. Another example of a marquee with scrolling mouseover items is the 10 Downing Street Web site at *www.number-10.gov.uk/index.html*, as shown in Figure 9.12.

Figure 9.12 *Another example of a marquee with scrolling mouseover items.*

Marquees offer many advantages. For example, a marquee is easy to add to a Web page and to create and update compared to other Web enhancements. You may have to add a few lines of code or apply some special settings, depending on what marquee you decide to add to your Web page. However, usually you will not need to know any complex programming language to do so, as you will learn later in this lesson. In addition, you do not need special plug-ins (special utilities available from various sources to view certain Web components) to see a marquee within your browser (unless you select a Shockwave marquee). Most marquees are cross-platform and cross-browser compatible, with the exception of certain DHTML and ActiveX marquees. The download time for DHTML, JavaScript, and HTML marquees is generally quick since most marquees are small in size.

Despite their many advantages, marquees also have some disadvantages. For example, marquees can annoy and distract some users with their continuous movement on the screen. You should make sure your marquee serves a purpose on the Web page. In addition, some marquees require a plug-in, some have browser/platform incompatibilities, and some marquee Java applets load slowly on a Web page.

ADDING A MARQUEE TO A WEB PAGE

You can add a marquee in several ways to your Web site. The easiest way is to add a simple HTML marquee by adding the <MARQUEE> tag to your HTML document. The tag looks similar to the following:

115

```
<MARQUEE>Your scrolling text...</MARQUEE>
```

You can control the width, background color, scrolling behavior, amount of scroll, scroll delay, font color, and direction of the marquee by adding attributes to the tag. For example, the tag for a right smooth scrolling marquee with white text on an aqua background looks something like this:

```
<MARQUEE> BGCOLOR=AQUA DIRECTION=RIGHT WIDTH=90%
BEHAVIOR=SCROLL SCROLLAMOUNT=3 SCROLLDELAY=30><FONT
COLOR="WHITE"> Your scrolling text... </FONT></MARQUEE>
```

You can also add a scrolling marquee to your Web page's status bar with a few lines of JavaScript (you will learn about JavaScript in Lesson 13, "Understanding and Working with JavaScript") that resembles the following:

```
<SCRIPT>

<!—// message to scroll in scrollbar

var msg = "Welcome to Our Web Site";

var spacer = "...        ...";

// current message position

var pos = 0;

//flag to control message

var showmsg = true;

function ScrollMessage() {

  if (!showmsg) {

    window.setTimeout("ScrollMessage()",1500);

    showmsg = true;

    return;

  }

  window.status = msg.substring(pos, msg.length) + spacer + msg.substring(0, pos);

  pos++;

  if (pos > msg.length) pos = 0;

  // set timeout for next update
```

```
    window.setTimeout("ScrollMessage()",200);

}

// Start the scrolling message

ScrollMessage();

// Display a link help message

function LinkMessage(text) {

  showmsg = false;

  window.status = text;

}//—>

</SCRIPT>
```

Many software programs, such as Ulead's GIF Animator or the Web Marquee Wizard freeware program, automatically create marquees for you. Many shareware and freeware resources are available for the more complex marquees, such as scrolling menu or vertical scrolling text marquees developed with DHTML, JavaScript, Java, Shockwave, ActiveX, and other programming languages. The Dynamic Drive site at *www.dynamicdrive.com/dynamicindex2/*, as shown in Figure 9.13, offers several options for marquees that work with both Netscape and Internet Explorer or just with Internet Explorer.

*Figure 9.13 The Dynamic Drive site at **www.dynamicdrive.com/dynamicindex2/**.*

117

Other resources for code and applets include *www.freecode.com*, *www.javaboutique.com*, and *www.davecentral.com*.

Now you are ready to add your first marquee to your Web page. In this lesson, you will add a simple freeware Shockwave marquee called Times Square Marquee. For more information on the Times Square Marquee, refer to *www.mediaeval.nl/TSMinstructions.html*. All the files you need to use for this exercise are in the LESSON9 directory on the CD-ROM that accompanies this book. Copy all of these files to a directory on your hard drive. The first step in adding a marquee to your Web page is to add the code to your HTML file. For the purposes of this lesson, the LESSON9 directory includes the code to embed the Shockwave marquee file called *marqsm21.dcr*. An example of how the code looks that you will add to your HTML document is shown below:

```
<EMBED SRC="marqsm21.dcr" WIDTH=416 HEIGHT=46 TEXTFOCUS=never

swText=" This is a test for the Times Square Marquee">
```

To add this code to your HTML document, perform the following steps:

1. Click your mouse on the Start button. Windows, in turn, will display the Start menu.

2. Within the Start menu, select the Programs option and then choose Windows NotePad from Accessories. Windows, in turn, will open the Windows NotePad ASCII text editor.

3. Select the File menu Open option. Windows NotePad, in turn, will display directories and lists of files.

4. Select the TSM-CODE.TXT file.

5. Click your mouse on the Open button.

6. Select all the code in the TSM-CODE.TXT file.

7. Select the Edit menu Copy option.

8. Select the File menu Open option. Windows NotePad, in turn, will display directories and lists of files.

9. Select the MARQUEE-TEST.HTM file.

10. Click your mouse on the Open button.

11. Position your cursor between the <BODY> tags, then select the Edit menu Paste option to paste all the code from the TSM-CODE.TXT file between the <BODY> tags. Windows Notepad, in turn, will display the code, as shown in Figure 9.14.

12. Save the file.

13. Open the MARQUEE-TEST.HTM file in Netscape or Internet Explorer 4.0 or higher. The Times Square Marquee should appear, as shown in Figure 9.15 (If it does not, you may have to download the Shockwave plug-in from *www.macromedia.com*).

Figure 9.14 *The MARQUEE-TEST.HTM file with the code as it appears in Windows NotePad.*

Figure 9.15 *The Times Square Marquee as it appears in your browser.*

ADDING A MARQUEE TO A WEB PAGE USING FRONTPAGE 2000

Adding a marquee to a Web page is easy with FrontPage 2000. To add a marquee using FrontPage 2000, perform the following steps:

119

1. Click your mouse on the Start button. Windows, in turn, will display the Start menu.

2. Within the Start menu, select the Programs option and then choose Microsoft FrontPage. Windows, in turn, will open the FrontPage Editor.

3. Click your mouse on the File menu Open Web option. FrontPage, in turn, will display the Open Web dialog box.

4. Enter a Folder name and click your mouse on Open.

5. Select the Insert menu Component option, then select Marquee from Options. FrontPage, in turn, will display the Marquee Properties window, as shown in Figure 9.16.

Figure 9.16 The FrontPage 2000 Marquee Properties window.

6. Type in the text you want your marquee to display.

7. Select your settings for direction, speed, behavior, alignment, size, background color, and looping.

8. Click your mouse on the OK button. The marquee should now appear as a tag on your page, as shown in Figure 9.17.

9. Publish and upload your page to your server.

10. Save the file.

11. Select the File menu Preview in browser option to view your marquee in a browser, as shown in Figure 9.18.

Figure 9.17 The marquee on the page after inserting it into FrontPage 2000.

Figure 9.18 The FrontPage 2000 marquee as it appears on the page in Internet Explorer.

WHAT YOU MUST KNOW

As you have learned, marquees are easy to add to a Web site and can make an otherwise static Web site more interesting. However, before you can add a marquee, you should first understand some basic concepts, such as marquee types and the advantages and disadvantages of their use. This lesson introduced marquees. In Lesson 10, "Working with Audio," you will learn how easy it is to add sound to your Web pages. Before you continue with Lesson 10, however, make sure you understand the following key concepts:

✓ Web designers add marquees to Web pages to draw attention to an announcement or to display current news or other information, to make an otherwise static Web pages more interesting, to display menus, and to add visual appeal to a Web page.

✓ Several types of marquees include the simple HTML marquee, scrolling status bar, as well as the more complex marquees accomplished with various programming technologies.

✓ Marquees offer many advantages, such as ease of implementation, no special plug-in required (except for a Shockwave marquee), cross-platform and browser compatibility (except for some DHTML and ActiveX marquees), and fast download time for most marquees. Among their disadvantages, marquees can annoy and distract some users, some marquees require a plug-in, some have existing browser and platform incompatibilities, and some marquee Java applets load slowly.

✓ Many software programs, such as Ulead's GIF Animator or the Web Marquee Wizard freeware program, automatically create marquees for you.

✓ To add a marquee, you will select a marquee, add the appropriate code to your HTML file, and upload the HTML file and any other files to your server.

✓ Adding a marquee to a Web page is relatively easy but you may need some special settings and some knowledge of programming concepts, depending on the type of marquee you select.

LESSON 10

WORKING WITH AUDIO

Adding sound to Web sites has been an option for several years and, if used effectively, can enhance a site. A Web audio file can play music, sound effects, or narration, and be one of several formats. Some Web audio formats take time to download, thus decreasing their effectiveness. However, streaming audio, which is a relatively new technology, offers a solution to the slow downloading of certain Web audio files since it lets an audio file play as it downloads without being copied to the user's hard disk.

In this lesson, you will learn how to add sound to your Web site. By the time you finish this lesson, you will understand the following key concepts:

- ◆ Web designers add sound to Web pages for several reasons, such as to enhance a site's appeal with background music, to provide narration, and to offer sound effects.

- ◆ Several formats are available for common Web audio and include WAV, AU, SND, AIFF, MP3, and MIDI. Shockwave and Flash files can include sound, too. Other formats exist for streaming audio, such as Emblaze and Real Audio.

- ◆ Adding audio to a Web site offers many advantages, including ease of implementation, no special plug-in software required (in most cases), cross-platform and cross-browser compatibility for standard file formats, short download time for some file formats, such as MIDI files and streaming audio formats. The drawbacks include some users' dislike of sound files, sound files not playing properly due to lack of code to fully support both Netscape and Internet Explorer browsers or users not having their browsers properly configured, and some file formats, such as WAV, requiring extra time to download.

- ◆ Many software programs, such as Syntrillium Software's Cool Edit 95, are available to edit sound files and convert them to a size and format appropriate for the Web.

- ◆ To add sound, you will select a sound file or create your own, convert the sound file to a proper format for the Web, add the appropriate code to your HTML file, and upload the HTML file and any other files to your server.

- ◆ Adding sound to a Web page is easy and generally requires only a few lines of code.

123

ENHANCING YOUR SITE WITH SOUND

Common Web audio formats include WAV, AU, SND, AIFF, MP2, and MIDI. Shockwave and Flash files can include sound, too. Other formats exist for streaming audio, such as Emblaze and Real Audio, which you will learn about later in this lesson. WAV format is the popular Microsoft Windows file format. Sound files with a SND or AU extension are the NeXT and Sun format. Macintosh systems use the AIFF format. A variation of the AIFF format (the AIFC format) offers options for compression. MPEG layer-2 files or MP2 files are becoming quite popular at online music archives because they offer high compression without compromising quality. Unlike these formats that can play both sound and music, MIDI files, which stands for Musical Instrument Digital Interface, play music only and are smaller in size.

You can use sound in several ways to enhance your Web site. For example, you can use background music to greatly enhance the appeal of your Web site. However, the background music should pertain to the Web site's theme to be effective. The Bali Highway site at *www.balihighway.com*, as shown in Figure 10.1, plays music in MIDI format as you enter the page.

Figure 10.1 The Bali Highway site at ***www.balihighway.com****.*

Another good example of sound pertaining to the theme of the site is National Geographic's Web site at *www.nationalgeographic.com/voices/*, as shown in Figure 10.2.

You can hear a brief sound clip, which is part of a Flash animation (you will learn about Flash later in this book), playing the National Geographic's well-known theme music. The sound clip's duration is brief so that it does not distract the user. Some sites give the user a choice of sound or

no sound because some users find sound too irritating or distracting. As shown in Figure 10.3, the 360 Alaska site at *www.360alaska.com*, gives the user the option of sound.

Figure 10.2 National Geographic's theme music at **www.nationalgeographic.com/voices/**.

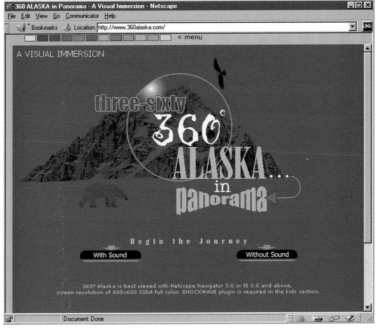

Figure 10.3 The 360 Alaska site at **www.360alaska.com**.

Some Web sites combine sound or music with animation. The Green House Group Web site at *www.greenhse.com* uses Flash to have sound and animation play simultaneously in synch, as shown in Figure 10.4.

*Figure 10.4 The Green House Group Web site at **www.greenhse.com**.*

Narration is another common use for audio in Web sites. For example, the Norad Santa Web site, at *www.noradsanta.org*, uses streaming audio narration, which lets an audio file play as it downloads to communicate the location of Santa Claus, as shown in Figure 10.5.

*Figure 10.5 The Norad Santa Web site at **www.noradsanta.org**.*

Another popular site, the Siskel and Ebert Web site at *www.siskelandebert.com*, offers audio movie reviews using a Shockwave player with controls, as shown in Figure 10.6.

Figure 10.6 *The Siskel and Ebert Web site at* ***www.siskelandebert.com***.

National Geographic's Web site, as shown in Figure 10.2, offers users the narration of stories in Real Audio format. You can also add narration with music playing in the background. An upbeat music clip with a brief narration using Shockwave plays as the user enters the Jordache splash page at *www.jordache.com*, as shown in Figure 10.7.

Figure 10.7 *The Jordache splash page at* ***www.jordache.com***.

Some music archive sites, such as SONICNET at *www.sonicnet.com*, as shown in Figure 10.8, play audio interviews and let users sample music clips using Real Player or other similar technology, as well as offer audio chats.

Figure 10.8 *Some music archive sites, such as SONICNET at **www.sonicnet.com**.*

Another common use of audio on Web sites is for sound effects. For example, many game Web sites, such as the space arcade game at *www.quick-silver.demon.co.uk/dhtml/galaxian/,* as shown in Figure 10.9, play a wide variety of sound effects as the user plays the games online.

Figure 10.9 *The space arcade game at **www.quick-silver.demon.co.uk/dhtml/galaxian**.*

You can also use sound effects for mouseovers. (You will learn about mouseovers or hot spots in Lesson 11, "Taking Advantage of Hot Spots.") A sound plays as the user passes his or her cursor over a button on a Web page. To see an example of audio mouseovers, go to the Web site *www.whatisthematrix.com/ index3.html,* as shown in Figure 10.10. When the user enters the What is the Matrix Web page and passes his or her cursor over the monitor screens, music and sound effects play.

Figure 10.10 *Sound effects play at **www.whatisthematrix.com/index3.html**.*

Other uses for audio on the Web include chat rooms as well as internet radio stations, which is a type of Push Technology. (You will learn about Push Technology in Lesson 18, "Implementing Server Push Operations.")

Adding audio to a Web site offers many advantages. For example, sound generally requires only a few lines of code to play. In addition, you generally do not need a special plug-in to hear a sound file play within your browser (unless you decide to use a technology, such as Shockwave or Real Audio). Many of the standard sound file formats are cross-platform and cross-browser compatible. Some file formats, such as MIDI, offer brief download time because MIDI files are small in size. Advancements in streaming audio also offer fast downloading of audio files, but at the price of a plug-in in many cases.

Despite its many advantages, adding sound to your Web pages does have some drawbacks. For example, some users may not appreciate the sound effects or music on your Web page. A user may not like the type of music you chose or the extra time it takes to load your page. You should always consider offering a choice regarding sound, if at all possible, such as offering a "sound or no sound" duplicate site, or displaying the console for the user to control the playing of audio, or to limit the number of times the sound file plays by setting the number of loops. Placing the code for the sound file toward the bottom of the page also ensures that the sound file will load in the background and not interfere with the loading of the text and graphics for the Web page for the user. You should also be

sure your sound serves a purpose on the Web page since some users do not favor sound. Another disadvantage is sound that does not play properly on a page using some browsers due to lack of code to support both browsers or users not having their browsers properly configured. For example, older versions of Internet Explorer require the <BGSOUND> tag to accompany the <EMBED> tag in the HTML document to play sound. Sometimes MIDI files do not play properly in certain browsers if the MIME (multipurpose Internet Mail Extension) type is not set up correctly. A further disadvantage is that some file formats, such as WAV, can be quite large in size and require time to download.

THE IMPORTANCE OF SMALL FILE SIZE

You should be sure your audio file is not too large in size or the file will take too much time to download and may discourage users. The audio file's sample rate and resolution determines its file size. When you record audio, A/D (analog to digital) conversion occurs. The A/D converter determines the rate the recorder samples the signal, known as the sample rate. Resolution or bit rate is the number of bits the recorder allocates for each sample value from the A/D converter. Audio files, such as WAV or SND files, can vary in both sample rate from 8kHz to 44,056kHz, and in resolution of 8-bit, 16-bit, or higher. The higher the sample rate and resolution is, the larger the file size will be. For example, a 22.05kHz, 16-bit audio file offers higher quality than a 11,025kHz, 8-bit audio file. However, the 16-bit audio file is much larger in size than the 8-bit version. Therefore, the better audio file choice for the Web is the 11,025kHz, 8-bit audio file. The length of the audio recording also effects the size of the file. For example, a five-minute sound clip is generally out of the question no matter what the sampling rate and resolution. The file would take too long to download. Streaming audio is an option for such large files, as you will learn later in this lesson.

Many software options are available to edit sound files and convert 44,056kHz or 22.05kHz, 16-bit audio files to 11,025kHz, 8-bit audio files, which is a size and format appropriate for the Web. Syntrillium Software's Cool Edit 95, as shown in Figure 10.11, is a shareware program available at *www.syntrillium.com* that lets you edit your sound files for the Web.

Figure 10.11 Syntrillium Software's Cool Edit is a shareware program available at www.syntrillium.com.

Gold Wave Audio Editor is another shareware option available at *www.goldwave.com*. Commercial software, such as Macromedia's SoundEdit, is also available.

STREAMING AUDIO

Streaming audio is a relatively new technology that lets an audio file play as it downloads without software copying files to the user's hard disk. Progressive Networks' RealAudio was the first to take advantage of this technology and continues to be a leader in streaming audio. Streaming audio offers playback without the wait for complete download or loss of quality, in some cases even using a 14.4 baud modem. The user also has controls to stop, pause, or rewind the audio clip. To understand how RealAudio streaming works, you have to understand how the RealAudio components work. RealAudio is comprised of three major components. The first component, the RealAudio Encoder, lets you create your own audio file or take one that already exists and convert it to a RealAudio highly compressed format with an RA (Real Audio) extension. The second component is the RealAudio Server which handles all the isochronous transmission (the type of data transmission that offers the lowest data rate) of streamed information from the sound file by pacing the information. The RealAudio Server works on any Web server that lets you modify MIME (Mulitpurpose Internet Mail Extensions) types. The third component, the RealAudio Player, is a plug-in which lets browsers view the RealAudio file. When you view an HTML file with an embedded RealAudio file, the browser sends the RealAudio file's location to the RealAudio Player, which requests the file from the RealAudio Server. The RealAudio Server, in turn, sends the requested file to the RealAudio Player and the RealAudio clip is buffered and played. You can see the RealAudio Player in use at *www.sonicnet.com*, as shown in Figure 10.8, and at National Geographic's Web site, as shown in Figure 10.2. You can find out more about RealAudio at *www.real.com*.

RealAudio is not the only option for streaming audio. Three other audio streaming technologies that work similarly to RealAudio are DSP Group's TrueSpeech, Xing Technology's Streamworks, and VolcalTec's Iwav. You can find out more about these streaming technologies at *www.dspg.com, www.xingtech.com*, and *www.vocaltec.com*, respectively. In addition, Quicktime and Shockwave also offer streaming audio. Emblaze Audio is a software program that offers streaming video without the need for a plug-in and converts WAV, AIFF, and SND files to its own special format. After you embed an audio file with the Emblaze format in an HTML file, a Java applet plays the audio file. You can find out more about Emblaze Audio at *www.emblaze.com*.

ADDING A SOUND CLIP TO A WEB PAGE

You have several options available for obtaining audio clips for your Web page. You can record your own sound clip using Windows Recorder for creating a WAV file or using other audio recording utilities to create an audio file in another format. You can also use a sound clip that is already available. Resources for audio clips include *www.thefreesite.com/freesounds.htm, www.geocities.com/Hollywood/Boulevard/1306/, www.onlinebusiness.com/shops/_midi/ BEST_MIDI_Archives.shtml, filecity.com/midi/*, and *www.midifarm.com*. Some of the sound clips found on these sites are free but you should always verify this is the case. In addition, you can purchase commercial sound clip CDs.

You can add sound in two ways to your Web site. First, you can let users click their mouse on a link to hear a sound. Therefore, you can make audio clips optional by using an anchor tag, which defines hyperlinks in Web pages, to create a link to the sound file in your HTML document. The anchor tag looks similar to the following:

```
<A HREF="filename">Click here to hear sound clip</A>
```

The second way to add sound is to use the <EMBED> tag to play sound as the user enters the page. The <EMBED> tag looks similar to the following:

```
<EMBED src="filename" autostart=true loop=false volume=100 hidden=true>
```

As you can see, the <EMBED> tag offers several attributes to control the sound clip. The autostart attribute lets the sound clip automatically start to play as the user enters the page. Setting the loop attribute to false lets the sound clip only play once. The sound console that lets the user control the sound clip will not appear if you set the hidden attribute to *false*. However, if you want the sound console to appear, you must add the height and width attributes to the line code, which will look similar to the following:

```
<EMBED src="filename" autostart=true loop=false volume=100 height=50 width=150>
```

The <EMBED> tag works for most browsers. However, if you want your sound to play in Internet Explorer 3.0, you should include the <BGSOUND> tag. You place the <BGSOUND> tag after the <EMBED> tag, which will look similar to the following:

```
<EMBED src="filename" autostart=true loop=false volume=100 hidden=true>

<NOEMBED><BGSOUND src="filename"></NOEMBED>
```

You can also use browser-detection JavaScript (you will learn about JavaScript in Lesson 13, "Understanding and Working with JavaScript") to add sound to a Web page. A typical script for browser-detection looks similar to the following:

```
<SCRIPT LANGUAGE="JavaScript">

<!—

var ver = navigator.appVersion;

if (ver.indexOf("MSIE") != -1)

{

document.write('<BGSOUND SRC="filename" LOOP=infinite>')

}else
```

```
document.write('<embed src="filename" height=2 width=2

autostart=true hidden=true loop=true>')

// —></SCRIPT>
```

JavaScript can also control LiveConnect and LiveAudio plug-ins to play sound and offer more control of sound clips regarding when to play the sound, increasing or decreasing the volume, pausing or stopping the sound, and other options. The JavaScript code for controlling LiveConnect and LiveAudio plug-ins looks similar to the following:

```
<HTML>
<BODY>

<EMBED SRC="filename"
  HIDDEN=TRUE
  NAME="audioclip1"
  MASTERSOUND>

<A HREF="javascript:document.audioclip1.play(false)">
Click here to hear the sound!</A>

</BODY>
</HTML>
```

In the future, you will have the option of controlling sound clips with the <OBJECT> tag, which is a new HTML 4.0 tag offering an all-in-one answer for Web media. However, for now, the <EMBED> tag is the common choice to add sound to a Web page.

Now you are ready to add your first audio clip to your Web page. For this lesson, you will add a MIDI file called SDHEY19.MID. All the files you need to use for this exercise are in the LESSON10 directory on the CD-ROM that accompanies this book. Copy all of these files to a directory on your hard drive. The first step in adding the MIDI file to your Web page is to add the code to your HTML file. For the purposes of this lesson, the code to embed the MIDI file is provided for you. An example of how the code looks that you will add to your HTML document is shown below:

```
<EMBED src="sdhey19.mid" autostart=true loop=false volume=100 hidden=true>

<NOEMBED><BGSOUND src="sdhey19.mid"></NOEMBED>
```

To add this code to your HTML document, perform the following steps:

1. Click your mouse on the Start button. Windows, in turn, will display the Start menu.

133

2. Within the Start menu, select the Programs option and then choose Windows NotePad from Accessories. Windows, in turn, will open the Windows NotePad ASCII text editor.

3. Select the File menu Open option. Windows NotePad, in turn, will display directories and lists of files.

4. Select the AUDIO-CODE.TXT file.

5. Click your mouse on the Open button.

6. Select all the code in the AUDIO-CODE.TXT file.

7. Select the Edit menu Copy option.

8. Select the File menu Open option. Windows NotePad, in turn, will display directories and lists of files.

9. Select the AUDIO-TEST.HTM file.

10. Click your mouse on the Open button.

11. Position your cursor between the <BODY> tags, then select the Edit menu Paste option. Windows Notepad, in turn, will display the code, as shown in Figure 10.12.

Figure 10.12 *The AUDIO-TEST.HTM file with the code as it appears in Windows NotePad.*

12. Save your file.

13. Open the AUDIO-TEST.HTM file in Netscape or Internet Explorer 4.0 or higher. Your browser will play the MIDI file and you will hear background music.

ADDING SOUND TO A WEB PAGE USING FRONTPAGE 2000

Adding sound to a Web page is easy with FrontPage 2000. To add a background sound using FrontPage 2000, perform the following steps:

1. Click your mouse on the Start button. Windows, in turn, will display the Start menu.

2. Within the Start menu, select the Programs option and then choose Microsoft FrontPage. Windows, in turn, will open the FrontPage Editor.

3. Click your mouse on the File menu Open Web option. FrontPage, in turn, will display the Open Web dialog box.

4. Enter a Folder name and click your mouse on Open.

5. Right-click your mouse on the page while in Page View. FrontPage, in turn, will display a shortcut menu with several options.

6. Select Page Properties. FrontPage, in turn, will display the Page Properties window, as shown in Figure 10.13.

Figure 10.13 The FrontPage 2000 Page Properties window.

7. Select the General tab.

8. Type in the sound file you want to use in the Location Box for Background Sound or click your mouse on Browse to locate the file. (You can use the SDHEY19.MID file included in the LESSON10 directory on the CD-ROM that accompanies this book).

135

9. Select the Forever checkbox to play the sound continuously.

10. Click your mouse on the Open button. FrontPage, in turn, will add the background sound to your page. It will appear in HTML, as shown in Figure 10.14.

***Figure 10.14** The background sound as it appears on your Web page in HTML view.*

11. Publish and upload your page to your server.

12. Select the File menu Preview in Browser option to hear the background sound play using the Internet Explorer browser.

WHAT YOU MUST KNOW

As you have learned, sound is easy to add to a Web site and can make a Web site more interesting, if you use it effectively. However, before you can add sound, you should first understand some basic concepts, such as sound file format types, streaming audio, and the advantages and disadvantages of adding sound to Web pages. This lesson introduced sound. In Lesson 11, "Taking Advantage of Hot Spots," you will learn about options to add hot spots or mouseovers to your Web pages. Before you continue with Lesson 11, however, make sure you understand the following key concepts:

✓ Web designers add sound to Web pages for several reasons, such as to enhance a site's appeal with background music, to provide narration, and to offer sound effects.

✓ Several formats are available for Web audio and include WAV, AU, SND, AIFF, MP3, MIDI, and Shockwave and Flash files. Other formats exist for streaming audio, such as Emblaze and Real Audio.

✓ Adding audio to a Web site offers many advantages, including ease of implementation, no special plug-in required (in most cases), cross-platform and cross-browser compatibility, and short download time for certain file formats. The drawbacks include some users' dislike of sound files, sound files not playing properly due to lack of code to fully support both browsers or users not having their browsers properly configured, and some file formats, such as WAV, requiring extra time to download.

✓ Many software programs, such as Syntrillium Software's Cool Edit 95, are available to edit sound files and convert them to a size and format appropriate for the Web.

✓ To add sound, you select a sound file or create your own, convert the sound file to a proper format for the Web, add the appropriate code to your HTML file, and upload the HTML file and any other files to your server.

✓ Adding sound to a Web page is easy and generally requires only a few lines of code.

LESSON 11

TAKING ADVANTAGE OF HOT SPOTS

Hot spots, also known as rollovers, hover buttons, or mouseovers, have become a common feature on many Web sites over the years and can add appeal to a site if you use them wisely. A hot spot is a button or an image on a Web page that changes in some manner or causes another image or part of the Web page to change as the user passes his or her cursor over the button or image. Hot spots can be as simple as changing status line messages to more complex hot spots that include animation or sound.

In this lesson, you will learn how to add a hot spot to your site. By the time you finish this lesson, you will understand the following key concepts:

- Web designers use hot spots for several reasons. Hot spots are used to make Web pages more interesting, to add interactivity, and to simplify Web site navigation.

- Some types of hot spots are highlighted menu bar items, status bar messages, pop-up messages, changing backgrounds, and scrolling marquees. More complex hot spots have sound, animation, or both, and even more complex hot spots make images appear elsewhere on Web pages.

- Several programming technologies, such as JavaScript, DHTML, Java, Flash, and Shockwave, are available for creating hot spots. Each technology has advantages and disadvantages.

- Hot spots offer many advantages, such as ease of implementation, promotion of interactivity, ease of Web site navigation, no special plug-in required (except for Shockwave or Flash hot spots), general cross-platform and cross-browser compatibility (except for some DHTML hot spots), and fast download time for most hot spots. Some drawbacks exist as well. For example, some hot spots require a plug-in, some have browser and platform incompatibilities, and some hot spot Java applets load slowly on a Web page.

- Many software programs, such as Ulead's Animation.Applet, Lotus BeanMachine, or Macromedia Fireworks, automatically create hot spots for you.

- To add hot spots, you select a hot spots script, applet, or other Web technology, add the appropriate code to your HTML file, and upload the HTML file and any other files to your server.

- Adding hot spots to a Web page is relatively easy but you may need some special settings and some knowledge of programming concepts, depending on the type of hot spots you select.

ENHANCING YOUR SITE WITH HOT SPOTS

Web designers use hot spots for several reasons. Hot spots are used to make Web pages more interesting, to add interactivity, and to simplify Web site navigation. Hot spots can dramatically change the appearance of a Web page and add life to static Web pages. By using hot spots, you can encourage the user to interact with information on Web pages. Hot spots can help users navigate Web sites more easily, since hot spots communicate quickly to the user that items are indeed hot and clearly differentiate the hot items from items that are not hot.

You can see many different types of hot spots on Web pages. Some types of hot spots are simple menu bar items, status bar messages, pop-up messages, changing backgrounds, scrolling marquees, and more complex hot spots with sound, animation, or both. Complex hot spots can make images appear elsewhere on Web pages. The most common use of hot spots is the simple menu bar Web page designers usually create with JavaScript or DHTML, although it is possible to use other Web technologies for creation. A menu bar is a group of buttons the user can click on to access other pages within a Web site. As shown in Figure 11.1, the small icon next to the buttons light up as the user passes his or her cursor over each of the menu bar items at the Communique Web site at *www.cvcmedia.com*.

Figure 11.1 *The simple menu bar items at **www.cvcmedia.com**.*

Another common use of hot spots is to have a message or description for a button appear in the status bar as the user passes the cursor over a hot spot item, as shown at *www.andyart.com* in Figure 11.2.

139

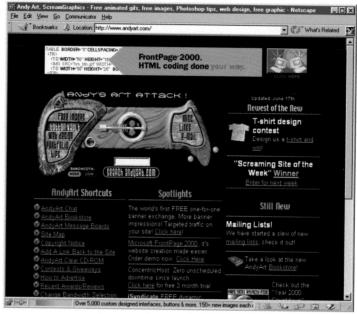

Figure 11.2 A message appears in the status bar as the user passes his or her cursor over a hot spot item.

Hot Spots can also make windows pop up with important messages or make descriptions appear in a certain area of the Web page. For example, the hot spots for the menu button at *www.petco.com* change the color of the paw print and display a description beside the menu bar for each item, as shown in Figure 11.3.

Figure 11.3 The hot spots for the menu button at www.petco.com displaying a description for each item.

As shown in Figure 11.4, passing your cursor over the menu items at the SIGS publication Web site at *www.sigs.com* will produce a list of books, conferences, or publications.

Figure 11.4 *The menu items offer a list of books, conferences, or publications.*

You can also see hot spots displaying descriptions at the Microsoft Trial Virtual Courtroom Web site at *www.mercurycenter.com/business/microsoft/trial/background.shtml*, as shown in Figure 11.5.

Figure 11.5 *The Microsoft Trial Virtual Courtroom Web site.*

In addition, hot spots can also display images on other areas of the page instead of just descriptions, as shown at the Perceptions Web site at *www.perceptions.org/mainnav2.htm* in Figure 11.6 and the Abscond Web site at *www.abscond.com/abscond/main.htm* in Figure 11.7.

Figure 11.6 The hot spots displaying images on other areas of the page instead of just descriptions.

Figure 11.7 The hot spots displaying images at the Abscond Web site.

Passing a cursor over a hot spot can also make a Web page's background change using DHTML, as shown in Figure 11.8.

*Figure 11.8 The background color at **www.select-plan.com/casa.htm** changes.*

You can also find hot spots on a scrolling Java marquee. For example, a Java marquee with hot spots is the circular marquee at the top of the Discovery home page at *www.discovery.com*, as shown in Figure 11.9.

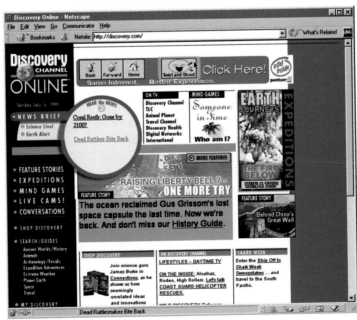

*Figure 11.9 A Java marquee with hot spots at the top of the Discovery home page at **www.discovery.com**.*

143

Another variation of hot spots and scrolling text is Charlie Morey's Resume Thing at *home.earthlink.net/~cmorey/*. The Resume Thing uses Java to let hot spots display scrolling text in the middle panel, as shown in Figure 11.10.

Figure 11.10 Charlie Morey's Resume Thing at **home.earthlink.net/~cmorey/.**

Hot spots can create some cool effects, as shown at *www.andyart.com* in Figure 11.2.

As the user passes his or her cursor over the buttons, the middle object not only points to the button but animates as well.

Hot spots can also include sound. You can use Flash, Java, or JavaScript to add sound to hot spots. For example, the Disney site at *www.disney.com*, as shown in Figure 11.11, and the What is the Matrix Web page at *www.whatisthematrix.com/index3.html*, as shown in Figure 11.12, both include some Flash-generated hot spots that play sound effects as the cursor passes over the buttons.

Figure 11.11 Hot spots with sound effects at *www.disney.com*.

Figure 11.12 Hot spots with sound effects at the What is the Matrix Web page.

You can see more complex hot spots at the Hotwired Web site at *www.hotwired.com/animation/*. The hot spots are part of a Flash-generated scrolling menu bar that displays animations as the cursor passes over each cartoon, as shown in Figure 11.13.

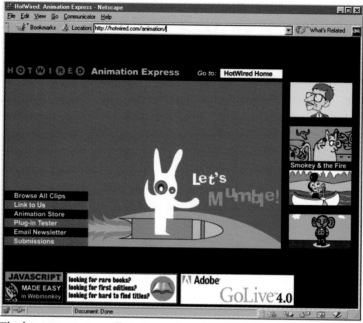

Figure 11.13 The hot spots on a scrolling menu bar displaying animation.

Several programming technologies are available for creating hot spots including JavaScript, DHTML, Java, Flash, and Shockwave. Each technology has advantages and disadvantages. For example, JavaScript and DHTML offer hot spots that load very quickly and do not require a plug-in. JavaScript allows more basic hot spots while DHTML allows more advanced functions, such as swapping text. However, JavaScript and DHTML do not support both versions of Netscape and Internet Explorer. DHTML supports Netscape 4 and Internet Explorer 4 and higher. JavaScript supports Netscape 3 and 4, as well as Internet Explorer 4, but is not fully compatible with Internet Explorer 3. If full support for Netscape and Internet Explorer 3 and higher is a concern, then Java may be the best option for creating hot spots. However, one major disadvantage of Java is speed. Java applets take much longer to load than other Web technologies, such as JavaScript or DHTML. You can also create hot spots with Shockwave or Flash. (You will learn more about Shockwave and Flash in Lesson 19, "Working with Shockwave and Flash.") Both Shockwave and Flash let you create hot spots with more advanced options. Flash and Shockwave are compatible with the 3 and 4 version browsers and some earlier browsers. Two disadvantages of these two technologies regard price and plug-ins. Director, which is the Macromedia program that creates Shockwave files, is an expensive program. Although Flash costs less than Director, the software program would not be the best choice if you just want simple hot spots, due to the program's cost. For simple hot spots, you should consider one of the other Web technologies like Java, DHTML, or JavaScript. Both Shockwave and Flash require plug-ins. Fortunately, the plug-ins are available now with Windows 98 and the latest versions of Netscape and Internet Explorer browsers.

Hot spots offer many advantages. For example, hot spots are easy to create and add to a Web page compared to other Web enhancements. You may just have to add a few lines of code or apply some special settings, depending on what Web technology you decide to use. However, usually you will not need to know any complex programming language to do so, as you will learn later in this lesson. Another advantage is that hot spots make Web site navigation easier for users. You can also make Web pages more interesting and interactive with hot spots. In addition, you do not need a special plug-in to view hot spots within your browser (unless you use Shockwave or Flash to create your hot spots). Most hot spots are generally cross-platform compatible and work with most of the latest browser versions, with the exception of those created with DHTML which work only with the version 4 browsers or higher. The download time for hot spots is generally fast if you create them with such technologies as DHTML, JavaScript, Shockwave, or Flash. Despite their many advantages, hot spots also have some disadvantages. For example, some hot spots require a plug-in, some have browser and platform incompatibilities, and some Java applets hot spots load slowly on a Web page.

ADDING HOT SPOTS TO A WEB PAGE

You can add hot spots to your Web site in several ways. You can create status bar message hot spots with a few lines of HTML. The following lines demonstrate a status bar message displaying upon moving the cursor over a text link:

```
<A HREF="http://www.yahoo.com"

        ONMOUSEOVER="window.status='Go to Yahoo!'; return true"

        ONMOUSEOUT="window.status="; return true">

        Visit Yahoo

        </A>
```

The ONMOUSEOVER="window.status=='Go to Yahoo!'; return true" line of code will display "Go to Yahoo" in the status bar. The ONMOUSEOUT="window.status="; return true"> line of code will remove the message from the status bar. To see a demonstration of the status bar hot spot, you can view the STATUSBAR.HTM file included in the LESSON 11 directory on the CD-ROM that accompanies this book.

You can also create a simple hot spot with HTML that changes one image to another when the cursor passes over the image. HTML hot spots work with Netscape 3 and 4 and Internet Explorer 4, but not with Internet Explorer 3. The HTML code to create a simple hot spot is shown below:

```
<A ONCLICK="return false"

        ONMOUSEOVER="document.images.imageDemo.src='graphic2 file
        name'"
```

147

```
        ONMOUSEOUT="document.images.imageDemo.src='graphic1 file name'"
HREF="#">

    <IMG border=0 NAME=imageDemo SRC="graphic1 file name">

    </A>
```

To see a demonstration of the simple HTML hot spot, you can view the HTMLHOTSPOT.HTM file included in the LESSON 11 directory on the CD-ROM that accompanies this book.

You can also add a few lines of JavaScript to have a sound clip play when the cursor passes over an image. The script that you add beween the <HEAD> tags is shown below:

```
<SCRIPT LANGUAGE="JavaScripthot spots">

function playsound(sfile)

{

        window.location.href=sfile;

}

</SCRIPT>
```

The HTML code that lets the image file play the sound appears as follows:

```
<A HREF="#" ONMOUSEOVER="playsound('sound file name');">

<IMG SRC="graphic file name" WIDTH="100" HEIGHT="75"> </A>
```

To see a demonstration of the sound HTML hot spot, you can view the SOUNDHOTSPOT.HTM file included in the LESSON 11 directory on the CD-ROM that accompanies this book.

You will learn more about JavaScript and how to use JavaScript to create Hot Spots in Lesson 13, "Understanding and Working with JavaScript".

Many software programs, such as Ulead's Animation.Applet, Lotus BeanMachine, or Macromedia Fireworks, automatically create hot spots for you. You can download hot spot scripts and applets from many online resources. Resources you can use as a reference and for sample code include Website Abstraction at *www.wsabstract.com*, Web Developer's JavaScript resources at *www.webdeveloper.com/javascript*, The Web Design Resource at *pageresource.com/jscript/index4.htm*, The Script Vault at *www.iw.com/daily/scripts/*, The JavaScript Tip of the Week archive at *www.WebReference.com/javascript/*, The JavaScript Source at *www.Javascriptsource.com*, the WebCoder

Scriptorium at *www.webcoder.com/scriptorium*, *www.freecode.com*, *www.javaboutique.com*, and *www.davecentral.com*.

Now you are ready to add your first hot spots to your Web page. In this lesson, you will add a simple freeware hot spot applet called PushIt!. For more information on the PushIt! applet, refer to *table.jps.net/~one1/stuff/java/pushit/*. All the files you need to use for this exercise are in the LESSON 11 directory on the CD-ROM that accompanies this book. Copy all of these files to a directory on your hard drive. (Be sure to copy the subdirectories as well.) The first step in adding hot spots to your Web page is to add the code to your HTML file. For the purposes of this lesson, the code to embed the PushIt! applet is provided for you. An example of how the code looks that you will add to your HTML document is shown below:

```
<APPLET WIDTH="430" HEIGHT="220" ARCHIVE="PushIt.jar" CODE="PushIt.class"
CODEBASE="java">

<PARAM NAME="bgImage" VALUE="images/marble.gif">

<PARAM NAME="elevation" VALUE="5">

<PARAM NAME="hMargin" VALUE="7">

<PARAM NAME="hMargin3" VALUE="0">

<PARAM NAME="vMargin" VALUE="5">

<PARAM NAME="vAlignment" VALUE="2">

<PARAM NAME="faceImage0" VALUE="images/pic1.gif">

<PARAM NAME="faceImage1" VALUE="images/pic2.gif">

<PARAM NAME="faceImage2" VALUE="images/pic3.gif">

<PARAM NAME="hoverFaceImage0" VALUE="images/over1.gif">

<PARAM NAME="hoverFaceImage1" VALUE="images/over2.gif">

<PARAM NAME="hoverFaceImage2" VALUE="images/over3.gif">

<PARAM NAME="pushedFaceImage0" VALUE="images/click1.gif">

<PARAM NAME="pushedFaceImage1" VALUE="images/click2.gif">

<PARAM NAME="pushedFaceImage2" VALUE="images/click3.gif">
```

```
<PARAM NAME="hoverLabelText0" VALUE="DEER">

<PARAM NAME="hoverLabelText1" VALUE="PRAIRIE DOG">

<PARAM NAME="hoverLabelText2" VALUE="DOLPHIN">

<PARAM NAME="labelOffset" VALUE="0 60">

<PARAM NAME="labelFont" VALUE="1 1 14">

<PARAM NAME="labelColor" VALUE="AFFF3F">

<PARAM NAME="pushedLabelOpacity" VALUE="0">

<PARAM NAME="description0" VALUE="deer">

<PARAM NAME="description1" VALUE="prairie dog">

<PARAM NAME="description2" VALUE="dolphin">

<PARAM NAME="onSound0" VALUE="sounds/cowbell.au">

<PARAM NAME="onSound1" VALUE="sounds/beep.au">

<PARAM NAME="onSound2" VALUE="sounds/pop.au">

<PARAM NAME="target" VALUE="applet:Sparky">

<PARAM NAME="action0" VALUE="Deer eat...">

<PARAM NAME="action1" VALUE="Prairie dogs eat...">

<PARAM NAME="action2" VALUE="Dolphins eat...">

</APPLET>
```

As you can see, the first line of code sets the width and height of the applet as well as specifies such items as the Java applet class file to load. As you have learned, Java applets usually have several lines of parameter settings for various applet options. To get an idea of what the parameter settings mean for PushIt!, view the PUSHIT_PARAMS.HTML file included in the LESSON 11 directory. To add the above code to your HTML document, perform the following steps:

1. Click your mouse on the Start button. Windows, in turn, will display the Start menu.

2. Within the Start menu, select the Programs option and then choose Windows NotePad from Accessories. Windows, in turn, will open the Windows NotePad ASCII text editor.

3. Select the File menu Open option. Windows NotePad, in turn, will display directories and lists of files.

4. Select the HOTSPOTS-CODE.TXT file.

5. Click your mouse on the Open button.

6. Select all the code in the HOTSPOTS-CODE.TXT file.

7. Select the Edit menu Copy option.

8. Select the File menu Open option. Windows NotePad, in turn, will display directories and lists of files.

9. Select the HOTSPOTS-TEST.HTM file.

10. Click your mouse on the Open button.

11. Position your cursor between the <BODY> tags, then select the Edit menu Paste option to paste all the code from the HOTSPOTS-CODE.TXT file between the <BODY> tags. Windows Notepad, in turn, will display the code, as shown in Figure 11.14.

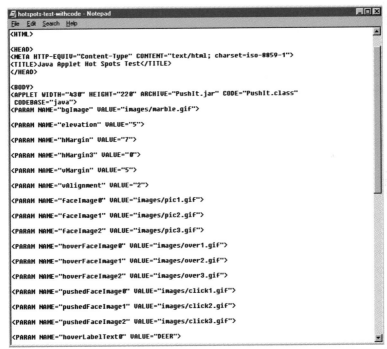

Figure 11.14 The HOTSPOTS-TEST.HTM file with the code as it appears in Windows NotePad.

12. Save your file.

13. Open the HOTSPOTS -TEST.HTM file in Netscape or Internet Explorer. Your browser, in turn, will display the PushIt! Hot Spots applet, as shown in Figure 11.15.

151

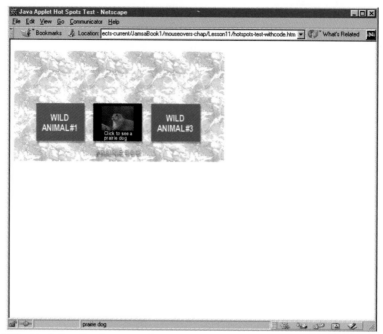

Figure 11.15 *The Push It! Hot Spots Applet as it appears in your browser.*

ADDING HOT SPOTS TO A WEB PAGE USING FRONTPAGE 2000

Adding a hot spot to a Web page is simple with FrontPage 2000. To add hot spots using FrontPage 2000, perform the following steps:

1. Click your mouse on the Start button. Windows, in turn, will display the Start menu.

2. Within the Start menu, select the Programs option and then choose Microsoft FrontPage. Windows, in turn, will open the FrontPage Editor.

3. Click your mouse on the File menu Open Web option. FrontPage, in turn, will display the Open Web dialog box.

4. Enter a Folder name and click your mouse on Open.

5. Select the Insert menu Component option, then select the Hover button from options. FrontPage, in turn, will display the Hover Button Properties window, as shown in Figure 11.16.

6. Click your mouse on the Custom button on the lower left of the Hover Button Properties window. FrontPage 2000, in turn, will display the Custom window to select specific files for the button image, the on hover

image, and the sound file to play. You can use the CLICK1.GIF, OVER1.GIF, COWBELL.AU, and BEEP.AU found in the LESSON11 directory on the CD-ROM that accompanies this book.

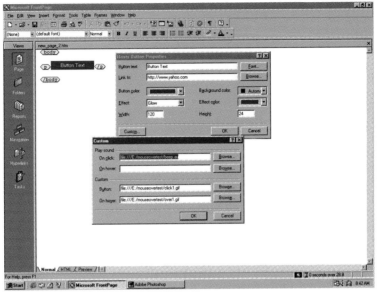

Figure 11.16 *The FrontPage 2000 Hover Button Properties window.*

7. Within the Play Sound area, select BEEP.AU as the sound file in the On click: field.

8. Within the Play Sound area, select COWBELL.AU as the sound file for the On hover: field.

9. Within the Custom area, select CLICK1.GIF as the image for the Button: field.

10. Within the Custom area, select OVER1.GIF as the image file for the On hover: button.

11. Click your mouse on the OK button. FrontPage 2000, in turn, will display the Hover Button Properties window.

12. Within the Button text: field, enter the word deer.

13. Within the Width: field, enter 100, and within the Height: field, enter 75.

14. Within the Link to: field, enter a link (for example, *http://www.yahoo.com*) for Link.

15. Click your mouse on the OK button. FrontPage 2000, in turn, will display the hot spot as a tag on your page, as shown in Figure 11.17.

Figure 11.17 The hot spot on the page after inserting it into FrontPage 2000.

16. Select the File menu Preview in browser option to view your hot spot in a browser, as shown in Figure 11.18.

Figure 11.18 The FrontPage 2000 hot spot as it appears on the page in Internet Explorer.

WHAT YOU MUST KNOW

As you have learned, hot spots are easy to add to a Web site and can make an otherwise static Web site more interesting and interactive, as well as make site navigation easier. However, before you can add hot spots, you should first understand some basic concepts, such as the types of hot spots, the various programming technologies you can use to create hot spots, and the advantages and disadvantages of their use. This lesson introduced hot spots. In Lesson 12, "Using Virtual Reality to Present a Virtual Tour," you will learn how easy it is to add VRML animations and panoramas to your Web pages. Before you continue with Lesson 12, however, make sure you understand the following key concepts:

- ✓ Web designers use hot spots for different reasons. Hot spots are used to make Web pages more interesting, to add interactivity, and to simplify Web site navigation.

- ✓ Some types of hot spots include highlighted menu bar items, status bar messages, pop-up messages, changing backgrounds, scrolling marquees, and more complex hot spots that with sound, animation, or both, or complex hot spots that make images appear elsewhere on Web pages.

- ✓ Several programming technologies are available for creating hot spots, such as JavaScript, DHTML, Java, Flash, and Shockwave. Each technology has advantages and disadvantages.

- ✓ Hot spots offer many advantages, such as ease of implementation, promotion of interactivity, ease of Web site navigation, no special plug-in required (except for Shockwave or Flash hot spots), general cross-platform and cross-browser compatibility (except for some DHTML hot spots), and fast download time for most hot spots. Some drawbacks exist as well. For example, some hot spots require a plug-in, some have browser/platform incompatibilities, and some hot spot Java applets load slowly on a Web page.

- ✓ Many software programs, such as Ulead's Animation.Applet, Lotus BeanMachine, or Macromedia Fireworks, automatically create hot spots for you.

- ✓ To add hot spots, you select a hot spots script, applet, or other Web technology, add the appropriate code to your HTML file, and upload the HTML file and any other files to your server.

- ✓ Adding hot spots to a Web page is relatively easy but you may need some special settings and some knowledge of programming concepts, depending on the type of hot spots you select.

LESSON 12

USING VIRTUAL REALITY TO PRESENT A VIRTUAL TOUR

Panoramas and VRML are two technologies Web designers use to add virtual worlds to Web sites. VRML, which stands for Virtual Reality Modeling Language, is a technology for animation and 3D modeling that lets you create 3D scenes for Web sites. A special VRML browser plug-in lets you control the viewing of VRML components on Web sites. Panoramas are another type of virtual reality component, similar in some ways to VRML in that the user needs a special plug-in to view and control the viewing of the panoramic virtual reality component. However, unlike VRML, panoramas are made up of a series of photographs stitched together to create one image that you can view entirely as you move your cursor across the image.

In this lesson, you will learn how to add a virtual reality component to your site. By the time you finish this lesson, you will understand the following key concepts:

- ◆ Two types of virtual worlds Web designers can add to Web pages are panoramas and VRML components.

- ◆ Web designers add virtual reality (VR) components to Web pages for several reasons, including to make Web pages more interesting and interactive, and to display an item in a three-dimensional realistic view.

- ◆ Some common formats for panoramas include QuickTime VR (QTVR), Live Picture for panoramas created with Live Picture, Inc.'s PhotoVista, VRML2, Black Diamond's Surround Video, and Infinite Pictures' SmoothMove.

- ◆ VRML offers uses for many types of Web sites, including entertainment, education, computer-aided design, product marketing, virtual malls, and much more. Panoramas are useful for these same types of Web sites, as well as real estate and travel.

- ◆ VR components offer many advantages to Web site designers. They make Web sites more interesting and interactive, provide more detail for objects or places than regular flat photos, there is no need for complex programming to add a VR component to your Web site, and they generally have cross-platform and cross-browser compatibility. Some disadvantages include requirement of a plug-in for viewing (in many cases), long download time for some Web VR components, depending on the file size and type, and the needed skills and creativity for quality output.

- Many software programs, such as Caligari's TrueSpace, Micrografx Simply 3D, Silicon Graphics' Internet3D Space Builder, and Platinum Technology's VRCreator Learning Edition, automatically create VRML files for you.

- Some software options for panorama creation include Apple's QuickTime VR Authoring Studio, Enroute Imaging's QuickStitch 360, VideoBrush Corporation's VideoBrush Panorama, Live Picture's PhotoVista, Infinite Pictures' SmoothMove,, Ulead's Cool360 and Black Diamond's Surround Video.

- To add VRML, you create a WRL file by writing code yourself or using VRML creator software, adding the appropriate code to your HTML file, and uploading the HTML file and any other files to your server.

- To add a panorama to a Web page, you take a series of photographs of an object or scene, digitize the photographs, stitch the photographs together with specialized software, save the file to an appropriate format for Web viewing, and embed the panorama into a Web page.

- Adding VRML and panoramas to a Web page is relatively easy, but you may need some knowledge of programming concepts to create your own VRML file.

ENHANCING YOUR SITE WITH VIRTUAL REALITY

Web designers add virtual reality (VR) components to Web pages for several reasons. VR components are used to make Web pages more interesting and interactive, to display an item in a three-dimensional realistic view, or to add more detail to the view of a location or place by letting the user view a 360-degree view. VR components add life to static Web pages and encourage the user to interact with the Web site pages in that the user moves his or her cursor to view the VR component.

Both VRML and most panoramas require special plug-ins for viewing the component on a Web page. One exception to the rule is the panoramas created with Live Picture, Inc.'s PhotoVista, which uses Java to display its panoramas rather than a plug-in. Some common formats for panoramas include QuickTime VR (QTVR), VRML2, Black Diamond's Surround Video, and Infinite Pictures' SmoothMove. You will learn more about the software program options for creating panoramas later in this lesson. To view VRML components, you need a special VRML plug-in for your browser, such as Netscape's Live3D VRML browser (*www.netscape.com/eng/live3d/download_live3d.html*), Intervista Software, Inc.'s Worldview 2.0 (*www.intervista.com*), Platinum Technology's WIRL (*www.platinum.com*), or Silicon Graphics' Cosmo Player (*www.sgi.com/software/cosmo/*).

As you browse the Internet, you can see many examples of how Web site designers use VR on Web pages to enhance Web sites. For example, VR is used to create online virtual worlds for museums, art galleries, exhibits, and other similar places. The Exploratorium Museum of Art, Science, and Human Perception displays a map with hot links to the various panoramas at *www.exploratorium.edu/vr/index.html,* as shown in Figure 12.1.

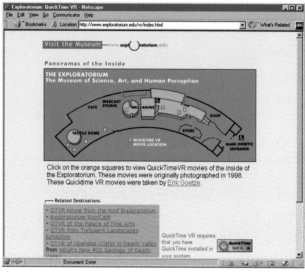

Figure 12.1 The Exploratorium Museum Web site's map with hot links to various panoramas.

Clicking on a map item brings you to the QuickTime VR (Apple's format for VR components) panorama similar to the panorama on the Web page at *www.exploratorium.edu/vr/5.html,* as shown in Figure 12.2.

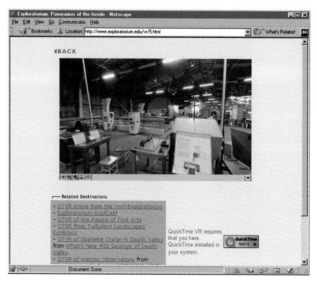

Figure 12.2 A sample panorama at the Exploratorium Museum Web site.

E-commerce sites can also benefit from VR. Users can view a detailed three-dimensional view of products in online catalogs instead of just flat photographs. For example, a user can click on a thumbnail image to view the outside of an automobile in QuickTime VR format at *www.evox.com/frameset.html*, as shown in Figures 12.3 and 12.4.

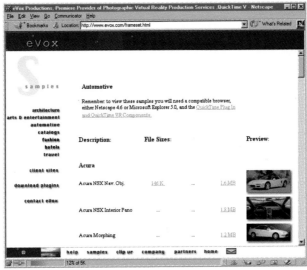

Figure 12.3 Clickable thumbnail images to view automobiles in QuickTime VR format.

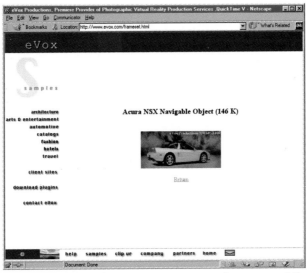

Figure 12.4 A sample 360 degree QuickTime VR panorama of an automobile.

You are not limited to viewing just the outside appearance of an item. You can also use panoramas to let the user view the inside of an automobile. For example, MSN's CarPoint New-Car Buying Service uses panoramas in Black Diamond's Surround Video format to let users view the

159

inside of various automobiles. Figure 12.5 shows a panoramic view of a Plymouth Voyager at *carpoint.msn.com/gallery*.

*Figure 12.5 A panoramic view of a Plymouth Voyager at **carpoint.msn.com/gallery**.*

VR can also help sell real estate. Panoramic views of both the outside and inside of homes gives potential home buyers a better idea of what a house looks like before seeing the house in person. 360House.com's Virtual Tour at *www.360house.com/houseview.cfm?house=4*, as shown in Figure 12.6, uses panoramas to sell real estate.

Figure 12.6 Century 21's Virtual Tour panoramas.

Unlike other Web sites using panoramas, 360House.com's Virtual Tour offers a choice for viewing with Java (no plug-in) or using the QTVR plug-in. Panoramas also offer a lot of promise for the travel industry. For example, Norwegian Cruise Line at *www.destination360.com/qvr.htm* uses panoramas to promote various destinations, as shown in Figure 12.7.

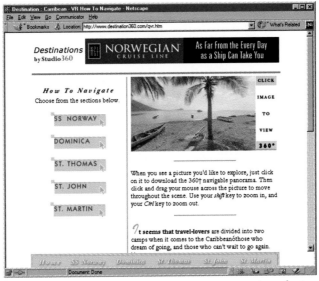

Figure 12.7 Norwegian Cruise Line uses panoramas to promote various destinations.

Many informative Web sites on various world locations now incorporate panoramas as part of virtual tours. For example, the Nova Online Adventure's information on Mount Everest at *www.pbs.org/wgbh/nova/everest/climb/,* as shown in Figure 12.8, includes panoramic views of the route to the Summit.

Figure 12.8 Nova Online Adventure's information on Mount Everest.

The user clicks on the map of the Summit to see a panorama, such as the QTVR view from the Summit, at *www.pbs.org/wgbh/nova/everest/climb/summit.html,* as shown in Figure 12.9.

Figure 12.9 Nova Online Adventure's QTVR view from the Summit.

Another example of an informative Web site using panoramas is the 360 Alaska Web site at *www.360alaska.com.* A sample panorama of Alaska's Seward Harbor is at *www.360alaska.com/index_sound.htm,* as shown in Figure 12.10.

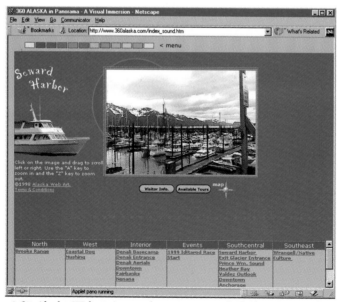

Figure 12.10 The 360 Alaska Web site's sample panorama of Alaska's Seward Harbor.

Panoramas are not the only way to show what a world location or building and other structures look like. You can also use VRML to create virtual worlds of locations as well as other structures. For example, some Web sites have virtual worlds based on real cities. Panet9 Studios at *www.planet9.com/indexnetscape.htm* created virtual worlds of San Francisco and Tokyo, as shown in Figures 12.11, 12.12, and 12.13.

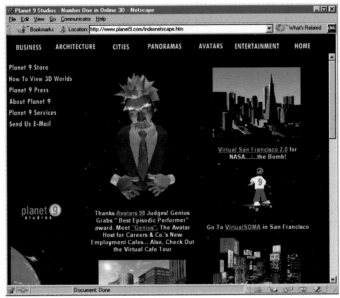

Figure 12.11 Panet9 Studios created virtual worlds of San Francisco and Tokyo.

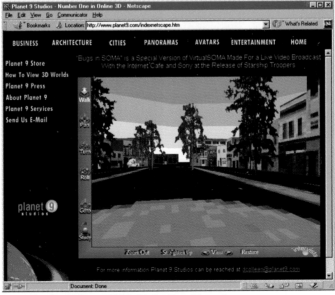

Figure 12.12 Panet9 Studios' VirtualSOMA in San Francisco.

163

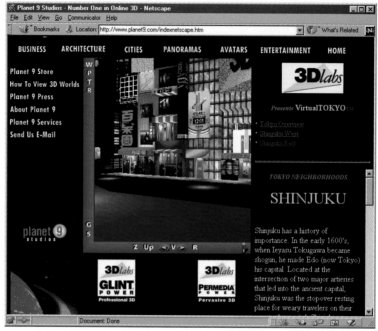

Figure 12.13 *Panet9 Studios' Virtual Tokoyo.*

You can also use VRML to create virtual worlds that do not exist in real life, such as the fantasy virtual world at the Cybertown Web site at *www.cybertown.com*, as shown in Figure 12.14.

Figure 12.14 *The Cybertown Web site at **www.cybertown.com**.*

Other examples of VRML worlds and animations can be seen at Blaxxun Interactive's Web site at *www.blaxxun.de/solutions/showcase/index.html*, as shown in Figure 12.15.

Figure 12.15 Blaxxun Interactive's Web site Solutions Showcase.

VRML is also used to display various 3D structures, such as rooms or tradeshow booths such as the Cybelius booth at *www.cybelius.com/frmStand.htm*, as shown in Figure 12.16.

Figure 12.16 The Cybelius VRML tradeshow booth at *www.cybelius.com/frmStand.htm*.

You can also use VRML to give a three-dimensional view of an object, such as the fossil at the Natural History Museum Web site at *www.nhm.ac.uk/museum/tempexhib/VRML/calymen.html*, as shown in Figure 12.17.

Figure 12.17 A three-dimensional view of a fossil seen at the Natural History Museum Web site.

You can use VR for more than just photographic and 3D images. For example, you can create a panorama of an illustration. A good example of a panoramic illustration is the 100 Acre Panorama at *half-asleep.com/pooh/poohrama/poohrama.html*, as shown in Figure 12.18.

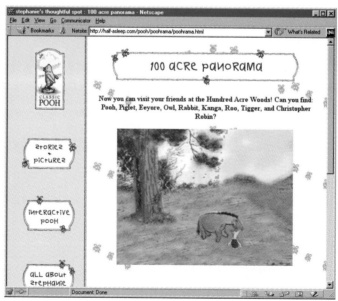

Figure 12.18 The Half Asleep Web site's panorama of an illustration.

The Half Asleep children's Web site gets children interactively involved with the site by having the children find the Winnie the Pooh characters in the panorama.

The first VR technology was VRML. When VRML first originated in November, 1994, VRML was known as 3DML, which stood for 3D mark-up language. However, the name was quickly changed to VRML (Virtual Reality Modeling Language). Although not as popular as other Web technologies, VRML is useful for many types of Web sites, including entertainment, education, computer-aided design, product marketing, virtual malls, and much more. VRML 1.0, the original VRML developed by Silicon Graphics, Inc., lets you simply browse through virtual worlds and click on various objects to access information. A user can freely move about and explore the virtual world. The VRML plug-in lets the user move in different directions, zoom in and zoom out, as well as interact with the 3D world. While the original VRML 1.0 had basic capabilities for working with virtual worlds, the latest VRML 2.0 offers interactivity with objects and their movements, 3D sound, and an object-oriented architecture. In addition, you can use VRML with JavaScript and Java for advanced capabilities. In late 1997, VRML97 became the standard for VRML, replacing VRML 2.0. VRML97 is much like VRML 2.0 with some minor modifications in functionality.

Soon a second type of VR technology, the panoramas, made a debut on Web sites. Panoramas are useful for the same types of Web sites as VRML, as well as real estate and travel. Panoramas differ from VRML in several ways, including the methods Web site designers use in their development and the types of images Web designers use for their creation. VRML requires scripting (or use of a software program to automatically do the scripting for you) and uses only 3D model images to create worlds. You can make panoramas from photographs, illustrations, and 3D images. Creating panoramas requires using specialized software to stitch a series of photos or images together to create one final navigable image. You can add three types of panoramas to Web pages: an object panorama, a full 360 degree panorama, or a partial panorama for a selected area of view. An object panorama lets you view the object from all sides, including top and bottom. A full 360-degree and partial panoramas let you view various locations, such as the inside or outside of a building and landscape scenes.

VR components offer many advantages for Web site designers. For example, panoramas and VRML both make Web sites more interesting and interactive in that the user must move the cursor to view the image. Web VR also provides more detail for objects or places than regular flat photos. In addition, although panoramas require some skills to create, you do not have to get into complex programming to add a VR component to your Web site, as you will soon see. Furthermore, most VR components are generally cross platform-compatible and work with most of the latest browser versions. Web VR is not without some disadvantages. For example, Web VR components generally require a plug-in for viewing. Download time for some Web VR components is lengthy, depending on the file size and the type of technology Web site designers use to make viewing VR possible. Furthermore, as discussed earlier, you must have some skills and be creative to create high quality panoramas. VRML requires some experience working with 3D models and many Web site designers do not have this experience.

ADDING A VRML COMPONENT TO A WEB PAGE

You can easily add a simple VRML component with a few lines of code. First, you must create a WRL file using an ASCII text editor, such as NotePad or one of the many VRML creation software packages on the market. (You will learn more about the specialized software later in this lesson.) You can also download some freeware VRML models and WRL files from various resources on the Internet, including the VRML Repository at *www.web3d.org/vrml/oblib.htm*, the Polygon Free VRML page at *www.zennet.com/pub/misc/vrml/index.html*, and Geometek at *www.geometrek.com/vrml/objects.html*. Unlike programming languages, such as Java, you do not compile a VRML file. VRML is similar to HTML in some ways in that you can simply use an ASCII text editor to create your file (if you know the programming language well enough). The number of lines of code for WRL files vary depending on complexity of the VRML file. For example, the code for a simple cone would only have a few lines and appear as follows:

```
#VRML V1.0 ascii

DEF Root Separator {

    Cone {

            parts   ALL

            bottomRadius    1

            height  3

    }

}
```

To embed the WRL file into your HTML document, you must add an <EMBED> tag similar to the following:

```
<embed src="cone.wrl" width=400 height=250>
```

To see a demonstration of the above VRML file in action, you can view the CONE.HTM file included in the LESSON 12 directory on the CD-ROM that accompanies this book.

Fortunately, you do not need to know the VRML programming language to create a VRML file for your Web page. Many commercial software programs, such as Caligari's TrueSpace, Micrografx Simply 3D, or Silicon Graphics' Internet3D Space Builder, automatically create VRML files for you. You can also download Platinum Technology's VRCreator Learning Edition for free from *www.platinum.com/products/appdev/vream/wirl_dl.htm*. VRCreator Learning Edition, as shown in Figure 12.19, provides all you need to quickly create VRML files without one line of code.

Figure 12.19 *The VRCreator Learning Edition VRML creation software program.*

Now you are ready to add your first VR component to your Web page. In this lesson, you will add a simple VRML file created with Platinum Technology's VRCreator Learning Edition. All the files you need to use for this exercise are in the LESSON12 directory on the companion CD-ROM that accompanies this book. Copy all of these files to a directory on your hard drive. The first step in adding a VRML component to your Web page is to add the code to your HTML file. For the purposes of this lesson, the code to embed the VRML file is provided for you. An example of how that code looks is shown below:

```
#VRML V2.0 utf8

# (Created with VRCreator) VRCreator (R) 1997 PLATINUM technology, inc.  All
rights reserved.

# http://www.platinum.com or 1-800-373-7528

Background {

    skyColor 1 1 1

}

DEF Default Viewpoint { position 0.52875 1 13.66078 orientation 0 1 0 0.149 de-
scription "Default" }
```

169

```
DirectionalLight { direction -0.33104 -0.74485 -0.57932 color 1 1 1 intensity 1 on
TRUE }

DEF cone_48 Transform {

    translation -0.67425 2.01959 5.02752

    rotation 0 1 0 0.149

    scale 1 1 1

    children [

        DEF acone Transform {

            translation 0 0 0

            rotation 0 0 -1 0

            scale 2 2 2

            children [

                Shape {

                    appearance Appearance {

                        material Material {

                            specularColor 1 1 1

                            diffuseColor 0 0.49804 0.49804

                            ambientIntensity 0

                            transparency 0

                            shininess 0.2

                        }

                    }

                    geometry IndexedFaceSet {

                        ccw FALSE

                        creaseAngle 3.14

                        coord Coordinate {
```

point [0 0.5 0,0 0.5 0,0 0.5 0,0 0.5 0,0 0.5 0,0 0.5
0,0 0.5 0,0 0.5 0,0 0.5 0,

0 0.5 0,0 0.5 0,0 0.5 0,0 0.5 0,0 0.5 0,0 0.5
0,0 0.5 0,0.5 -0.5 0,0.46194 -0.5 0.19134,

0.35355 -0.5 0.35355,0.19134 -0.5 0.46194,0
-0.5 0.5,-0.19134 -0.5 0.46194,

-0.35355 -0.5 0.35355,-0.46194 -0.5
0.19134,-0.5 -0.5 0,-0.46194 -0.5 -0.19134,

-0.35355 -0.5 -0.35355,-0.19134 -0.5 -
0.46194,0 -0.5 -0.5,0.19134 -0.5 -0.46194,

0.35355 -0.5 -0.35355,0.46194 -0.5 -
0.19134,0.5 -0.5 0,0.46194 -0.5 0.19134,

0.35355 -0.5 0.35355,0.19134 -0.5 0.46194,0
-0.5 0.5,-0.19134 -0.5 0.46194,

-0.35355 -0.5 0.35355,-0.46194 -0.5
0.19134,-0.5 -0.5 0,-0.46194 -0.5 -0.19134,

-0.35355 -0.5 -0.35355,-0.19134 -0.5 -
0.46194,0 -0.5 -0.5,0.19134 -0.5 -0.46194,

0.35355 -0.5 -0.35355,0.46194 -0.5 -
0.19134,0 -0.5 0,]
}

coordIndex [17,1,0,-1,16,17,0,-1,18,2,1,-1,17,18,1,-
1,19,3,2,-1,18,19,2,-1,20,4,3,-1,

19,20,3,-1,21,5,4,-1,20,21,4,-1,22,6,5,-1,21,22,5,-
1,23,7,6,-1,22,23,6,-1,24,8,7,-1,

23,24,7,-1,25,9,8,-1,24,25,8,-1,26,10,9,-
1,25,26,9,-1,27,11,10,-1,26,27,10,-1,

28,12,11,-1,27,28,11,-1,29,13,12,-1,28,29,12,-
1,30,14,13,-1,29,30,13,-1,31,15,14,-1,

30,31,14,-1,16,0,15,-1,31,16,15,-1,48,33,32,-
1,48,34,33,-1,48,35,34,-1,48,36,35,-1,

48,37,36,-1,48,38,37,-1,48,39,38,-1,48,40,39,-

171

```
1,48,41,40,-1,48,42,41,-1,48,43,42,-1,

                                        48,44,43,-1,48,45,44,-1,48,46,45,-1,48,47,46,-
1,48,32,47,-1, ]

                        }

                    }

                ]

            }

        ]

    }
```

As you can see, the VRML file contains many lines of code. For the purposes of this lesson, you should not concern yourself with the code. If you want to learn the VRML programming language, a good resource is the VRML Repository at *www.web3d.org/vrml/oblib.htm*. The code you will add to the HTML document to embed the VRML file is shown below:

```
<embed src="my-cone.wrl" width=400 height=250>
```

To add the code to your HTML document, perform the following steps:

1. Click your mouse on the Start button. Windows, in turn, will display the Start menu.

2. Within the Start menu, select the Programs option and then choose Windows NotePad from Accessories. Windows, in turn, will open the Windows NotePad ASCII text editor.

3. Select the File menu Open option. Windows NotePad, in turn, will display directories and lists of files.

4. Select the VRML-CODE.TXT file.

5. Click your mouse on the Open button.

6. Select all the code in the VRML-CODE.TXT file.

7. Select the Edit menu Copy option.

8. Select the File menu Open option. Windows NotePad, in turn, will display directories and lists of files.

9. Select the VRML-TEST.HTM file.

10. Click your mouse on the Open button.

11. Select the Edit menu Paste option to paste all the code from the VRML-CODE.TXT file between the <BODY> tags. Windows NotePad, in turn, will display the code, as shown in Figure 12.20.

Figure 12.20 The VRML-TEST.HTM file with the code as it appears in Windows NotePad.

12. Save your file.

13. Open the VRML-TEST.HTM file in Netscape or Internet Explorer. The VRML component should appear, as shown in Figure 12.21.

Figure 12.21 The VRML component as it appears in your browser.

ADDING A PANORAMA TO A WEB PAGE

Adding a panorama to your Web page requires completion of several steps. You will take a series of photographs of an object or scene, digitize the photographs, stitch the photographs together with specialized software, save the file to an appropriate format for Web viewing, and embed the panorama into a Web page. The initial step of taking the actual photographs for the panorama determines the quality of the resulting panorama. You can use a digital camera or a 35 mm camera to take the shots. A camera with a lens wider than 28 mm is best. You will need to take fewer photographs for your panorama with wide views. You should be sure to keep the camera level as you take the shots. Mounting your camera on a tripod, if possible, is a good idea. The next step is to digitize the photographs. You can have your film processed and have the images put on a photo CD or use a scanner to digitize the resulting photos. After you have the series of digitized photos, you are ready to use specialized software to create your panorama. You have several software options to create panoramas. Apple Computer's QuickTime VR (QTVR) is the most popular of software programs available for generating panoramas for the Web. QTVR also offers many advanced features not present in the other available software options, such as embedded sounds, pictures, and 3D animated objects in resulting movies, as well as multiple levels of navigation via hot spots in movies, and more. However, although you can view QTVR movies on both Mac and Windows platforms with Apple's QuickTime plug-in, most of the better QTVR production tools are only Mac-based. For example, Apple's QuickTime VR Authoring Studio for $395 with many advanced features, VR Toolbox's VR PanoWorx for $149, and VR ObjectWorx, also selling for $149, are currently only available for the Mac with the Windows version to be available in the future. Inexpensive software options for creating QTVR movies are available but lack advanced features found on Mac-based QTVR software. Some Windows-based QTVR software options include Enroute Imaging's QuickStitch 360 for $69.95 and VideoBrush Corporation's VideoBrush Panorama for $59.95. A drawback to QTVR is the requirement of the QuickTime plug-in for viewing. Most panoramas need a plug-in that does not take long to download. QTVR requires downloading a 7 MB file to install the plug-in. For users with slower connections, this can take some time. Fortunately, QuickTime comes with Macs and many PC software programs include QuickTime with installation. For more information about QTVR, you can visit their Web site at apple.com/QuickTime/.

While QTVR is very popular for creating panoramas, several other software options exist for panorama creation. For example, Live Picture's PhotoVista for $59.95 is an easy-to-use program to quickly create panoramas. Unlike most of the other formats for panoramas, you do not need a plug-in to view the resulting panorama because PhotoVista exports panoramas in Flashpix format, which are viewable with a Java applet. PhotoVista also lets you create a VRML format file to create hot spots or add elements, such as video, sounds, 3D objects, and animation to the resulting panoramas. For more information about PhotoVista, you can visit LivePicture's Web site at *www.livepicture.com*. Other panorama software options include Infinite Pictures' SmoothMove for $99 (*www.smoothmove.com*), Ulead's Cool360, and Black Diamond's Surround Video for $199 (*www.blackdiamond.com*).

No matter which software option you choose, the panorama creation software will generate an HTML file with the embedded panorama for you. In addition, most panorama creation software will offer streaming content or some type of file compression options.

CREATING A PANORAMA

Now you are ready to create your first panorama. As you have learned, the first step for creating any panorama is to take a series of photographs. For the purposes of this lesson, some image files of a partial panorama to use for this exercise are included in the LESSON12 directory on the CD-ROM that accompanies this book. Copy all of these files to a directory on your hard drive. For this lesson, you will use Live Picture's PhotoVista to create your panorama. If you do not own PhotoVista, you can download a trial copy of PhotoVista at Live Picture's Web site at *www.livepicture.com*. Other panorama creation programs have similar settings to PhotoVista.

To create a panorama with PhotoVista, perform the following steps:

1. Click your mouse on the Start button. Windows, in turn, will display the Start menu.

2. Within the Start menu, select the Programs option and then choose PhotoVista. Windows, in turn, will cascade the PhotoVista sub-menu.

3. Within the PhotoVista sub-menu, click your mouse on the PhotoVista option. Windows, in turn, will open PhotoVista.

4. Click your mouse on the icon picture of three photos on the top left to add your images. PhotoVista, in turn, will display an Open Source Images window, as shown in Figure 12.22, with directories and lists of files. You will import the test image files (image01.bmp, image02.bmp, image03.bmp, image04.bmp, image05.bmp, image06.bmp, and image07.bmp) from the LESSON12 directory on the CD.

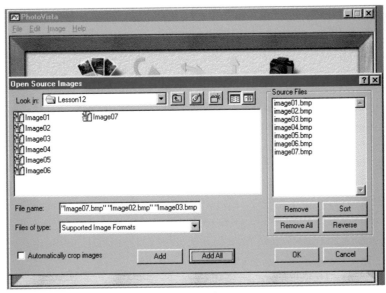

Figure 12.22 PhotoVista's Open Source Images window.

5. Click your mouse on the Add All button to select all the images for importing. PhotoVista, in turn, will add your files to the Source Files list on the right.

6. Click your mouse on the OK button. PhotoVista, in turn, will display the imported images, as shown in Figure 12.23.

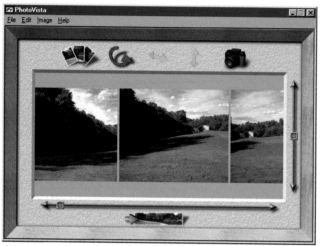

Figure 12.23 The imported images displayed in PhotoVista.

7. Select the icon of a stitched panorama at the bottom of the screen. PhotoVista, in turn, will display a Stitch Options dialog box. Be sure Full 360 Panorama, Disable Warping, and Disable Blending are unchecked.

8. Click on the Full Stitch button at the bottom of the dialog box. (PhotoVista also lets you preview your panorama but for the purposes of this lesson, you will bypass this option).

9. Crop the image in the large rendered preview, as shown in Figure 12.24, to remove the extra top and bottom parts of the image due to the unavailability of a tripod at the time of taking photographs. To crop the images, you simply move the horizontal lines at the top and bottom of the image up or down to remove the uneven edges of the stitched images.

10. Select the Panorama menu Show Panorama option from the large preview image's menu. PhotoVista, in turn, will display the completed panorama.

11. Select the File menu Save As option from the preview panorama's menu. PhotoVista, in turn, will display the Save As dialog box.

12. Select the For Java option from Export to HTML: options at the bottom of the dialog box.

13. Be sure the Web preview is checked. You can leave PhotoVista's default settings as they are for File Name, Save as type, and Remote Path.

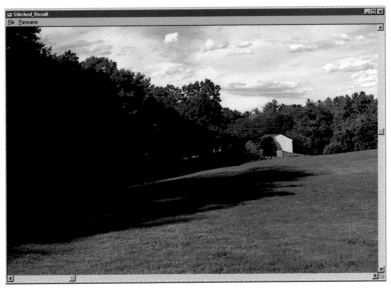

Figure 12.24 PhotoVista lets you crop the large rendered preview image.

14. Click your mouse on the Save button. PhotoVista, in turn, will display a Compression Options dialog box.

15. Select the High-Medium option.

16. Click your mouse on the OK button. You browser, in turn, will display the resulting panorama, as shown in Figure 12.25.

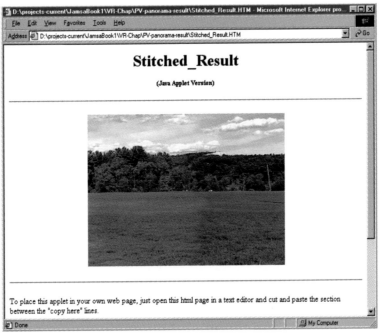

Figure 12.25 The resulting panorama as it appears in your browser.

WHAT YOU MUST KNOW

As you have learned, VR components are easy to add to a Web site and can make an otherwise static Web site more interesting and interactive as well as provide more detail to objects and scenes than photographs. However, before you can add VR components, you should first understand some basic concepts, such as the types of VR components, the various options you can use to create VR components and the advantages and disadvantages of their use. This lesson introduced VR components. In Lesson 13, "Understanding and Working with JavaScript," you will learn how easy it is to add JavaScript to your Web pages. Before you continue with Lesson 13, however, make sure you have learned the following key concepts:

✓ Two types of virtual worlds Web designers can add to Web pages are panoramas and VRML components.

✓ Web designers add virtual reality (VR) components to Web pages for several reasons, including to make Web pages more interesting and interactive, and to display an item in a three-dimensional realistic view.

✓ Some common formats for panoramas include QuickTime VR (QTVR), Live Picture for panoramas created with Live Picture, Inc.'s PhotoVista, VRML2, Black Diamond's Surround Video, and Infinite Pictures' SmoothMove.

✓ VRML is useful uses for many types of Web sites, including entertainment, education, computer-aided design, product marketing, virtual malls, and much more. Panoramas are useful for these same types of Web sites as well as real estate and travel.

✓ VR components offer many advantages to Web site designers. They make Web sites more interesting and interactive, and provide more detail for objects or places than regular flat photos. There is no need of complex programming to add a VR component to your Web site, and generally has cross-platform and cross-browser compatibility. Some disadvantages include requirement of a plug-in for viewing, long download time for some Web VR components, depending on the file size and type, and the needed skills and creativity for quality output.

✓ Many software programs, such as Caligari's TrueSpace, Micrografx Simply 3D, Silicon Graphics' Internet3D Space Builder, and Platinum Technology's VRCreator Learning Edition, automatically create VRML files for you.

✓ Some software options for panorama creation include Apple's QuickTime VR Authoring Studio, Enroute Imaging's QuickStitch 360, VideoBrush Corporation's VideoBrush Panorama, Live Picture's PhotoVista, Infinite Pictures' SmoothMove, Ulead's Cool360 and Black Diamond's Surround Video.

✓ To add VRML, you create a WRL file by writing code yourself or using VRML creator software, adding the appropriate code to your HTML file, and uploading the HTML file and any other files to your server.

✓ To add a panorama to a Web page, you take a series of photographs of an object or scene, digitize the photographs, stitch the photographs together with specialized software, save the file to an appropriate format for Web viewing, and embed the panorama into a Web page.

✓ Adding VRML and panoramas to a Web page is relatively easy, but some knowledge of programming concepts may be required for creating your own VRML file.

LESSON 13

UNDERSTANDING AND WORKING WITH JAVASCRIPT

Sun Microsystems' JavaScript is a popular and simple interpreted programming language that provides control over browsers and Web page content. Many Web designers have been using JavaScript in the past several years to enhance HTML's capabilities and add interactivity to static Web site pages. Current uses of JavaScript involve Dynamic HTML (DHTML) since JavaScript is generally the scripting language of choice for DHTML. JavaScript works together with the other two main technologies of Dynamic HTML, which are HTML and Cascading Style Sheets (CSS), to make Web pages dynamic.

In this lesson, you will learn how to effectively use JavaScript and add the technology to your Web site. By the time you finish this lesson, you will understand the following key concepts:

- JavaScript serves several functions in Web development, which include implementation and control of HTML, advanced browser capabilities, plug-ins, various Web components, as well as server-side applications.

- Many users assume JavaScript is related to Java. However, the two programming languages are not related with the exception of similar names.

- JavaScript is versatile, and you can use JavaScript to create animations, special effects, mouseovers, rotating ads, scrolling text, validated forms, pop-up windows, cookies, and much more.

- JavaScript offers many benefits for Web designers, including versatility of use, no special plug-ins required to view Web pages, no extensive programming experience needed to use JavaScript, shorter download time than ActiveX or Java, cross-platform viewing, general compatibility with Netscape and Internet Explorer browsers, and less of a burden placed on the network servers. Some disadvantages include some incompatibility between browsers and the writing of separate scripts for both browsers.

- To add JavaScript to your Web page, you add the appropriate code to the HTML file, modify other settings, if necessary, and upload the HTML file, along with any scripts and graphics files, to your server, or view in your browser offline.

- Adding JavaScript to a Web page is as simple as adding a few lines of code in many cases. You generally need no special complex settings or plug-ins.

ENHANCING YOUR WEB SITE WITH JAVASCRIPT

JavaScript serves several functions in Web development, including implementation and control of HTML, advanced browser capabilities, plug-ins, various Web components as well as server-side applications. You can make your Web pages interesting and interactive by using JavaScript to control multimedia, VRML, and other browser capabilities. You can also take advantage of Netscape's LiveConnect capability to control Java applets and plug-ins. Server-side applications traditionally were possible only with CGI scripts. (You will learn about CGI in Lesson 14, "Understanding CGI".) Now you can use JavaScript for server-side applications as well. You can embed the JavaScript code for such applications into the HTML document, unlike CGI which requires separate files. Netscape also introduced LiveWire, an add-on that allows communication between the browser and server. LiveWire makes client-side and server-side applications possible with JavaScript. LiveWire Pro uses JavaScript to integrate databases into your Web pages.

Many users assume JavaScript is related to Java. However, the two programming languages are not related, with the exception of similar names and some of JavaScript's syntax being vaguely based on Java. JavaScript is a simple scripting language you can use for controlling Web page browsers and content. Java is a more complex programming language used to develop advanced applications for outside browsers or applets for viewing with browsers only. Java lets you perform more complex tasks, such as networking, but does not control browsers like JavaScript. You can use JavaScript to control Java applets on Web pages for more advanced Web applications.

You can also use JavaScript to add interactivity to your Web site in many ways. For example, instead of having users just click on a button for more information, you can have them access information using pull-down menus. As shown in Figure 13.1, the pull-down menu lets the user select a map of the city to view online at *www.newsmaps.com*.

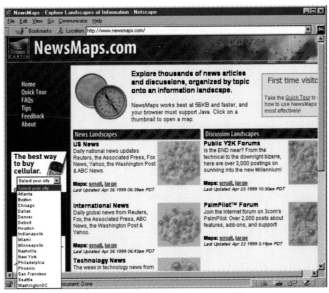

Figure 13.1 The pull-down menu lets the user select a map of the city to view online.

You can also add a pop-up window to display important information, an alert, or even a presentation, such as the Virtual Tour at *www.wd40.com/english/index.asp*, as shown in Figure 13.2.

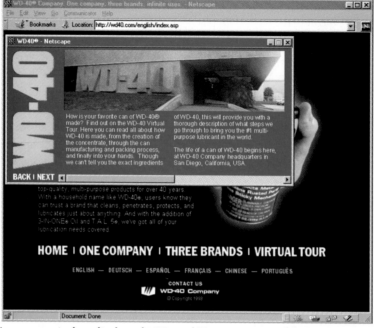

*Figure 13.2 A pop-up window displays the Virtual Tour at **www.wd40.com/english/index.asp**.*

You can have more than just one pop-up window. In fact, you can have several pop-up windows to create an effect, such as the effect at *www.mediaboy.net*, as shown in Figure 13.3.

*Figure 13.3 Several pop up windows create an effect at **www.mediaboy.net**.*

Another common use of JavaScript is for hot spots or mouseovers. Two sites using JavaScript mouseovers include the Balihighway site at *www.balihighway.com/newestmap.html,* as shown in Figure 13.4, and the PetSmart Web site at *www.petsmart.com*, as shown in Figure 13.5.

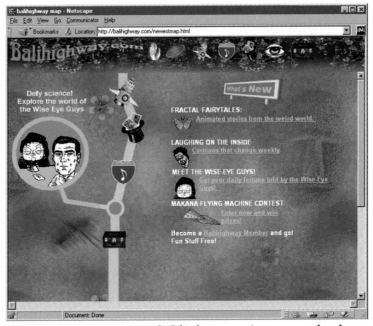

*Figure 13.4 The Balihighway site at **www.balihighway.com/newestmap.html**.*

*Figure 13.5 The PetSmart Web site at **www.petsmart.com**.*

You can also use JavaScript to make background colors change as the user's cursor passes over a button. For example, the colored squares on the left represent the different color options for the background at the Precision Digital Images site at *www.precision-digital.com*, as shown in Figure 13.6.

Figure 13.6 Background colors change as the user's cursor passes over a button representing the different color options.

JavaScript also lets you add messages to the browser's status bar. The message can be a simple scrolling marquee, such as the message at *www.cancergenetics.org*, as shown in Figure 13.7.

*Figure 13.7 A scrolling marquee message displays in the status bar at **www.cancergenetics.org**.*

You can also use JavaScript to have the message display in the status bar as the user's cursor passes over a button, as illustrated at *www.andyart.com*, shown in Figure 13.8.

Figure 13.8 A message displays in the status bar as the user's cursor passes over a button.

Messages can also appear as alert message boxes. As you can see in Figure 13.9, an alert tells the user how long it took to load the page.

Figure 13.9 An alert message telling the user how long it took to load a Web page.

A more complex example of JavaScript is the JavaScript Notebook at *www.bgdconsulting.com/ bgd/home.htm*. As shown in Figure 13.10, the notebook has several tabs for the user to click the mouse to get to other pages of the notebook.

Figure 13.10 the JavaScript Notebook at www.bgdconsulting.com/bgd/home.htm.

185

You can also display a series of images or banner ads in a smaller pop-up window similar to the rotating banner ads at *www.geocities.com/SiliconValley/7116/*, as shown in Figure 13.11.

Figure 13.11 *The rotating banner ads at* **www.geocities.com/SiliconValley/7116/.**

JavaScript can load items from a database. For example, the main image at *www.usf.com* changes to a different page component for attractions from a database each time the site loads, as shown in Figure 13.12.

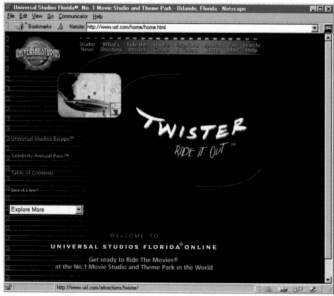

Figure 13.12 *A different page component for attractions appears from a database each time the* **www.usf.com** *Web site loads.*

Another use of JavaScript is for cookies, which are hidden mechanisms sent by the server that retrieve and store various types of client-side user information for future use on a Web site. You can use cookies to store information about a user's navigation throughout a Web site, their preferences for a Web site, user names and passwords, answers to form questions, and much more. You will learn more about cookies in Lesson 16, "Implementing and Using Cookies."

Other uses for JavaScript include controlling plug-ins as well as sound and other forms of multimedia, dragging and dropping items on a Web page, validating form information, setting up password access, performing calculations, setting up frames, and creating more complex items, such as clocks or calendars.

JavaScript offers many benefits for Web designers. For example, you do not need special plug-in software to view a page with JavaScript within your browser. JavaScript requires less complex code than ActiveX or Java. You do not need extensive programming experience to add JavaScript to your Web site pages. JavaScript also generally takes less time to download than ActiveX or Java. In addition, most JavaScript offers cross-platform viewing and is generally compatible with both Netscape and Internet Explorer browsers with a few exceptions. Versatility is yet another advantage of JavaScript. JavaScript also places less of a burden on the network servers to which you upload your files because the code is less complex than Java or ActiveX. However, some disadvantages exist, too. For example, some JavaScript code will work only with Netscape. Furthermore, Microsoft has its own version of JavaScript, called Jscript, which means you may need to include one script for Netscape and another for Internet Explorer if you want certain items to work with both browsers.

How JavaScript Works

JavaScript is an object-based language that requires a compatible browser, such as Netscape or Internet Explorer. JavaScript's code becomes part of the HTML document with use of special tags, known as <SCRIPT> tags. You usually place the <SCRIPT> tags within the <HEAD> tags. By placing the script within the <HEAD> tags, the script will load before the page displays. As you can see in the HTML file below, a few lines of JavaScript indicated by bolded type are within the <HEAD> tags:

```
<HTML>
 <HEAD>
<TITLE></TITLE>
<SCRIPT LANGUAGE="JavaScript">
<!—
function imgchange()
{
```

```
                var si = document.frm.selbox.selectedIndex;

                var fname = document.frm.selbox.options[si].value

                document.img.src = fname

         }
    //—>

    </SCRIPT>

    </HEAD>

    <BODY><FORM name="frm">

    <SELECT NAME="selbox" size=1>

    <OPTION VALUE="image1.gif" height="150" width="200">Image 1

    <OPTION VALUE="image2.gif" height="150" width="200">Image 2

    <OPTION VALUE="image3.gif" height="150" width="200">Image 3

    </SELECT>

    <INPUT type="button" value="View" onClick="imgchange()">

    </FORM>

    <IMG SRC="blank.gif"

    height="150" width="200" NAME="img">

    </center>

    </BODY>

    </HTML>
```

However, depending on the type of script, you could also find the code elsewhere in the HTML document. You should always make sure you include the HTML comment for older browsers, the "<!—" following the beginning <SCRIPT> tag and "//—>" right before the closing <SCRIPT> tag, as demonstrated above. Older browsers that do not support JavaScript will display your JavaScript code as text on your Web page. Fortunately, you can use the HTML comment to make the older browser ignore the code within the <SCRIPT> tags. The JavaScript code above controls a pull-down menu with a choice of three thumbnail images for the user to view. As you can see, some tags include certain commands that refer to the script, such as the onClick command for

188

button to call the imgchange() function of the script. The form element has the name "frm" and the above script references the name. You can open the HTML file called TEST-THUMBNAILS.HTM to see this script in action. You can also substitute your own images for BLANK.GIF, IMAGE1.GIF, IMAGE2.GIF, and IMAGE3.GIF. However, you must be sure to change the height and width attributes for these images.

Many resources for JavaScript code, as well as references and JavaScript tips, are available on the Internet. For example, the Java Goodies site at *www.javagoodies.com*, as shown in Figure 13.13, has many examples of JavaScript code.

Figure 13.13 The Java Goodies site has many examples of JavaScript code.

Some excellent resources to use as a reference and for sample code include Website Abstraction at *www.wsabstract.com*, Web Developer's JavaScript resources at *www.webdeveloper.com/javascript*, The Web Design Resource at *pageresource.com/jscript/index4.htm*, The Script Vault at *www.iw.com/daily/scripts/*, The JavaScript Tip of the Week archive at *www.WebReference.com/javascript/*, The JavaScript Source at *www.Javascriptsource.com*, and WebCoder Scriptorium at *www.webcoder.com/scriptorium/*.

ADDING JAVASCRIPT TO A WEB PAGE

You can now add your first JavaScript code to your Web page. In this lesson, you will add a freeware JavaScript code to create a mouseover effect for three buttons. All the files you need to use for this exercise are in the LESSON13 directory on the CD-ROM that accompanies this book. Copy all of these files to a directory on your hard drive. The first step in adding JavaScript

189

to your Web page is to add the code to your HTML file. For the purposes of this lesson, the JavaScript code is provided for you. An example of how the code looks (indicated in bold) that you will add to your HTML document is shown below:

```
<head>

<meta http-equiv="Content-Type" content="text/html; charset=iso-8859-1">

<title>Javascript Image Changer</title>

<script language="Javascript">

<!— Script by Ricke Stauffer, 1998

// Feel free to use, but please include these two lines

img1 = new Image ()

img1.src = "over1.gif"

img2 = new Image ()

img2.src = "over2.gif"

img3 = new Image ()

img3.src = "over3.gif"

img11 = new Image ()

img11.src = "click1.gif"

img21 = new Image ()

img21.src = "click2.gif"

img31 = new Image ()

img31.src = "click3.gif"

function over(Name,num)

{
```

```
Name.src=eval("img"+num+".src")

}

function out(Name2,num2)

{

Name2.src="pic"+num2+".gif"

}

function act(Name3,num3)

{

Name3.src=eval("img"+num3+".src")

}

// —>

</script>

</head>

<body>

<p><a href="http://www.excite.com/" onMouseOver="over(document.mypic1,1)"

onMouseOut="out(document.mypic1,1)" onClick="act(document.mypic1,11)"><img
src="pic1.gif"

name="mypic1" width="100" height="75" border="0"></a><br>

<a href="http://www.htmlgoodies.com" onMouseOver="over(document.mypic2,2)"

onMouseOut="out(document.mypic2,2)" onClick="act(document.mypic2,21)"><img
src="pic2.gif"

name="mypic2" width="100" height="75" border="0"></a><br>

<a href="http://www.yahoo.com/" onMouseOver="over(document.mypic3,3)"

onMouseOut="out(document.mypic3,3)" onClick="act(document.mypic3,31)"><img
src="pic3.gif"

name="mypic3" width="100" height="75" border="0"></a></p>
```

```
</body>

</html>
```

As you can see, the commands regarding the script (such as onMouseOver, onClick) for the three graphics are already in place in the HTML file, as indicated in italic text. To add the code to your HTML document, perform the following steps:

1. Click your mouse on the Start button. Windows, in turn, will display the Start menu.

2. Within the Start menu, select the Programs option and then choose Windows NotePad from Accessories. Windows, in turn, will open the Windows NotePad ASCII text editor.

3. Select the File menu Open option. Windows NotePad, in turn, will display directories and lists of files.

4. Select the javascript-code.txt file.

5. Click your mouse on the Open button.

6. Select all the code in the javascript-code.txt file.

7. Select the Edit menu Copy option.

8. Select the File menu Open option. Windows NotePad, in turn, will display directories and lists of files.

9. Select the javascript-test.htm file.

10. Click your mouse on the Open button.

11. Position your cursor between the <HEAD> tags right after the <TITLE> tag, then select the Edit menu Paste option to paste all the code from the javascript-code.txt file between the tags. Windows NotePad, in turn, will display the code with the commands regarding the script (such as onMouseOver, onClick) for the three graphics already in place, as shown in Figure 13.14.

12. Save your file.

13. Open the javascript-test.htm file in Netscape or Internet Explorer 4.0 or higher. The images should change as you move your cursor over, or click your mouse on, the images, as shown in Figure 13.15.

```
javascript-test - Notepad
File  Edit  Search  Help

<head>
<meta http-equiv="Content-Type" content="text/html;
charset=iso-8859-1">
<title>Javascript Image Changer</title>
<script language="Javascript">
<!-- Script by Ricke Stauffer, 1998
// Feel free to use, but please include these two lines

img1 = new Image ()
img1.src = "over1.gif"
img2 = new Image ()
img2.src = "over2.gif"
img3 = new Image ()
img3.src = "over3.gif"
img11 = new Image ()
img11.src = "click1.gif"
img21 = new Image ()
img21.src = "click2.gif"
img31 = new Image ()
img31.src = "click3.gif"

function over(Name,num)
{
Name.src=eval("img"+num+".src")
}
function out(Name2,num2)
{
Name2.src="pic"+num2+".gif"
}
function act(Name3,num3)
{
Name3.src=eval("img"+num3+".src")
}
// -->
</script>
</head>

<body>

<p><a href="http://www.excite.com/"
onMouseOver="over(document.mypic1,1)"
onMouseOut="out(document.mypic1,1)"
onClick="act(document.mypic1,11)"><img src="pic1.gif"
name="mypic1" width="100" height="75" border="0"></a><br>
<a href="http://www.htmlgoodies.com"
```

Figure 13.14 The JAVASCRIPT-TEST.HTM file with the code.

```
Javascript Image Changer - Netscape
File  Edit  View  Go  Communicator  Help
  Bookmarks   Location: file:///D|/projects-current/JamsaBook1/JavaScript-Chap/test-js/test-mouseovers.htm

   WILD
   ANIMAL#1

   Click to see a
   prairie dog

   WILD
   ANIMAL#3

                              http://www.htmlgoodies.com
```

Figure 13.15 The JavaScript mouseover effect as it appears in your browser.

193

WHAT YOU MUST KNOW

JavaScript offers versatility that can greatly enhance a Web page and make it interesting. However, before you can start using JavaScript, you should first understand some basic concepts, such as its functions in Web development and the many ways JavaScript can add interactivity and bring life to Web pages. This lesson introduced JavaScript. In Lesson 14, "Understanding CGI," you will find out how CGI scripts can enhance a Web site. Before you continue with Lesson 14, however, make sure you understand the following key concepts:

✓ JavaScript serves several functions in Web development, including implementation and control of HTML, advanced browser capabilities, plug-ins, various Web components, as well as server-side applications.

✓ JavaScript is not related to Java, with the exception of similar names.

✓ JavaScript is versatile. Some of its uses include animations, special effects, mouseovers, rotating ads, scrolling text, validated forms, pop-up windows, cookies, and much more.

✓ JavaScript offers many benefits for Web designers, including versatility of use, no special plug-ins required to view Web pages, no extensive programming experience needed to use JavaScript, shorter download time than ActiveX or Java, cross-platform viewing, general compatibility with browsers, and less of a burden placed on the network servers. Some disadvantages include some incompatibility between browsers and the writing of separate scripts for both browsers.

✓ To add JavaScript to your Web page, you add the appropriate code to the HTML file, modify other settings, if necessary, and upload the HTML file, along with any scripts and graphics files, to your server, or view in your browser offline.

✓ Adding JavaScript to a Web page is as simple as adding a few lines of code in many cases. You generally need no special complex settings or plug-ins.

LESSON 14

UNDERSTANDING CGI

Many Web site designers use CGI scripts, which are one of the original Web programming technologies, to enhance Web sites and make Web pages interactive and dynamic. CGI, which stands for Common Gateway Interface, is not a programming language. CGI is a standardized set of conventions that designate how the server communicates with a Web application, such as a form. A gateway is simply a program that manages requests for information and displays the requested document on the fly. Unlike other Web programming languages, such as DHTML, VRML, or VBScript, CGI programs run on a Web server and then quickly display results in your browser. The results can be items the user cannot normally view on a server, such as database items. You can use C, C++, Java, Visual Basic, and many other programming languages to create CGI programs. However, Perl (Practical Extraction and Report Language) is the most popular language for creating CGI programs because of the abundance of pre-existing code available. (You will learn about Perl in more detail in Lesson 15, "Understanding and Working with Perl.")

In this lesson, you will learn how to effectively use CGI and add a CGI program to your Web site. By the time you finish this lesson, you will understand the following key concepts:

- ◆ CGI, which stands for Common Gateway Interface, is not a programming language. CGI is a standardized set of conventions that designate how the server communicates with a Web application, such as a form.

- ◆ You can use C, C++, Java, Visual Basic, and many other programming languages to create CGI programs, but Perl (Practical Extraction and Report Language) is the most popular language for creating CGI programs because of the abundance of pre-existing code.

- ◆ CGI is versatile and serves several functions in Web development, including implementation and control of various Web components, as well as server-side applications, such as forms and databases.

- ◆ CGI offers several benefits, including no need of a special plug-in software to view, fast download time, cross-platform and browser viewing, and versatility. Some disadvantages include the requirement of extra settings for Unix servers, the possible need for knowledge of programming, difficulties with troubleshooting CGI scripts, possible security risks, some ISPs not allowing the upload of CGI scripts to their servers, and the burden CGI scripts can place on servers.

- ◆ To add a CGI script, you select a CGI script, set up the variables, upload the files, set file permissions, add the appropriate linking information to the HTML file, and upload the HTML file.

- ◆ Adding a CGI script is relatively easy but some special settings and some knowledge of programming concepts may be required.

195

ENHANCING YOUR WEB SITE WITH CGI

CGI is versatile and serves several functions in Web development, including implementation and control of various Web components, such as animation, as well as server-side applications, such as forms and databases. You can use CGI applications to store information about customers and their actions in a database, add current data on a Web page, incorporate search capabilities to Web sites, add a rotating banner, process form information, implement shopping carts, add animation to Web pages, incorporate a message board or a chat room, and much more. However, CGI scripts can place a burden on servers so if you can use another Web technology to perform a task, such as JavaScript, then CGI may not be the best choice. If your goal is to process form information, store retrieved information in a database, or perform other server-side functions, then CGI is a good option.

You can use CGI scripts to make your Web pages interactive and dynamic in many ways. For example, reply forms offer several options for obtaining customer information. As shown in Figure 14.1, the reply form at Azure's Web site at *www.azuremag.com/cgi-bin/webc.exe/form/mailing.html* asks some general questions, such as name, street address, and e-mail address, as well as some marketing questions.

Figure 14.1 Azure's reply form.

You can also use CGI scripts to let users enter a user name or password to access certain areas of a Web site. The script stores the information for future use. For example, the user enters his or her e-mail address as his or her user name and a password for the InsWeb Web site's Customer Profile at *secure1.insweb.com/cgi-bin/pim.exe?page=myinsweb/prfmgmt/signup.htj*, as shown in Figure 14.2.

Figure 14.2 InsWeb Web site's Customer Profile.

The user will then use the user name and password for login to the Web site at *secure1.insweb.com/cgi-bin/pim.exe*, as shown in Figure 14.3.

Figure 14.3 InsWeb Web site's Login page at secure1.insweb.com/cgi-bin/pim.exe.

Another form for creating passwords and user names is found at the When.com Web site's Instant Sign Up at *www.when.com/cgi-bin/gx.cgi/AppLogic+Login*, as shown in Figure 14.4.

Figure 14.4 The When.com Web site's Instant Sign Up.

Another common use for CGI scripts is to add various types of search capabilities to a Web site. For example, you can add a script to let the user search a Web site for key terms and phrases, like Computer Associates/Platinum Technology's Web site at *www.platinum.com/Architext/gsearch.htm*, as shown in Figure 14.5, or the Deadly Viruses Web site at *hyperion.advanced.org/23054/gather/index.shtml*, as shown in Figure 14.6.

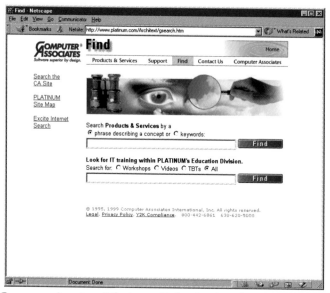

Figure 14.5 The Computer Associates/Platinum Technology's Web site search page.

Figure 14.6 *Deadly Viruses Web site's Search capabilities.*

You can also add a CGI script to let the user search a database for information. For example, the Northern New England Real Estate Network's House Selection Wizard at *www.nnerealestate.com/~imagemap/nhrlest?419,61*, as shown in Figure 14.7, lets the user select the town and price range and then search a database of homes.

Figure 14.7 *The Northern New England Real Estate Network's House Selection Wizard.*

Another example of a CGI search script is Domain Games' Domain Name Search Engine and Manager at *www. domaingames.com*, as shown in Figure 14.8.

Figure 14.8 Domain Games' Domain Name Search Engine and Manager.

Message boards and chat rooms are other common uses for CGI. As shown in Figure 14.9, the CollegeBowl.com Web site at *www.collegebowl.com/indexbbs.html* invites users to post messages to other users in various categories.

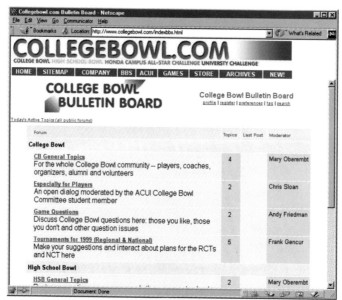

Figure 14.9 CollegeBowl.com Web site's Message Board.

Chat rooms, such as the Oregon Live Web site's Chat Index at *www. oregonlive.com/chat/*, as shown in Figure 14.10, lets users engage in live chats.

Figure 14.10 The Oregon Live Web site's Chat Index at **www. oregonlive.com/chat/**.

CGI scripts are versatile. You can customize scripts for many types of applications besides search engines, message boards, and chat rooms. For example, the online dictionary and thesaurus Web linking lookup reference tool at *www.voycabulary.com* lets the user transform any phrase or Web page into links to dictionary or thesaurus lookups, as shown in Figure 14.11.

Figure 14.11 Web linking lookup reference tool at **www.voycabulary.com**.

A major problem with CGI scripts is that many Internet Service Providers (ISPs) do not allow the upload of CGI scripts to servers. Several reasons exist for ISPs' discontent with CGI scripts.

Security is a major concern since poorly written server-side scripts can pose a risk. Another concern is the burden CGI scripts can place on a server due to poorly written scripts possibly crashing the server or too many users accessing the CGI application. However, many ISPs do realize the importance of using CGI scripts and offer some compromises. For example, many ISPs now offer several scripts that their customers can modify. Furthermore, some ISPs will permit custom CGI scripts if they can inspect the scripts prior to upload.

CGI offers several benefits for Web designers. For example, you do not need special plug-in software to view a page with CGI applications within your browser. CGI scripts also generally take less time to download than ActiveX or Java. In addition, most CGI scripts offer cross-platform viewing and are compatible with most browsers. Versatility is yet another advantage of CGI. However, CGI has several disadvantages too. For example, CGI requires extra settings for Unix servers in order to get the scripts to work. CGI scripts also can get complex and require some knowledge of programming. Troubleshooting CGI scripts can also be difficult at times because there are so many server variables involved. Security can also be an issue for some CGI scripts since poorly written server-side scripts can pose a security risk. Another related drawback is many ISPs do not allow the upload of CGI scripts to their servers due to security and other concerns. Some CGI scripts can also place a burden on servers.

How CGI Works

To add a CGI script, you select a CGI script, set up the variables, upload the files, set file permissions, add the appropriate linking information (such as the correct path for where the CGI script exists on your server) to the HTML file, and upload the HTML file. Unlike JavaScript, you do not embed CGI scripts in the HTML document with the use of <SCRIPT> tags. You generally place your CGI scripts in a special directory on your server known as the cgi-bin directory. A cgi-bin is a special directory identified in a Web server's config files, allowing CGI scripts to run only in certain directories. However, newer servers now allow the execution of any scripts with .CGI extensions. You should upload most CGI scripts to the cgi-bin directory unless instructed otherwise. If you are unsure, you should check with your system administrator. An example of what a simple CGI script would look like is shown below:

```
#!/usr/local/bin/perl

# hello.cgi

print "Content-Type: text/html\n\n";

# Note there is a new line between

# this header and Data
```

```
# Simple HTML code follows

print "<html> <head>\n";

print "<title>Hello, world!</title>";

print "</head>\n";

print "<body>\n";

print "<h1>Hello, world!</h1>\n";

print "</body> </html>\n";
```

The first line of the CGI script is the path to your Perl interpreter. The path to the Perl interpreter can vary, and you also should check with your system administrator to make sure your script has the correct path. Two common paths are *usr/bin/perl* and *usr/local/bin/perl*. You can also type "which perl" or "whereis perl" at a TELNET command prompt and press ENTER to find out where Perl is on your server. As you can see, some lines begin with a # symbol. Any lines beginning with the # symbol are for comments. Command lines will not have the # symbol. To run a CGI script, you add the correct path as a link in your HTML document. For example, a path for the above script could look like the following example:

http://www.**nameofserver**.com/cgi-bin/hello.cgi

In some cases, the path should be what is known as an absolute path. The absolute path is the path to a specific file or directory on the server. Absolute paths vary from server to server. An example of what an absolute path may look like is shown below:

/home/html/**yourloginname**/cgi-bin/hello.cgi

If you do not know the absolute path for a file, you should ask your system administrator.

UPLOADING FILES AND SETTING THE PERMISSIONS

You can use an FTP program like Ipswitch, Inc.'s WS-FTP for Windows available at *www.ipswitch.com* to FTP your files, or another similar FTP program. No matter what program you decide to use, your FTP software should have settings for binary and ASCII transfer. Except for the graphics files, you must be sure to upload all of the project CGI files as ASCII. You should only upload the graphics and most HTML files as binary. After the files are in place, you must set the permissions using the CHMOD command. The CHMOD command is a Unix command that lets you set the access privileges for CGI files so you can execute the files in a browser.

Basically three types of privileges exist for CGI files: Read (using the letter "r" as the symbol), Write (using the letter "w" as the symbol), and eXecute (using the letter "x" as the symbol). You assign privileges with an equal sign (for example, =r or =rw). You can also add with a plus sign (for example, +rw or +rwx) or subtract with a minus sign (for example, -rw or -rx). You can also assign permissions for owner, group, and others with digits ranging from 0 to 7. Each digit represents a different level of permission as shown below:

Number	Permission(s) Granted
0	No Permissions
1	Execute Only
2	Write Only
3	Write and Execute Permissions
4	Read Only
5	Read and Execute Permissions
6	Read and Write Permissions
7	Read, Write, and Execute Permissions

CHMOD 777, for example, means anyone can read, write, and execute the file. Many ISPs will not allow CGI files set for 777 for security reasons. CHMOD 644 means the owner can read and write, while others can only read the file. Another common setting is CHMOD 755, which lets the owner read, write, and execute while anyone else can only read and execute.

DEALING WITH ERROR MESSAGES

Setting up CGI applications is not always easy. You are likely to see several types of errors at one time or another. One common error is the Document Contains No Data error, which is usually due to incorrect permissions setting of files and directories or incorrect path specifications in the scripts. The Internal Server Error is also common and can mean either your server offers no support for CGI or your script is not set up properly. Error 500 can be caused by a number of factors, such as incorrect path for the Perl interpreter, incorrect permissions settings, script syntax errors, missing files, runtime errors in the script, incorrect version of Perl, or server configuration errors. The Access Denied error can also indicate no support for CGI. Server

Error 403 ("File Not Found") errors can mean an incomplete or incorrect URL path. Error 501 ("Cannot POST to non-script area") can mean you must rename a file extension from .PL to .CGI or that your cgi-bin is invalid. "Internal Error: execve() failed" can indicate the path for your Perl interpreter is incorrect.

CGI scripts can get complex and many variables can cause error messages or scripts to not run properly. Therefore, you should be careful with permissions settings, the path you choose for your Perl interpreter, absolute paths, URLs, extra characters in files, and how you FTP the files (binary versus ASCII).

You do not have to write your own CGI scripts. Many resources exist for CGI scripts on the Internet, such as The CGI Resource Index at *www.cgi-resources.com*, FreeCode.com at *www.freecode.com*, Matt's Script Archive at *www.worldwidemart.com/scripts/*, CGI City at *icthus.net/CGI-City/*, CGI-Free at *www.cgi-free.com*, The CGI Directory at *www.cgidir.com*, Dream Catcher's CGI Scripts at *dreamcatchersweb.com/scripts/*, and Freescripts at *www.freescripts.com*.

ADDING A *CGI* FORM TO A WEB PAGE

Now you are ready to set up your first CGI script. In this lesson, you will add a simple reply form using the FormMail.pl CGI script. For more information on FormMail.pl, you can visit *www.worldwidemart.com/scripts/formmail.shtml*. All the files you need to use for this exercise are in the LESSON14 directory on the accompanying CD. Copy all of these files to a directory on your hard drive. The first step in setting up the script is setting up the variables.

To set up the variables for your CGI file, perform the following steps:

1. Click your mouse on the Start button. Windows, in turn, will display the Start menu.
2. Within the Start menu, select the Programs option and then choose Windows NotePad from Accessories. Windows, in turn, will open the Windows NotePad ASCII text editor.
3. Select File menu Open option. Windows NotePad, in turn, will display directories and lists of files.
4. Select the FORMMAIL.PL file.
5. Click Open. Windows NotePad, in turn, will display the script (you may have to set the Edit menu Word Wrap option), as shown in Figure 14.12.

Figure 14.12 *The FormMail.pl CGI file as it appears in Windows NotePad.*

You should first make sure that the file is set for the correct path to your Perl Interpreter. This path is found on the first line of the CGI script and looks similar to: #!/usr/bin/perl. If you are not sure what your path should be, contact your system administrator to ask for the correct path. If this path is not correct, your script will not work. The FormMail.pl CGI file has several variables that must be set correctly. Under the Define Variables section, you need to adjust two settings. The first setting is $mailprog = and defines the location of your sendmail program on your server and you must adjust the path, if necessary, as indicated in bold below:

$mailprog = '/usr/lib/sendmail'

The next setting is @referers= and lets forms be located only on servers which are defined in this field. For this setting, you will have to replace the current URL and IP address with your own URL and IP address, as indicated in bold below:

@referers = ('**worldwidemart.com**','**206.31.72.203**')

You only have to set the above two settings for the actual CGI script and save the file. Next, you need to set up the HTML reply form to work with the CGI script. For this lesson, an HTML reply form for you to modify is included in the LESSON14 directory.

To modify the HTML reply form, perform the following steps:

1. Click your mouse on the Start button. Windows, in turn, will display the Start menu.

2. Within the Start menu, select the Programs option and then choose Windows NotePad from Accessories. Windows, in turn, will open the Windows NotePad ASCII text editor.

3. Select the File menu Open option. Windows NotePad, in turn, will display directories and lists of files.

4. Select the Form-Test.htm file.

5. Click Open. Windows NotePad, in turn, will display the HTML file, as shown in Figure 14.13.

Figure 14.13 The Form-Test.htm file as it appears in Windows NotePad.

You must modify three lines of code to set up the HTML reply form file to work with the FORMMAIL.PL CGI script. The three lines of code to modify are shown below.

```
<FORM ACTION="http://www.yourhost.com/cgi-bin/FormMail.pl"
METHOD="POST">
```

207

```
<INPUT TYPE="HIDDEN" NAME="subject" VALUE="Form Response">

<INPUT TYPE="HIDDEN" NAME="recipient" VALUE="email@yourhostname.net">
```

The areas you must modify are indicated in bold. First, you must adjust the URL in the first line of code with your own URL for where the script will be located (which, for the purposes of this lesson, will be the cgi-bin). Next, you must modify the value for the subject to whatever you want to call your form response. In the third line of code, you must add your e-mail address.

You are now ready to FTP your files to your server. Your FTP software should have settings for binary and ASCII transfer. Except for the graphics files, you must be sure to upload all of the project CGI files as ASCII. You should only upload the graphics and most HTML files as binary. After the files are in place, you must set the permissions using the CHMOD command. If you are not familiar with this command, talk to your system administrator. To upload the files to the proper location on your server, perform the following steps:

1. Connect to your server via FTP using WS-FTP or other FTP software program. (If you are not sure how to do this, ask your system administrator.)
2. Double-click your mouse on your CGI-BIN directory to access it. You should see some files in this directory.
3. Upload FormMail.pl to your CGI-BIN directory (be sure the FTP software's setting for ascii is on).
4. Set the permissions to 755 for FormMail.pl.
5. Upload Form-Test.htm as you normally would to the directory where you keep your other html files.

You are now ready to view your form in your browser. The command to view the form looks similar to the example shown below (replace the bolded text with your domain name):

http://www.**your-domain-name**.com/form-test.htm

The form should appear as shown in Figure 14.14.

After clicking your mouse on the Submit button, the Thank You page should appear with the information you entered and should indicate where the information was sent to your e-mail address, as shown in Figure 14.15.

Figure 14.14 The CGI form as it appears in your browser.

Figure 14.15 The CGI form Thank You page as it appears in your browser.

ADDING A FORM TO A WEB PAGE USING FRONTPAGE 2000

Adding a form to a Web page is easy with FrontPage 2000. However, you must make sure your server has support for FrontPage Server Extensions. (If you are not sure, you can ask your system administrator.) To add a form using FrontPage 2000, perform these steps:

1. Click your mouse on the Start button. Windows, in turn, will display the Start menu.

2. Within the Start menu, select the Programs option and then choose Microsoft FrontPage. Windows, in turn, will open the FrontPage Editor.

3. Click your mouse on the File menu Open Web option. FrontPage, in turn, will display the Open Web dialog box.

4. Enter a Folder name and click your mouse on Open.

5. Select the File menu New option and then select Page from options.

6. Double-click your mouse on the Form Page Wizard icon on the General tab. Microsoft FrontPage, in turn, will display the initial screen of the Form Page Wizard.

7. Click your mouse on the Next button. Microsoft FrontPage, in turn, will display the screen of the Form Page Wizard window for adding form elements.

8. Click your mouse on the Add button. Microsoft FrontPage, in turn, will display the Form Page Wizard's options for type of input to collect, as shown in Figure 14.16.

Figure 14.16 Microsoft FrontPage's Form Page Wizard offers options for type of input to collect.

9. Select Contact Information.

10. Click on the Next button. Microsoft FrontPage, in turn, will display the Form Page Wizard's options for Contact Information.

11. Select the item you want to collect.

12. Click your mouse on the Next button. Microsoft FrontPage, in turn, will display the Form Page Wizard's options for adding more input types. For the purposes of this lesson, you can ignore this.

13. Click your mouse on the Next button. Microsoft FrontPage, in turn, will display the Form Page Wizard's Presentation Options. For the purposes of this lesson, you can keep the default settings.

14. Click your mouse on the Next button. Microsoft FrontPage, in turn, will display the Form Page Wizard's Output Options.

15. Select Save Results To a Web Page for the purposes of this lesson. The Save Results To a Web Page option will save all form responses to any Web page you specify. For the purposes of this lesson, you can keep the default file name (FORMRSLT.HTM).

16. Click your mouse on the Finish button. FrontPage, in turn, will display a form similar to the form shown in Figure 14.17.

Figure 14.17 *The Form Page Wizard resulting form.*

17. Save your file.

18. Select the File menu Publish option and upload your page to your server.

19. Preview your form page in a browser. The form page should appear similar to the form shown in Figure 14.18.

Figure 14.18 The form page as it appears in Netscape.

20. Enter sample data to test your form. The results page should look similar to the results page shown in Figure 14.19.

Figure 14.19 The form page sample results.

What You Must Know

CGI can greatly enhance Web sites as well as make Web pages interactive and dynamic. However, before you start using CGI, you should first understand some basic concepts, such as its functions and uses in Web development, as well as its strengths and weaknesses. This lesson introduced CGI. In Lesson 15, "Understanding and Working with Perl," you will continue working with CGI and learn more about Perl. Before you continue with Lesson 15, however, make sure you understand the following key concepts:

- ✓ CGI (Common Gateway Interface) is not a programming language. CGI is a standardized set of conventions that designate how the server communicates with a Web application.

- ✓ You can use Perl, C, C++, Java, Visual Basic, and many other programming languages to create CGI programs.

- ✓ CGI is versatile and serves several functions in Web development including implementation and control of various Web components, as well as server-side applications, such as forms and databases.

- ✓ CGI offers several benefits, including no need of a special plug-in software to view, fast download time, cross-platform and browser viewing, and versatility. Some disadvantages include the requirement for extra settings for Unix servers, the possible requirement of knowledge of programming, difficulties with troubleshooting CGI scripts, possible security risks, some ISPs not allowing the upload of CGI scripts to their servers, and the burden CGI scripts can place on servers.

- ✓ To add a CGI script, you select a CGI script, set up the variables, upload the files, set file permissions, add the appropriate linking information to the HTML file, and upload the HTML file

- ✓ Adding a CGI script is relatively easy but some special settings and some knowledge of programming concepts may be required.

LESSON 15

UNDERSTANDING AND WORKING WITH PERL

As you learned in Lesson 14, "Understanding CGI," many Web site designers use CGI scripts to enhance Web sites and make Web pages interactive and dynamic. You can use C, C++, Java, Visual Basic, and many other programming languages to create CGI programs. However, Perl (Practical Extraction and Report Language) is the most popular programming language for creating CGI programs because of the available abundance of pre-existing code.

In this lesson, you will learn how to effectively use Perl and add a Perl script to your Web site. By the time you finish this lesson, you will understand the following key concepts:

◆ Perl is a powerful, general purpose, interpreted programming language that has stong string matching capabilities and is used for searching and retrieving information in text files, printing the retrieved information, as well as for many system management applications.

◆ Incorporating Perl scripts into Web sites is easy because many Perl scripts are available for free. Furthermore, the CGI.pm Perl 5 Library and cgi-lib.pl are two free Perl libraries that make the actual writing of Perl scripts easier than some other programming languages.

◆ Perl has many outstanding features, its best features having been acquired from other programming languages, such as C and BASIC. You can use Perl with HTML, XML, and other mark-up languages. Perl incorporates other programming languages. For example, it can call C/C++ applications. Perl supports third-party databases, such as Oracle. Perl lets you develop procedural and object-oriented programming applications.

◆ Using Perl for CGI applications offers many advantages, including the availability of free Perl scripts, the two free Perl libraries that make the writing of Perl scripts easier than some other programming languages, Perl requiring less code than C/C++ applications, and Perl's power, versatility, and platform compatibility.

◆ To add a Perl CGI script, you select a CGI script, set up the variables, upload the files, set file permissions, add the appropriate linking information to the HTML file, and upload the HTML file.

◆ Adding a Perl CGI script to your Web site is relatively easy but some special settings and some knowledge of programming concepts may be required.

ENHANCING YOUR WEB SITE WITH PERL

Perl, the most popular programming language for CGI, is a powerful, general purpose, interpreted programming language that has strong string matching capabilities and is used for searching and retrieving information in text files, printing the retrieved information, as well as for many system management applications. Although Perl was originally developed for Unix platforms, you can use Perl on just about any platform now, including Macs and PCs. Incorporating Perl scripts into Web sites is easy because many Perl scripts are available for free. Furthermore, the CGI.pm Perl 5 Library and cgi-lib.pl are two free Perl libraries of pre-existing code that make the actual writing of Perl scripts easier than some other programming languages.

Perl has a long history, spanning over a decade of advancements. In 1987, Larry Wall released the first version of the Perl language, Perl 1.0, to the usenet group comp.sources. A few years later, versions for other platforms became available. In 1996, a group of users established the first nonprofit group, the Perl Institute. In recent years, many Perl publications, user groups, and conferences started to emerge. Perl 5 is now the latest version available.

Perl has many outstanding features. For example, Perl has acquired its best features from other programming languages, such as C and BASIC. You can use Perl with HTML, XML, and other mark-up languages. Perl incorporates other programming languages. For example, Perl can call C/C++ applications. In the future, Perl should interface with Java in a similar way. Another capability is Perl's support of third-party databases, such as Oracle. Perl also lets you develop procedural and object-oriented programming applications. In addition, Perl is a good choice for Web programming for several reasons. Perl's CGI.pm module lets you easily create Web forms for your Web pages. Perl is also a good choice for secure transactions, as demonstrated in the shopping cart at Amazon.com at *www.amazon.com*, as shown in Figure 15.1.

*Figure 15.1 Amazon.com's shopping cart at **www.amazon.com**.*

215

Amazon.com also uses Perl for other applications at their Web site, such as for online search capabilities.

Using Perl for CGI applications offers many advantages for Web designers. For example, many resources offer Perl scripts for free. You can download free Perl scripts on the Internet for incorporating into your Web sites. The two free Perl libraries (CGI.pm Perl 5 Library and cgi-lib.pl) of pre-existing code also make the actual writing of Perl scripts easier than other programming languages, such as C/C++. In addition, Perl also requires less code than C/C++ applications. Perl offers power and versatility. For example, Perl can call C/C++ modules. Furthermore, you do not have to worry about platform compatibility because Perl is compatible with most platforms.

Many excellent resources exist to learn more about Perl scripting, such as the Perl Language Page at *www.perl.com*, as shown in Figure 15.2.

Figure 15.2 The Perl Language Page at www.perl.com.

Another resource to learn about Perl scripting is the Perl Mongers/Perl Institute at *www.perl.org*, as shown in Figure 15.3.

The Perl Institute no longer exists. However, the new Perl Mongers group maintains the Web site with new information about Perl. Two other informative Perl resources include CPAN: Comprehensive Perl Archive Network at *www.cpan.org* and Effective Perl Programming at *www.effectiveperl.com*. The Perl Clinic at *www.perlclinic.com* is also available for Perl troubleshooting issues.

Figure 15.3 *The Perl Mongers/Perl Institute at* **www.perl.org**.

As discussed earlier in this lesson, you do not have to write your own Perl scripts. Many resources exist for free Perl scripts on the Internet, such as The CGI Resource Index at *www.cgi-resources.com*, FreeCode.com at *www.freecode.com*, Matt's Script Archive at *www.worldwidemart.com/scripts/*, CGI City at *icthus.net/CGI-City/*, CGI-Free at *www.cgi-free.com*, The CGI Directory at *www.cgidir.com*, Dream Catcher's CGI Scripts at *dreamcatchersweb.com/scripts/*, and Freescripts at *www.freescripts.com*.

ADDING A PERL FORM TO A WEB PAGE FOR STORING CUSTOMER INFORMATION

As you do for any CGI script, to add a Perl CGI script, you will select a CGI script, set up the variables, upload the files, set file permissions, add the appropriate linking information (such as the correct path for where the CGI script exists on your server) to the HTML file, and upload the HTML file.

Now you are ready to set up your Web form Perl CGI script for storing customer information. In this lesson, you will add a more complex reply form using a modified version of FormMail.pl Perl CGI script from Lesson 14, called yForm.cgi, to store customer information. For more information on yForm.cgi, you can visit *www.fyi.net/~abass/domino/misc.htm*. All the files you need to use for this excercise are in the LESSONS directory on the CD-ROM that accompanies the book. Copy all of these files to a directory on your hard drive. The first step in setting up the script is setting up the variables.

To set up the variables for your CGI file, perform the following steps:

1. Click your mouse on the Start button. Windows, in turn, will display the Start menu.

2. Within the Start menu, select the Programs option and then choose Windows NotePad from Accessories. Windows, in turn, will open the Windows NotePad ASCII text editor.

3. Select the File menu Open option. Windows NotePad, in turn, will display directories and lists of files.

4. Select the YFORM.CGI file.

5. Click your mouse on Open. Windows NotePad, in turn, will display a script, as shown in Figure 15.4.

Figure 15.4 The Yform.cgi Perl CGI file as it appears in Windows NotePad.

As with the FormMail.pl CGI file discussed in Lesson 14, you should first make sure that the file is set for the correct path to your Perl Interpreter. You find the path on the first line of the CGI script which looks similar to: #!/usr/bin/perl. If you are not sure what your path should be, contact your system administrator to ask for the correct path. If this path is not correct, your script will not work. The Yform.cgi Perl CGI file has the same variables as Lesson 14's FormMail.pl CGI file that you must set correctly. Under the Define Variables section, you need to adjust two settings. The first setting is $mailprog = and defines the location of your sendmail program on your server. You must adjust the path, if necessary, as indicated in bold below:

$mailprog = '/usr/lib/sendmail'

If you are not sure what your path should be, contact your system administrator to ask for the correct path. The next setting is @referers= and allows forms to be located only on servers which are defined in this field. For this setting, you will have to replace the current URL and IP address with your own URL and IP address, as indicated in bold below:

@referers = ('**worldwidemart.com**','**206.31.72.203**')

You only have to set the above two settings for the actual CGI script and save the file. Next, you need to modify Lesson 14's HTML reply form to work with the CGI script. For this lesson, an HTML reply form for you to modify is included in the LESSON15 directory.

To modify the HTML reply form, perform the following steps:

1. Click your mouse on the Start button. Windows, in turn, will display the Start menu.

2. Within the Start menu, select the Programs option and then choose Windows NotePad from Accessories. Windows, in turn, will open the Windows NotePad ASCII text editor.

3. Select the File menu Open option. Windows NotePad, in turn, will display directories and lists of files.

4. Select the Yform-Test.htm file.

5. Click Open. Windows NotePad, in turn, will display the HTML file, as shown in Figure 15.5.

Figure 15.5 The Yform-Test.htm file as it appears in Windows NotePad.

As shown in Figure 15.5, several new lines have been added to the updated reply form from Lesson 14. You need to modify several lines of code to set up the HTML reply form file to work with the YFORM.CGI Perl CGI script. The several lines of code to modify are shown below.

```
<FORM ACTION="http://www.yourhost.com/cgi-bin/Yform.cgi"
METHOD="POST">

<INPUT TYPE="hidden" NAME="required" VALUE="required-contact,required-
address1,required-city,required-state,required-zip,required-comments">

<INPUT TYPE="hidden" NAME="sort"

 VALUE="order:required-contact,company,required-address1,address2,required-
city,required-state,required-zip,country,required-comments">

<INPUT TYPE="hidden" NAME="mail_recipient" VALUE="
email@yourhostname.net ">

<INPUT TYPE="hidden" NAME="mail_subject" VALUE="Email YFORM Response">

<INPUT TYPE="hidden" NAME="mail_top"

 VALUE="This text prints above the field list.">

<INPUT TYPE="hidden" NAME="mail_listfields" VALUE="value">

<INPUT TYPE="hidden" NAME="mail_bottom"

 VALUE="This text prints below the field list.">

<INPUT TYPE="hidden" NAME="data_filename" VALUE="formdata/formdata.txt">

<INPUT TYPE="hidden" NAME="data_fields_to_log"

VALUE="required-contact,company,required-address1,required-city,required-
state,required-zip,required-state">

<INPUT TYPE="hidden" NAME="data_env_to_log"
VALUE="HTTP_USER_AGENT">

<INPUT TYPE="hidden" NAME="data_delimiter" VALUE="|"><INPUT
TYPE="hidden"

   NAME="data_listvertical" VALUE="">
```

These lines of code refer to settings for action of the form, where the form data will be sent, and the data file to collect the data. For more information on these settings and other available settings for the script, you can view the Yform.txt file included in the LESSON15 directory on the CD-ROM that accompanies this book. The areas you must modify are indicated in bold. First, you must adjust the URL in the first line of code to your own URL for where the script will be located (which, for the purposes of this lesson, will be the cgi-bin). Next, you must add your e-mail address.

You are now ready to FTP your files to your server. As you learned in Lesson 14, your FTP software should have settings for binary and ASCII transfer. Except for the graphics files, you must be sure to upload all the project CGI files as ASCII. You should only upload the graphics and most HTML files as binary. After the files are in place, you must set the permissions using the CHMOD command. If you are not familiar with this command, talk to your system administrator. To upload the files to the proper location on your server, perform the following steps:

1. Connect to your server via FTP using WS-FTP or other FTP software program. (If you are not sure how to do this, ask your system administrator.)

2. Upload Yform-Test.htm as you normally would to the directory where you keep your other HTML files.

3. Double-click your mouse on your CGI-BIN directory to access it. You should see some files in this directory.

4. Upload Yform.cgi to your CGI-BIN directory (be sure the FTP software's setting for ASCII is on for this file).

5. Set the permissions to 755 for Yform.cgi.

6. Create a subdirectory in the CGI-BIN called FormData.

7. Double-click your mouse on your new FORMDATA subdirectory to access it.

8. Upload FormData.txt to your FormData subdirectory (be sure the FTP software's setting for ASCII is on).

9. Set the permissions to 666 for FormData.txt.

You are now ready to view your form in your browser. The command to view the form looks similar to the example shown below (replace the bolded text with your domain name):

http://www.**your-domain-name**.com/yform-test.htm

The form appears as shown in Figure 15.6.

Figure 15.6 *The Perl CGI form as your browser should display.*

After clicking your mouse on the Submit button, the Thank You page should appear with the information you entered and should indicate where the information was sent to your e-mail address. After you enter more fictitious form data, you can view the updated text file that stores the form data on your server. You can access your FormData.txt file now located in the FormData subdirectory of your CGI-BIN using FTP software. You should see results similar to the data shown in Figure 15.7.

Figure 15.7 *The FormData.txt file containing form response data.*

WHAT YOU MUST KNOW

Perl can greatly enhance Web sites as well as make Web pages interactive and dynamic. However, before you can start using Perl, you should first understand some basic concepts, such as its features and uses in Web development as well as its strengths. This lesson introduced Perl. In Lesson 16, "Implementing and Using Cookies," you will discover the many ways you can use cookies for your Web site. Before you continue with Lesson 16, however, make sure you have learned the following key concepts:

✓ Perl is a powerful, general purpose, interpreted programming language that has strong string matching capabilities and is used for searching and retrieving information in text files, printing the retrieved information, as well as for many system management applications.

✓ Incorporating Perl scripts into Web sites is easy because many Perl scripts are available for free. Furthermore, the CGI.pm Perl 5 Library and cgi-lib.pl are two free Perl libraries that make the actual writing of Perl scripts easier than some other programming languages.

✓ Perl has many outstanding features; its best features having been acquired from other programming languages, such as C and BASIC. You can use Perl with HTML, XML, and other mark-up languages. Perl incorporates other programming languages. For example, it can call C/C++ applications. Perl supports third-party databases, such as Oracle. Perl lets you develop procedural and object-oriented programming applications.

✓ Using Perl for CGI applications offers many advantages, including the availability of free Perl scripts, the ease of writing of Perl scripts, Perl requiring less code than C/C++ applications, and its power, versatility, and platform compatibility.

✓ To add a Perl CGI script, you select a CGI script, set up the variables, upload the files, set file permissions, add the appropriate linking information to the HTML file, and upload the HTML file.

✓ Adding a Perl CGI script to your Web site is relatively easy but some special settings and some knowledge of programming concepts may be required.

LESSON 16

IMPLEMENTING AND USING COOKIES

Many Web designers now take advantage of cookies to enhance and make their Web sites more effective and efficient. A cookie is a standard mechanism by which server-side applications (such as CGI scripts) and client-side scripts (such as JavaScript or VBScript) store small bits of information on a user's system as a text file for later use. A cookie can retrieve information from a reply form or work invisibly in the background retrieving useful information about the user.

In this lesson, you will learn how to add a cookie to your site. By the time you finish this lesson, you will understand the following key concepts:

◆ Cookies serve several functions on Web pages, such as storing various types of information, personalizing Web sites, tracking Web site navigation, storing information about what products users purchase, retrieving information for target marketing, and much more.

◆ Cookies can display information or work invisibly behind the scene.

◆ A cookie can capture only two types of information: information supplied by filling out a form, and system and user information captured as users visit a Web site.

◆ Cookies offer many advantages, including ease of implementation, no need of a special plug-in, cross-platform and cross-browser compatibility, retrieval of valuable system and marketing information, and development of more efficient and personalized Web sites. The disadvantages of cookies include users who view cookies as an invasion of privacy or a security risk, browsers that are set to not accept cookies, users deleting their cookie files, use of cookie management software, new technologies without storage devices to store cookies, and users who use more than one computer system.

◆ Browsers set limitations for cookies, such as, a server or domain can have only 20 cookies in a cookie text file and the cookie text file itself can only contain 300 cookies.

◆ Cookies have the reputation of being a security risk. However, since browsers set the rules for cookies, cookies are actually secure. Cookies can not capture e-mail mail addresses unless supplied by reply form, and they cannot access top secret documents or modify files on hard drives.

- To add a cookie, you select a script, add the appropriate code to your HTML file, and upload the HTML file and any other files to your server.

- Adding a cookie to a Web page is relatively easy but some special settings and some knowledge of programming concepts may be required, depending on the type of script you select.

ENHANCING YOUR SITE WITH COOKIES

Cookies serve several functions on Web pages, including storing various types of information, personalizing Web sites, tracking Web site navigation, storing information about what products users purchase, retrieving information for target marketing, and much more. Storing such items as passwords, user names, and site preferences make the user's visit more enjoyable. Cookies can also provide good tracking information by tracking where users go when they visit your site. You can see what attracts users to your site. Obtaining information about what products users purchase can lead to sales of other similar products.

You can use cookies in many ways to enhance your Web sites. For example, you can add a cookie to personalize a Web site for a user. Personalizing a Web page can be a simple Welcome message with the user's name obtained from the user filling out a form, as shown in Figures 16.1 and 16.2, or taking a quiz, as shown in Figure 16.3.

Figure 16.1 A user enters his or her name in a form box to be used by a cookie for a Welcome message.

225

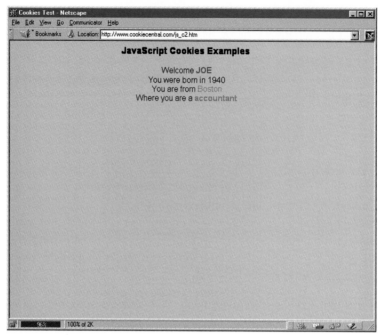

Figure 16.2 *A sample Web page displaying a personalized Welcome message with the user's name obtained from the user filling out a form.*

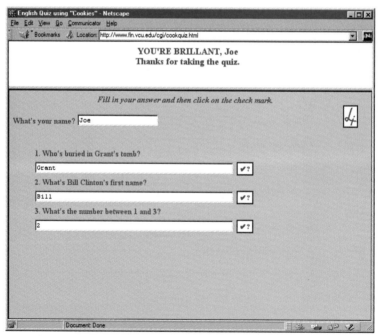

Figure 16.3 *A sample Web page displaying a personalized message after the user takes a quiz.*

A cookie can also track the number of times a user visits a Web site. For example, the actual count of visits can appear within the text on the page, as shown in Figure 16.4, or as a pop-up alert box, as shown in Figure 16.5.

Figure 16.4 *The number of a user's visits to a Web page can appear within the actual text.*

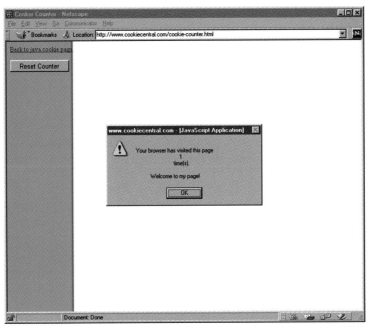

Figure 16.5 *A pop-up alert box can also display the number of user's visits to a Web page.*

227

You can also add a cookie that determines the date of a user's last visit to alert the user to new information since his or her last visit, as demonstrated in Figure 16.6.

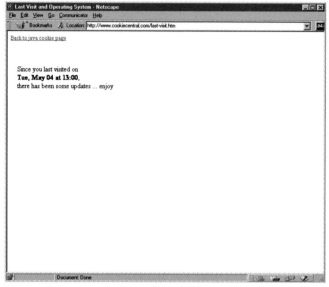

Figure 16.6 A cookie can determine the date of a user's last visit.

You can also personalize your site for users in many other ways with cookies. For example, cookies can store information about site preferences, such as a preference for frames or no frames. You might also add a cookie to a Web site that controls what a user sees or does not see at your Web site. For example, after a user visits a site, the next visit will bypass the initial introductory Web pages and display some new information instead. You can have users select an option to not view certain types of information at a Web site. For example, a cookie could prevent the display of any information about politics at a site for a user if the user selects that for an option. Cookies can also personalize Web sites by displaying certain banner ads of interest to a user. For example, if a user navigates to a certain Web page or fills out a form about his or her interests, a cookie can control what banner ads they see. Cookies can also store user names and passwords so the user does not have to enter the same information each time he or she visits a site. The Ziff Davis University Web site shows an example of using cookies to store access information. When a user returns to the site, a personalized Welcome greeting displays, as shown in Figure 16.7.

Search engines also take advantage of cookies. Infoseek retrieves information about a user's searches and analyzes it to provide more efficient searches in the future. Another example of search engines using cookies is Lycos. Lycos uses cookies to capture information on a user's searches for better targeting of the search engine's banner ads.

Cookies also play an important role in e-commerce and marketing. For example, in e-commerce, when a user adds products to an online shopping cart and then decides to leave before purchasing the items, the shopping cart information would be lost without cookies. A cookie can store shopping cart information for the next time that the user returns to the Web site. You can also use cookies to retrieve information about a user's purchases online. By knowing what products are of

interest to a user, a company could possibly sell similar products to the user. For example, if a user purchases books about Java programming from an online bookstore, such as Amazon.com, then Amazon.com could display special offers on other books on the topic when the user returns to the Web site. Targeted marketing is another use for cookies. For example, you can control the number of times a user sees the same advertisements. Some large online advertising networks, such as DoubleClick at *www.doubleclick.com*, as shown in Figure 16.8, uses cookies to create profiles on users regarding their travels at their Web site or their advertisers' Web sites. DoubleClick uses the user profiles to display banner ads that match the users' interests.

Figure 16.7 *A personalized Welcome greeting.*

Figure 16.8 *DoubleClick at* ***www.doubleclick.com*** *uses cookies to create profiles.*

Another use of cookies is to collect information about the user's browser, system, plug-ins, and much more. You can use BrowserSpy, which is an online JavaScript utility at *www.gemal.dk/browserspy/*, as shown in Figure 16.9, to get an idea of what kind of information a cookie can retrieve.

*Figure 16.9 BrowserSpy is an online JavaScript utility at **www.gemal.dk/browserspy/**.*

As shown in Figure 16.10, you simply select a BrowserSpy category to spy on and BrowserSpy, in turn, will display information, such as a user's basic system information, as shown in Figure 16.11, or a list of the user's plug-ins, as shown in Figure 16.12.

230 *Figure 16.10 The BrowserSpy utility lets you select a category to spy on.*

Figure 16.11 A sample of BrowserSpy utility results for a user's basic system information.

Figure 16.12 A sample of BrowserSpy utility results for a list of the user's plug-ins.

CNET's Download.com Web site at *www.download.com*, as shown in Figure 16.13, illustrates how knowing some information about a user's system can make the user's search for software online more efficient.

Figure 16.13 *A cookie determines the user's platform and a PC user sees the PC Downloadables page.*

A cookie retrieves information about the user's platform. The cookie then sends the user to a Web page with downloadable software for his or her platform only.

You can find cookies everywhere on Web sites. You can see some cookies, such as welcome messages, displays of system information, and other similar items. However, the most powerful cookies are the cookies working behind the scenes making the user's visit to your site more pleasurable and productive. To find out where the hidden cookies are on Web sites, you can change your browser settings to warn before accepting cookies. For example, in Netscape 4.0 and above, you can find the setting to warn before accepting cookies in the Preferences' Advanced settings. As you travel to different Web site pages, your browser will display warnings about cookies that look similar to the warnings shown in Figures 16.14 and 16.15. As your browser displays the warnings, you can get an idea of how cookies are at work behind the scenes.

Figure 16.14 A common sample warning before accepting cookies.

Figure 16.15 Another sample warning before accepting cookies.

All cookies work in a similar manner. The user visits a Web site that uses a CGI script, JavaScript, or other programming script set up to capture user information. As the script sends the cookie from the server to the browser, the script adds a new line to a text file (cookie.txt) that resides on the user's system. As shown in Figure 16.16, the cookie text file appears as a long list of items.

Figure 16.16 A sample cookie text file.

An individual cookie can only be 4 kilobytes or less in size and appears similar to the cookie shown below:

.switchboard.com TRUE / FALSE 933057554 SEARCHMODE
Standard

As you can see, the cookie contains information about a type of search that a user performed at *www.switchboard.com*. Cookies can have six parameters, including its name, value, expiration date, URL path the cookie is for, domain name of the site that sent the cookie, and secure setting. However, only the name and value parameters are a requirement for all cookies. Browsers never release cookie information to other servers. The cookie information sent by the server is for that server only.

Each server or domain has a limit of only 20 cookies that can be part of the cookie text file. The cookie text file itself can only contain 300 cookies. When the 300 cookie limit approaches, the browser removes cookies that are not used much.

Cookies have a reputation for being a security risk. However, since browsers set the rules for cookies, cookies are actually secure. A cookie can only capture two types of information. The first is information you supply when you fill out a form. Cookies can capture information about your system but this information is readily available as you visit Web sites. Some users think cookies can acquire their e-mail mail addresses, access top secret documents, or modify

files on hard drives, but cookies cannot perform such tasks. The only way a cookie can acquire information, such as e-mail addresses, is if the user enters this information into a reply form. You should, of course, never store sensitive information, such as your social security number or credit card numbers.

Cookies offer many advantages. For example, a cookie is easy to add to a Web page. Generally, all you must add is a few lines of JavaScript for cookies. You usually do not need to know any complex programming language to do so, as you will learn later in this lesson. In addition, you do not need a special plug-in to use cookies on a Web page. Most cookies are cross-platform and cross-browser compatible. Cookies also make a user's visit to a Web site more efficient and personalized. You can also obtain valuable system information or marketing information about the user from using cookies. Despite their many advantages, cookies also have some disadvantages. For example, many users think cookies are an invasion of privacy or a security risk. Therefore, you should state your policy regarding cookies. Browsers also include settings so users can choose not to accept cookies, leaving your cookie useless. Some users have cookie management software, such as The Cookie Web Kit, Cookie Pal, or Cookie Crusher. Users can also delete cookie files themselves from their systems. Furthermore, certain new technologies, such as WebTV, do not have storage devices and cannot accept cookies. Another disadvantage is obtaining false marketing information since some users use more than one computer to browse the Internet.

You can find many references and resources for cookies on the Internet. For example, the Cookies Central site at *www.cookiecentral.com*, as shown in Figure 16.17, has a lot of information about cookies as well as sample JavaScript and CGI code.

*Figure 16.17 The Cookies Central site at **www.cookiecentral.com**.*

Other cookie resources include the WebCoder Scriptorium at *www.webcoder.com/scriptorium/*, *www.freecode.com*, and *webreference.com*, Matt's Script Archive at *www.worldwidemart.com/scripts/* , and the JavaScript Source at *javascript.internet.com/cookies/*.

ADDING A COOKIE TO A WEB PAGE

Now you are ready to add your first cookie to your Web page. In this lesson, you will add a simple freeware cookie that will display a user's name and how many times the user has visited the Web site. For more information on the script and other scripts, refer to the JavaScript Source at *javascript.internet.com*. All the files you need to use for this exercise are in the LESSON16 directory on the companion CD-ROM. Copy all of these files to a directory on your hard drive. The first step in adding a cookie to your Web page is to add the code to your HTML file. For the purposes of this lesson, the code to embed the cookie is provided for you. An example of how the code looks that you will add to your HTML document between the <HEAD> tags is shown below:

```
<SCRIPT LANGUAGE="JavaScript">

<!— Original: Mattias Sjoberg

<!— This script and many more are available free online at —>

<!— The JavaScript Source!! http://javascript.internet.com —>

<!— Begin

var expDays = 30;

var exp = new Date();

exp.setTime(exp.getTime() + (expDays*24*60*60*1000));

function Who(info){

var VisitorName = GetCookie('VisitorName')

if (VisitorName == null) {

VisitorName = prompt("Who are you?");

SetCookie ('VisitorName', VisitorName, exp);

}
```

```
return VisitorName;

}

function When(info){

var rightNow = new Date()

var WWHTime = 0;

WWHTime = GetCookie('WWhenH')

WWHTime = WWHTime * 1

var lastHereFormatting = new Date(WWHTime);

var intLastVisit = (lastHereFormatting.getYear() * 10000)+(lastHereFormatting.getMonth()
* 100) + lastHereFormatting.getDate()

var lastHereInDateFormat = "" + lastHereFormatting;

var dayOfWeek = lastHereInDateFormat.substring(0,3)

var dateMonth = lastHereInDateFormat.substring(4,11)

var timeOfDay = lastHereInDateFormat.substring(11,16)

var year = lastHereInDateFormat.substring(23,25)

var WWHText = dayOfWeek + ", " + dateMonth + " at " + timeOfDay

SetCookie ("WWhenH", rightNow.getTime(), exp)

return WWHText

}

function Count(info){

var WWHCount = GetCookie('WWHCount')

if (WWHCount == null) {

WWHCount = 0;

}

else{

WWHCount++;
```

```
}

SetCookie ('WWHCount', WWHCount, exp);

return WWHCount;

}

function set(){

VisitorName = prompt("Who are you?");

SetCookie ('VisitorName', VisitorName, exp);

SetCookie ('WWHCount', 0, exp);

SetCookie ('WWhenH', 0, exp);

}

function getCookieVal (offset) {

var endstr = document.cookie.indexOf (";", offset);

if (endstr == -1)

endstr = document.cookie.length;

return unescape(document.cookie.substring(offset, endstr));

}

function GetCookie (name) {

var arg = name + "=";

var alen = arg.length;

var clen = document.cookie.length;

var i = 0;

while (i < clen) {

var j = i + alen;

if (document.cookie.substring(i, j) == arg)

return getCookieVal (j);

i = document.cookie.indexOf(" ", i) + 1;
```

```
if (i == 0) break;

}

return null;

}

function SetCookie (name, value) {

var argv = SetCookie.arguments;

var argc = SetCookie.arguments.length;

var expires = (argc > 2) ? argv[2] : null;

var path = (argc > 3) ? argv[3] : null;

var domain = (argc > 4) ? argv[4] : null;

var secure = (argc > 5) ? argv[5] : false;

document.cookie = name + "=" + escape (value) +

((expires == null) ? "" : ("; expires=" + expires.toGMTString())) +

((path == null) ? "" : ("; path=" + path)) +

((domain == null) ? "" : ("; domain=" + domain)) +

((secure == true) ? "; secure" : "");

}

function DeleteCookie (name) {

var exp = new Date();

exp.setTime (exp.getTime() - 1);

var cval = GetCookie (name);

document.cookie = name + "=" + cval + "; expires=" + exp.toGMTString();

}

// End —>

</SCRIPT>
```

You will also add the following code between the <BODY> tags:

```
<SCRIPT LANGUAGE="JavaScript">

document.write("Hello " + Who() + ". You've been here " + Count() + " time(s).  Last time
was " + When() +".");

</SCRIPT>

</CENTER>

<!— Script Size:  3.42 KB —>
```

To add the above script to your HTML document, perform the following steps:

1. Click your mouse on the Start button. Windows, in turn, will display the Start menu.

2. Within the Start menu, select the Programs option and then choose Windows NotePad from Accessories. Windows, in turn, will open the Windows NotePad ASCII text editor.

3. Select the File menu Open option to open the first script. Windows NotePad, in turn, will display directories and lists of files.

4. Select the cookie-code-part1.txt file.

5. Click your mouse on the Open button.

6. Select all the code in the cookie-code-part1.txt file.

7. Select the Edit menu Copy option.

8. Select the File menu Open option. Windows NotePad, in turn, will display directories and lists of files.

9. Select the cookie-test.htm file.

10. Click your mouse on the Open button.

11. Position your cursor between the <HEAD> tags, right after the <TITLE> tag, then select the Edit menu Paste option to paste all the code from the cookie-code-part1.txt file between the tags. Windows Notepad, in turn, will display the code, as shown in Figure 16.18.

12. Save your file.

13. Select the File menu Open option to add the second script. Windows NotePad, in turn, will display directories and lists of files.

14. Select the cookie-code-part2.txt file.

15. Click your mouse on the Open button.

16. Select all the code in the cookie-code-part2.txt file.

17. Select the Edit menu Copy option.

18. Select the File menu Open option. Windows NotePad, in turn, will display directories and lists of files.

Figure 16.18 *The cookie-test.htm file with the code as it appears in Windows NotePad.*

19. Select the cookie-test.htm file.

20. Click your mouse on the Open button.

21. Position your cursor between the <BODY> tags, then select the Edit menu Paste option to paste all the code from the cookie-code-part2.txt file between the tags.

22. Save your file.

23. Open the cookie-test.htm file in your browser. You will be asked to enter a name. Windows NotePad, in turn, will display the Web page, as shown in Figure 16.19.

Figure 16.19 *The cookie-test.htm file as it should appear in your browser.*

You should see a sentence appear on the Web page similar to the one shown below:

Hello Joe. You've been here 2 time(s). Last time was Mon, May 10 at 10:05.

If you look at your COOKIES.TXT file for your browser, the entries similar to the ones below will also appear:

```
FALSE      /D|/projects-current/JamsaBook1/Cookies-chap/Lesson16/cookie-
codeinplace FALSE 928947115     VisitorName    Joe

FALSE      /D|/projects-current/JamsaBook1/Cookies-chap/Lesson16/cookie-
codeinplace FALSE 928947115     WWHCount   0

FALSE      /D|/projects-current/JamsaBook1/Cookies-chap/Lesson16/cookie-
codeinplace FALSE 928947115     WWhenH     926355130800
```

WHAT YOU MUST KNOW

As you have learned, it is easy for you to add cookies to a Web site. You can use them to personalize a Web site or to work invisibly behind the scene to make the user's experience at a Web site more pleasant. However, before you can add a cookie, you should first understand some basic concepts, such as the ways to use cookies and the advantages and disadvantages of their use. This lesson introduced cookies. In Lesson 17, "Understanding and Working With VB Script," you will learn how to add VBScript to your Web pages. Before you continue with Lesson 17, however, make sure you understand the following key concepts:

- ✓ Cookies serve several functions on Web pages, such as storing various types of information, personalizing Web sites, tracking Web site navigation, storing information about what products users purchase, retrieving information for target marketing, and much more.

- ✓ Cookies can display information or work invisibly behind the scene.

- ✓ A cookie can only capture two types of information: information supplied by filling out a form, and system and user information captured as users visit a Web site.

- ✓ Cookies offer many advantages, including ease of implementation, no need of a special plug-in, cross-platform and cross-browser compatibility, retrieval of valuable system and marketing information, and development of more efficient and personalized Web sites. The disadvantages include users who view cookies as an invasion of privacy or a security risk, browsers that are set to not accept cookies, users deleting their cookie files, use of cookie management software, new technologies without storage devices to store cookies, and users who use more than one computer system.

✓ Browsers set limitations for cookies, such as a server or domain can have only 20 cookies in a cookie text file and the cookie text file itself can only contain 300 cookies.

✓ Cookies have the reputation of being a security risk. However, since browsers set the rules for cookies, cookies are actually secure.

✓ To add a cookie, you select a script, add the appropriate code to your HTML file, and upload the HTML file and any other files to your server.

✓ Adding a cookie to a Web page is relatively easy but some special settings and some knowledge of programming concepts may be required, depending on the type of script you select.

LESSON 17

UNDERSTANDING AND WORKING WITH VBSCRIPT

Microsoft's VBScript is an alternative choice to using JavaScript for some Web designers to enhance and add interactivity to static Web site pages. Based on Microsoft's Visual Basic programming language, VBScript (Visual Basic Scripting Edition) is scripting language that works with Microsoft's Internet Explorer browser. Microsoft released VBScript when it released Internet Explorer 3.0 and Web site developers continue to use it today. Current uses of VBScript include control of HTML and advanced browser capabilities, Dynamic HTML (DHTML), NT administrative tasks and applications, and Active Server Pages (ASP).

In this lesson, you will learn what functions VBScript can perform and how to add a script to your Web site. By the time you finish this lesson, you will understand the following key concepts:

- VBScript's functions include control of HTML and advanced browser capabilities, Dynamic HTML (DHTML), NT administrative tasks and applications, and Active Server Pages (ASP).

- JavaScript and VBScript are alike in many ways. Both can make your Web pages interesting and interactive. However, JavaScript works with more browser versions and platforms. VBScript only works with Internet Explorer. VBScript does not work with Netscape or on Macintosh systems.

- Uses for VBScript include mouseovers, pull-down menus, online games, gadgets (such as calculators), pop-up windows and alert messages, control of plug-ins, validating form information, setting up password access, performing calculations, frames set up, cookies, and much more.

- VBScript offers many advantages, including no need of special plug-in software to view, ease of implementation, fast downloads, versatility, and less of a burden placed on the network servers than CGI. However, VBScript does have a major downside regarding compatibility because VBScript only works with Microsoft's Internet Explorer browser and Windows and Unix (Solaris) platforms.

- To add VBScript to your Web page, you add the appropriate code to the HTML file, modify other settings, if necessary, and upload the HTML file, along with any scripts and graphics files, to your server, or view in

your Internet Explorer browser offline.

◆ Adding VBScript to a Web page is as simple as adding a few lines of code, in many cases. You generally need no special complex settings or plug-ins.

ENHANCING YOUR WEB SITE WITH VBSCRIPT

VBScript's functions include control of HTML and advanced browser capabilities, Dynamic HTML (DHTML), NT administrative tasks and applications, and Microsoft's Active Server Pages (ASP). Just as you do when using JavaScript, you can use VBScript to make your Web pages interesting and interactive. VBScript can control multimedia, VRML, and other browser capabilities. JavaScript is the most popular choice for DHTML since JavaScript is compatible with most browsers and platforms. However, you can use VBScript as an alternative to JavaScript for DHTML. You should beware though that VBScript does have some limitations regarding browser and platform compatibility since VBScript only works with Microsoft's Internet Explorer browser and Windows or Unix (Solaris only) platforms. Despite the browser-platform incompatibility disadvantages, VBScript is a popular choice for certain applications. For example, VBScript is a popular scripting language for creating server side scripts for Active Server Pages (ASP), which is Microsoft's technology to develop dynamic HTML pages for interactive Web sites. For NT administrative tasks and other applications, VBScript is also a common choice. Intranets are also a good use for VBScript since most users tend to use only one browser to view intranets. VBScript can greatly enhance Web pages in any of the situations discussed above so it is best to take advantage of the technology as long as it does not interfere with unsupported browsers. You can also use JavaScript to call VBScript functions. By doing so, you allow options for both Netscape and Internet Explorer regarding the issued command.

JavaScript and VBScript are alike in many ways. Both languages can make your Web pages interesting and interactive for users. You can use both scripting languages for DHTML since both support the Document Object Model (DOM). You can use JavaScript and VBScript for server side applications as well. You embed the JavaScript and VBScript code for server-side applications into the HTML document, unlike CGI, which requires separate files. However, as discussed before, a major difference between the two scripting languages involves browser and platform compatibility. JavaScript works with more browser versions and platforms. VBScript only works with Internet Explorer. VBScript does not work with Netscape or on Macintosh systems.

As with JavaScript, you can use VBScript to add interactivity to your Web site in many ways. For example, you can have users access information using pull-down menus. As shown in Figure 17.1, the pull-down menu lets the user select a topic to learn more about at *www.webexpressions.com/resource/vbscript/selectmenu.htm.*

Figure 17.1 *A Resource Central example of a VBScript pull-down menu.*

You can add a fast-loading rotating banner, such as the one at *www.webexpressions.com/resource/vbscript/randimage.htm*, as shown in Figure 17.2.

Figure 17.2 *A Resource Central example of a VBScript rotating banner.*

You can use VBScript for message menus, such as the Web site at *www.webexpressions.com/resource/vbscript/messmenu.htm*, as shown in Figure 17.3. As you click your mouse on the message menu items, the message board displays the corresponding information on the right.

Figure 17.3 A Resource Central example of a VBScript message menu.

Another common use of VBScript is for hot spots or mouseovers. For example, see the sample mouse tracking script at *msdn.microsoft.com/scripting/vbscript/*. As shown in Figure 17.4, the image contains several links to URLs for more information. As you move your mouse over each hot spot, the script causes a message to appear in the box below the image.

*Figure 17.4 The sample mouse tracking script at **msdn.microsoft.com/scripting/vbscript/**.*

You can also add nice effects to HTML text using VBScript. For example, you can add gradient color to text, as shown in Figure 17.5.

Figure 17.5 The gradient text script at www.webexpressions.com/resource/vbscript/textfade.htm.

Online games, such as the sample hangman game at *msdn.microsoft.com/scripting/vbscript/*, as shown in Figure 17.6, are another popular use for VBScript.

Figure 17.6 The sample hangman game at msdn.microsoft.com/scripting/vbscript/.

Online gadgets and utilities are another use for VBScript. For example, you can add a calculator to your Web page similar to the sample calculator shown in Figure 17.7. Or, you can add a utility like the one at *www.rts.com.au/warp/colorchart_vbs/colorchartloader.html* that displays how a page looks with different colors of background or text, as shown in Figure 17.8.

*Figure 17.7 The sample calculator at **msdn.microsoft.com/scripting/vbscript**.*

Figure 17.8 The HTML Color Chart utility displays how a page looks with different colors of background or text.

249

Other uses for VBScript include pop-up windows and alert messages, control of plug-ins, validating form information, setting up password access, performing calculations, frames set up, cookies, and much more.

VBScript offers many advantages. For example, you do not need special plug-in software to view a page with VBScript within your browser. Like JavaScript, VBScript requires less complex code than ActiveX or Java. You do not need extensive programming experience to add VBScript to your Web site pages. VBScript also generally downloads fast, compared to ActiveX or Java. VBScript is versatile and places less of a burden on the network servers to which you upload your files because the code is less complex than Java or ActiveX. However, VBScript does have a major downside regarding compatibility. VBScript will work only with Microsoft's Internet Explorer browser and Windows and Unix (Solaris) platforms. If you want a scripting language that supports more browsers, VBScript would not be the best choice. JavaScript would be a better option.

How VBScript Works

Like JavaScript, VBScript's code becomes part of the HTML document with the use of special tags, the <SCRIPT> tags. You usually place the <SCRIPT> tags within the <HEAD> tags. As shown in the HTML file below, a few lines of VBScript indicated by bolded type are within the <HEAD> tags:

```
<HTML>

<HEAD>

<META HTTP-EQUIV="Content-Type" CONTENT="text/html; charset=iso-8859-1">

<TITLE>VBScript Test</TITLE>

        <SCRIPT language="vbscript">

    <!—

        Function DoWelcome()

        Dim iHour

        Dim sGreet

        iHour = Hour(Now)

        If iHour >= 0 and iHour < 12 Then
```

```
                    sGreet = "Good Morning!"

                 ElseIf iHour > 12 and iHour < 18 Then

                    sGreet = "Good Afternoon!"

                Else

                    sGreet = "Good Evening!"

                End If

                DoWelcome = sGreet

                End Function
        //—>
                </SCRIPT>
</HEAD>
<BODY>              <SCRIPT language="vbscript">
                Document.Write DoWelcome
                </SCRIPT>
</BODY>
</HTML>
```

However, depending on the type of script, you could also find the code elsewhere in the HTML document. You should always make sure you include the appropriate HTML comment tags for hiding the scripts from older browsers. These HTML comment tags are the "<!—", following the beginning <SCRIPT> tag, and "//—>", right before the closing <SCRIPT> tag, as demonstrated above. Older browsers that do not support VBScript will display your VBScript code as text on your Web page. Fortunately, you can use the HTML comment tags to make the older browser ignore the code within the <SCRIPT> tags. The VBScript code above displays a greeting (Good Morning, Good Afternoon, Good Evening), depending on the time of day.

You can find many references and resources for VBScript code on the Internet, such as the Script Search Web site at *www.scriptsearch.com*, as shown in Figure 17.9, and Watchout.com's Visual Basic Web Directory at *www.watchout.com*, as shown in Figure 17.10.

Figure 17.9 The Script Search Web site at *www.scriptsearch.com*.

Figure 17.10 Watchout.com's Visual Basic Web Directory at *www.watchout.com*.

Other resources to use as a reference and for sample code include VBScript's Web site at *www.vbscripts.com*, CNET's Builder.com at *www.builder.com/Programming/VBScript/*,

eScriptZone.com's Web site at *www.escriptzone.com*, and the Visual Basic Web Directory at *www.vb-web-directory.com/vbscript/vbscript.shtml*.

ADDING VBSCRIPT TO A WEB PAGE

You can now add your first VBScript code to your Web page. In this lesson, you will add the freeware VBScript you saw earlier that displays a greeting, depending on the time of day. All the files you need to use for this exercise are in the LESSON17 directory on the CD-ROM that accompanies this book. Copy all of these files to a directory on your hard drive. The first step in adding VBScript to your Web page is to add the code to your HTML file. For the purposes of this lesson, the VBScript code is provided for you. An example of how the code looks that you will add to your HTML document between the <HEAD> tags is shown below:

```
<SCRIPT language="vbscript">

<!—

    Function DoWelcome()

    Dim iHour

    Dim sGreet

    iHour = Hour(Now)

    If iHour >= 0 and iHour < 12 Then

      sGreet = "Good Morning!"

    ElseIf iHour > 12 and iHour < 18 Then

      sGreet = "Good Afternoon!"

    Else

      sGreet = "Good Evening!"

    End If

    DoWelcome = sGreet

    End Function

//—>

</SCRIPT>
```

253

You will also add the following code between the <BODY> tags:

```
<SCRIPT language="vbscript">

        Document.Write DoWelcome

        </SCRIPT>
```

To add the above two scripts to your HTML document, perform the following steps:

1. Click your mouse on the Start button. Windows, in turn, will display the Start menu.

2. Within the Start menu, select the Programs option and then choose Windows NotePad from Accessories. Windows, in turn, will open the Windows NotePad ASCII text editor.

3. Select the File menu Open option to open the first script. Windows NotePad, in turn, will display directories and lists of files.

4. Select the vbscript-code-part1.txt file.

5. Click your mouse on the Open button.

6. Select all the code in the vbscript-code-part1.txt file.

7. Select the Edit menu Copy option.

8. Select the File menu Open option. Windows NotePad, in turn, will display directories and lists of files.

9. Select the vbscript-test.htm file.

10. Click your mouse on the Open button.

11. Position your cursor between the <HEAD> tags right after the <TITLE> tag, then select the Edit menu Paste option to paste all the code from the vbscript-code-part1.txt file between the tags. Windows Notepad, in turn, will display the code, as shown in Figure 17.11.

12. Save your file.

13. Select the File menu Open option to add the second script. Windows NotePad, in turn, will display directories and lists of files.

14. Select the vbscript-code-part2.txt file.

15. Click your mouse on the Open button.

16. Select all the code in the vbscript-code-part2.txt file.

17. Select the Edit menu Copy option.

18. Select the File menu Open option. Windows NotePad, in turn, will display directories and lists of files.

19. Select the vbscript-test.htm file.

20. Click your mouse on the Open button.

```
vbscript-test.htm - Notepad
File  Edit  Search  Help
<HTML>

<HEAD>
<META HTTP-EQUIV="Content-Type" CONTENT="text/html; charset=iso-8859-1">
<TITLE>VBScript Test</TITLE>
 <SCRIPT language="vbscript">
                    Function DoWelcome()
                       Dim iHour
                       Dim sGreet

                       iHour = Hour(Now)
                       If iHour >= 0 and iHour < 12 Then
                         sGreet = "Good Morning!"
                       ElseIf iHour > 12 and iHour < 18 Then
                         sGreet = "Good Afternoon!"
                       Else
                         sGreet = "Good Evening!"
                       End If

                    DoWelcome = sGreet

                    End Function

                    </SCRIPT>
</HEAD>

<BODY>
</BODY>
</HTML>
```

Figure 17.11 The vbscript-test.htm file with the code as it appears in Windows NotePad.

21. Select the Edit menu Paste option to paste all the code from the vbscript-code-part2.txt file between the <BODY> tags.

22. Save your file.

23. Open the vbscript -test.htm file in your Internet Explorer browser. The script, in turn, will display a greeting (Good Morning, Good Afternoon, Good Evening), depending on the time of day. Internet Explorer, in turn, will display the Web page, as shown in Figure 17.12.

```
VBScript Test - Microsoft Internet Explorer provided by NEC - [W...
File  Edit  View  Go  Favorites  Help
Address  D:\projects-current\JamsaBook1\VBScript\Lesson17\Lesson17-with-codei

Good Evening!

                                                 My Computer
```

Figure 17.12 The vbscript-test.htm file as it appears in your Internet Explorer browser.

255

WHAT YOU MUST KNOW

VBScript offers versatility that can greatly enhance a Web page. However, before you can start using VBScript, you should first understand some basic concepts, such as its functions in Web development, incompatibility issues, and how VBScript can add interactivity to Web pages. This lesson introduced VBScript. In Lesson 18, "Implementing Server Push Operations," you will learn how Push Technology works. Before you continue with Lesson 18, however, make sure you understand the following key concepts:

- ✓ VBScript's functions include control of HTML and advanced browser capabilities, Dynamic HTML (DHTML), NT administrative tasks and applications, and Active Server Pages (ASP).

- ✓ JavaScript and VBScript are alike in many ways. Both can make your Web pages interesting and interactive. However, unlike JavaScript, VBScript works only with Internet Explorer.

- ✓ Uses for VBScript include mouseovers, pull-down menus, online games, gadgets (such as calculators), pop-up windows and alert messages, control of plug-ins, validating form information, setting up password access, performing calculations, frames set up, cookies, and much more.

- ✓ VBScript offers many advantages, including no need of special plug-in software to view, ease of implementation, fast downloads, versatility, and less of a burden placed on the network servers. However, VBScript does have a major downside regarding compatibility since VBScript works only with Microsoft's Internet Explorer browser and Windows and Unix (Solaris) platforms.

- ✓ To add VBScript to your Web page, you add the appropriate code to the HTML file, modify other settings, if necessary, and upload the HTML file, along with any scripts and graphics files, to your server, or view in your Internet Explorer browser offline.

- ✓ Adding VBScript to a Web page is as simple as adding a few lines of code in many cases. You generally need no special complex settings or plug-ins.

LESSON 18

IMPLEMENTING SERVER PUSH OPERATIONS

Push technology has become increasingly popular over the years. New uses and ways to implement push content are always on the rise. Push technology, also known as Webcasting, is a relatively new technology that delivers or pushes current content to the computer's Desktop of a user who requests it. The pushed content can be any type of information, from the latest stock quotes to a news flash about a new software program and can include text, audio, video, animation, software, and other types of media. Push technology is becoming very popular as it offers a lot of promise for the future.

In this lesson, you will learn how to add push technology to your Web site. By the time you finish this lesson, you will understand the following key concepts:

- ◆ Push technology offers a solution to finding out about current Web site content without revisiting the Web site since push technology delivers the new content automatically to users who request the information.

- ◆ Push content is versatile. For example, the push content itself can include text, audio, video, animation, Shockwave, DHTML, software, and many other types of media.

- ◆ Typical push content information includes current stock quotes, software upgrades, late-breaking news, sporting event scores, and much more.

- ◆ Push technology offers many advantages, such as users being able to view current information without frequent repeat visits to the Web site, display of push content in many versatile formats (screen savers, tickers, and the like), the possibility of offline browsing of information, ease of creation with the many available authoring programs, certain push technology programs (such as Netcaster and Active Channel) not requiring special server software, and the ability to obtain information when your computer is idle. Push technology also has several disadvantages. Some push technology programs' development software (such as Castanet and BackWeb) is expensive, some browser and platform incompatibilities exist, and users can convert Web sites to channels with Netcaster and Internet Explorer 4, leading to the download of too much content or outdated content as well as downloading at a time that is not optimal.

- ◆ To create push content, you select your push platform, transform your Web pages to channels, and add special effects and other items to make your Web pages more interesting.

- ◆ Adding push content to a Web page is relatively easy using special available authoring software and wizards, but some special server software may be required, depending on the type of push technology software you choose.

257

How Push Technology Works

Before the days of push technology, users had to revisit Web sites to find out the latest information. If no new content was available, the user had just wasted precious time visiting the Web site again and again and surfing through all the Web site's pages. Push technology offers a solution to finding out about current Web site content since push technology delivers the new content automatically to interested users who request the information. To request push content, a user subscribes to a channel which is made available for push technology. At the time a user subscribes to a channel, he or she decides how often to acquire new information and how much to acquire by size, in megabytes, or how much of a site's sublevels to include. The user will receive new push content based on the selections made and can view the information online or offline. Push content is versatile. For example, the push content itself can include text, audio, video, animation, Shockwave, DHTML, software, and many other types of media. Typical push content information can be current stock quotes, software upgrades, late-breaking news, sporting event scores, and much more.

Several types of push technology delivery methods are common to see. Using various programming methods, new information can appear automatically in pop-up windows for the user to view online or offline. Sometimes the delivery method can just be a simple pop-up window that lists URLs of interest for the user. The user can then click on a URL to view information online. Other methods of delivery include marquees, tickers, screen savers, fax, or e-mail.

The push technology program options are quite complex since some technologies overlap and a lot of push technology programs pose compatibility concerns. Many push technology programs exist today. The five most popular programs include Internet Explorer 4/Microsoft's Active Channel, Netscape's Netcaster, The PointCast Network, Marimba's Castanet Tuner, and Back Web. Even though the push technology programs compete against each other, some programs added a competitor's technology to their own program. For example, Microsoft incorporated PointCast's channels into their program. Netscape added Marimba's Castanet to NetCaster.

Choosing a push technology program depends on several compatibility factors. You will have to decide what platform, browser, and DHTML you want your push content to support. Obviously you want the content to support as many platforms and browsers as possible. However, not all five major push technology programs offer full browser and platform compatibility. Each push technology program has its own set of strengths and limitations.

Internet Explorer 4/Microsoft's Active Channel

Microsoft's Internet Explorer 4 browser offers several options for push technology. For example, you can subscribe to a site to receive news and updated information simply by using Internet Explorer's bookmarks, known as Favorites, as shown in Figure 18.1.

Figure 18.1 *Users can subscribe to a site to receive news and updated information.*

Upon adding a favorite, Internet Explorer works behind the scene searching for site updates. If new information exists, Internet Explorer can send you an e-mail message about the new information, download the site for offline viewing, and display an alert next to the favorite. You can also subscribe to actual channels or convert a Web site to a channel in CDF (Channel Definition Format). CDF channels are Active Channels and are only compatible with PointCast, unless you add special code for compatibility with Netscape's Netcaster, and will only work on Windows-based systems. You can develop Active Channels easily with the Channel Wizard, which is available from Microsoft. (You will learn how to use the Channel Wizard to create push content later in this lesson.) Microsoft offers fewer active channels for users than Netcaster. However, Active Channels offer more options for delivery of push content than Netcaster, easy channel creation without the need of JavaScript or other programming language, more control of content for users, and viewing of channels in a browser without the need of a separate application. In addition, you will need no special server software to push content, unlike PointCast, BackWeb, and Marimba's Castanet.

NETSCAPE'S NETCASTER

Netscape Netcaster, available at *www.netscape.com*, is part of earlier versions of Netscape Communicator 4 and standalone Navigator 4. For Netscape 4.x versions that do not include Netcaster,

you can download Netcaster using Netscape's special SmartUpdate software available from the Netscape Web site. To subscribe to a channel, you use Netscape's Channel Finder Guide, as shown in Figure 18.2.

Figure 18.2 *The Netscape's Channel Finder Guide displaying a preview of The Weather Channel.*

Netcaster also lets you subscribe to Web sites so it can automatically send any new information at set intervals. Netscape's Netcaster uses JavaScript 1.2. Therefore, if you develop channels for Netcaster, expect these channels to be incompatible with some of the other types of push technology programs. Netcaster is compatible with Netscape Communicator 4 and standalone Navigator 4 running on Windows, Macintosh, or Unix platforms. Netcaster offers several advantages over Active Channels. For example, Netcaster has more available channels than Active Channels, it converts to channels using more compatible Java and JavaScript and does not need an extra CDF file, it supports Castanet, and offers support for more platforms than Active Channels. Netcaster has some disadvantages too. Unlike Active Channels, you can only create single-level channels (the main categories) as opposed to subchannels (subdivisions of main categories) you can edit separately. You also use JavaScript, which requires a higher learning curve than creating Active Channels' simple CDF files.

As with Active Channels, developing Netcaster channels is easy with the Netcaster Webtop Wizard. The Webtop channels can appear as windows on the Desktop or cover the entire Desktop, as shown in Figure 18.3, and are best for applications with information that is updated regularly. Unlike PointCast, BackWeb, and Marimba's Castanet, you will need no special server software.

Figure 18.3 A sample Webtop for The Weather Channel that covers the entire Desktop screen.

THE POINTCAST NETWORK

PointCast, at *www.pointcast.com*, as shown in Figure 18.4, is one of the pioneers of push technology and is known for its wide variety of news.

Figure 18.4 The PointCast Web site offers the free download of their latest PointCast software.

PointCast can display the news you select as a screen saver, a scrolling ticker, or a Desktop application, as shown in Figures 18.5 and 18.6.

Figure 18.5 The PointCast Desktop application and scrolling ticker.

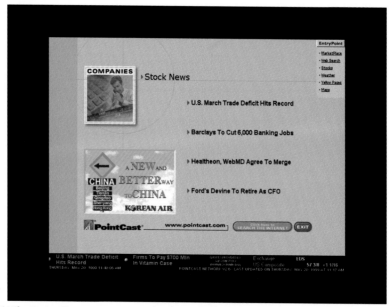

Figure 18.6 The PointCast screen saver displays current news items continuously.

The PointCast screen saver displays current news items that you can click on for details. For example, if you click on the top news item, U.S. March Trade Deficit Hits Record, the program sends you to the PointCast Desktop application, as shown in Figure 18.7, for the details.

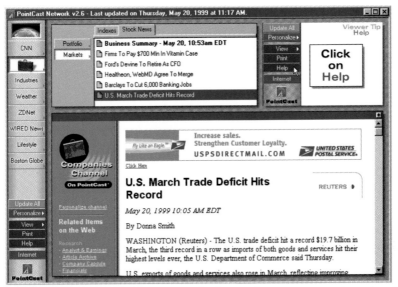

Figure 18.7 The PointCast Desktop application displaying the current news item details.

The PointCast CDF files work with the PointCast program and Internet Explorer 4, in most cases, and require a Windows or Macintosh-based system. You can create CDF channels for PointCast using the PointCast Connections Builder or add animations and other items with PointCast Studio. PointCast has joined forces with Microsoft to make Internet Explorer more attractive to users. However, some PointCast channels are not available with Internet Explorer and you can only access the channels with PointCast.

MARIMBA'S CASTANET TUNER

Marimba's Castanet, at *www.marimba.com*, as shown in Figure 18.8, illustrates how to push more than channels with HTML text.

Now you can push Shockwave through Castanet, since Macromedia and Marimba made Shockwave an option. Marimba's Castanet's Java-based tuner does not work with other push technology programs, with the exception of Netcaster. The platforms Castanet is compatible with include Windows 95, NT 4.0, Solaris 2.5, and PowerPC. Although its Java-based tuner is free for subscribers, the required Bongo authoring tool to create push content and the transmitter software to send push content to the user both generally run from $1,495 to $25,495. The price depends on how many connections you will need.

Figure 18.8 The Marimba's Castanet Web site at www.marimba.com.

BACKWEB

BackWeb, at *www.backweb.com*, as shown in Figure 18.9, lets users not only subscribe to channels but download software as well.

Figure 18.9 The BackWeb site at www.backweb.com.

You receive InfoPaks for each channel you subscribe to for more information. The special BackWeb software downloads information for you as you browse the Internet, or even when you are not on the Internet, since it works behind the scenes and automatically connects to the Internet at set intervals to retrieve new information. BackWeb InfoPaks appear on your system's desktop in the form of screen savers, wall paper, or tiny icons called InfoFlashes. InfoFlashes offer automatic download of software upgrades as well as news or recreational items. Like Marimba's Castanet, the server software and authoring software are not free and the price is $10,000 and up. Some monthly charges for messages also add to the cost. The platforms BackWeb supports include Windows 3.1/95, NT 4.0, Solaris, and PowerPC.

The five push technology programs discussed above are among the most popular. Other push technology programs include After Dark Online from Berkely Systems (the creators of the well-known After Dark screen savers), Lanacom, Inc.'s Headliner Professional, Intermind Corporation's Intermind Communicator, Astound's WebCast (Astound's products include multimedia presentations software), and Diffusion's IntraExpress.

Push technology offers many advantages. For example, users are able to view current information without frequent repeat visits to the Web site. You can display push content in many interesting formats (screen savers, tickers, and the like). Users can browse the information offline without being connected to the Internet. Push content is also easy to create with the many available authoring programs or wizards. Certain push technology programs, such as Netcaster and Active Channel, do not require expensive special server software. You can also automatically obtain new information or software upgrades when your computer is idle. Some push technology programs' development software (such as Castanet and BackWeb), however, is expensive. Some browser and platform incompatibilities exist, too. For example, Netscape and Internet Explorer support different versions of DHTML and not all push technology programs are compatible with all browsers or platforms. Another problem is that users can convert Web sites to channels themselves with Netcaster and Internet Explorer 4. Placing too much push content control into the hands of the user can lead to the download of too much content or outdated content as well as downloading at a time that is not optimal for the user. Push technology content also takes much time to download.

SOME SAMPLES OF SITES USING PUSH TECHNOLOGY

As you browse through Internet Explorer/Active Channel, Netcaster, PointCast, Castanet, Back Web, and other push technology programs, you will see the many ways Web designers creatively enhance push technology channel Web sites for interactivity and make the channel Web sites interesting. For example, many channels, such as National Geographic's Active Channel, as shown in Figure 18.10, have captivating introductions using Shockwave, Flash, DHTML, or other Web technology.

Figure 18.10 *National Geographic's Active Channel has a captivating introductory presentation with music.*

Other examples of channels with appealing introductions include CNN Interactive, Warner Bros. Online, and ZDNet, as shown in Figures 18.11, 18.12, and 18.13.

Figure 18.11 *CNN Interactive Active Channel.*

Figure 18.12 Warner Bros. Online Active Channel.

Figure 18.13 ZDNet Active Channel.

Some channels let users listen to the latest music, view video clips, and even watch television. The Broadcast.com channel, as shown in Figure 18.14, lets users listen to Real Audio music clips and watch live television with Real Player.

Figure 18.14 Listen to Real Audio music clips and watch live television with Real Player.

As shown in Figure 18.15, the Disney channel offers many streaming video clips of movies to users.

Figure 18.15 Disney channel offers many streaming video clips of movies to users.

Some channels offer not only nice eye-catching animations or graphics but display current information as well. For example, the ESPN Sportszone, as shown in Figure 18.16, provides the latest sports score online.

Figure 18.16 ESPN Sportszone *provides the latest sports score online.*

In the upper right-hand corner of the Sportzone is a JavaScript marquee ticker that displays the most up-to-date scores. Many channels offer the most current stock and mutual fund quotes. For example, the Microsoft Investor Active Channel, as shown in Figure 18.17, keeps you up-to-date on all financial news.

Figure 18.17 The Microsoft Investor Active Channel.

The Wall Street Journal Active Channel, as shown in Figure 18.18, is another site offering current stock and mutual fund quotes.

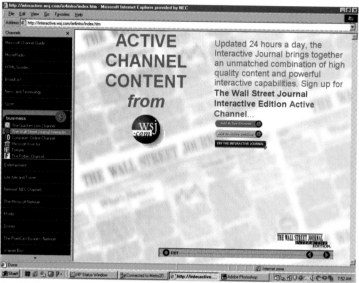

Figure 18.18 The Wall Street Journal Active Channel.

As shown in Figure 18.18, you have a choice of adding the channel as an Active Channel or Active Desktop. Some channels only let you add them as channels. Other channels give you a second option of adding a ticker or small application to your system's Desktop to keep you current on information. If you select The Wall Street Journal's Active Desktop, an installation utility will install a small search application, as shown in Figure 18.19, on your Desktop.

Figure 18.19 The Wall Street Journal's Active Desktop installation utility will install a small search application on your Desktop.

Many other types of push technology channels are available. A good site to search for specific channels is PushCentral at *www.pushcentral.com*, as shown in Figure 18.20.

Figure 18.20 PushCentral at **www.pushcentral.com.**

At PushCentral, you can download many tickers that can push current content to your system. For example, MSNBC offers the News Alert ticker at *www.msnbc.com*, as shown in action in Figure 18.21.

Figure 18.21 MSNBC's News Alert ticker.

Another example of a news ticker is the My Yahoo! News Ticker available at *www.netcontrols.com*. The My Yahoo! News Ticker appears as a scrolling marquee in your Windows taskbar.

CREATING PUSH CONTENT

Several steps are necessary to create push content. You need to create or select pre-existing site page(s) for the channel, select your push platform, transform your Web pages to channels, add special effects and other items to make your Web pages more interesting, and upload the files to your server.

Now you are ready to create your first channel. In this lesson, you will use Microsoft's Channel Wizard to create push content. All the files you need to use for this exercise are in the LESSON18 directory on the CD-ROM that accompanies this book. Copy all of these files to a directory on your hard drive. The first step in creating an Active Channel CDF file is to create two small JPG or GIF files for a logo and a small icon for your channel. The channel logo will appear in the Channels Bar upon subscribing to the channel and should be an 80x32-pixel GIF or JPG file. The channel icon should be a 16x16-pixel transparent GIF file and will appear in the user's Favorites menu Channels sub-menu. However, for the purpose of this lesson, the icon and logo files (test-push-icon.gif and test-push-logo.gif) are included in the LESSON18 directory. Therefore, the first step you should perform to create the Active Channel CDF file is to upload ac-test.htm, test-push-icon.gif, and test-push-logo.gif from your LESSON18 directory to a directory called AC-TEST on your server. (If you do not know how to do this, ask your system administrator for help.) After this is done, you should open the special tool called the Active Channel Wizard that lets you easily create the needed code for the CDF file. You can access the Active Channel Wizard at *msdn.microsoft.com/workshop/delivery/channel/cdfwiz/intro.asp*. The Active Channel Wizard window, as shown in Figure 18.22, will appear on your screen.

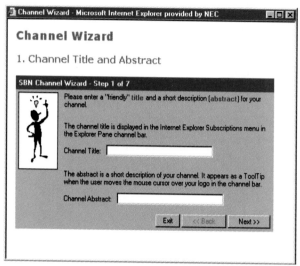

Figure 18.22 The Active Channel Wizard window.

The Active Channel Wizard will ask you for various information about your channel files, such as the channel's title, a channel description, location of the first page for your channel, channel update interval, location of the 80x32 pixel logo, and location of the 16x16 pixel icon. To proceed through the Active Channel Wizard, starting at the initial screen, and create a channel, perform the following steps:

1. Type in Active Channel Test for the Channel Title and Channel Abstract. (The Channel Abstract is the description that appears as the user moves his or her cursor over your logo in the channel bar.)

2. Click your mouse on the Next button to continue to the next screen.

3. Enter the URL for the first page of your site which, in this case, is http://**YOUR URL**/ac-test/ac-test.htm.

4. Select an Update Interval for your test channel.

5. Click your mouse on the Next button to continue to the next screen.

6. Enter the URL for your channel's logo and icon which, in this case, are http://**YOUR URL**/ac-test/test-push-logo.gif and http://**YOUR URL**/ac-test/test-push-icon.gif.

7. Click your mouse on the Next button to continue to the next screen.

The wizard screen should appear with the code you need to copy and paste to create your CDF file and the code should appear as follows:

```
<?XML VERSION="1.0" ENCODING="UTF-8"?>

<CHANNEL HREF="http://YOUR URL/ac-test/ac-test.htm" LEVEL="1">

<TITLE>Active Channel Test</TITLE>

<ABSTRACT>Active Channel Test</ABSTRACT>

<LOGO HREF="http:// YOUR URL/ac-test/test-push-logo.gif" STYLE="IMAGE" />

<LOGO HREF="http:// YOUR URL/ac-test/test-push-icon.gif" STYLE="ICON"/>

<SCHEDULE>

  <INTERVALTIME DAY="7" />

</SCHEDULE>

</CHANNEL>
```

To add the above code and create a new CDF file, perform the following steps:

1. Select and copy the code the Active Channel Wizard provides.

273

2. Click your mouse on the Start button. Windows, in turn, will display the Start menu.

3. Within the Start menu, select the Programs option and then choose Windows NotePad from Accessories. Windows, in turn, will open the Windows NotePad ASCII text editor.

4. Select the File menu New option. NotePad, in turn, will display a new window.

5. Select the Edit menu Paste option to paste all the code from the Active Channel Wizard.

6. Select the File menu Save option.

7. Save your new CDF file as ac-test.cdf.

8. Upload the file to the same location on your server as before.

After uploading the ac-test.cdf file successfully, you should return to the Active Channel Wizard screen where you left off. To proceed with the Active Channel Wizard, perform the following steps:

1. Click your mouse on the Next button to continue to the next screen.

2. Enter the URL for the new CDF file which, in this case, is http://**YOUR URL**/ac-test/ac-test.cdf.

3. Click your mouse on the Next button to continue to the next screen.

4. Right-click your mouse and save the Add Active Channel Logo as IEAddChannel.gif to your LESSON18 directory on your hard drive.

5. Click your mouse on the View Code button.

The Active Channel Wizard will display two different sets of code. The first set of code is between the <HEAD> tags at the top of the HTML document. The second set of code is for the Add Active Channel button to appear on the page. You will copy the JavaScript code between the <HEAD> tags of your HTML file, as instructed, and then paste the second code where you would like to have the Add Active Channel button appear on the page.

To add the above code to your HTML document, perform the following steps:

1. Copy the first set of code from the Active Channel Wizard's window, as instructed.

2. Click your mouse on the Start button. Windows, in turn, will display the Start menu.

3. Within the Start menu, select the Programs option and then choose Windows NotePad from Accessories. Windows, in turn, will open the Windows NotePad ASCII text editor.

4. Select the File menu Open option. Windows NotePad, in turn, will display directories and lists of files.

5. Select the ac-test.htm file.

6. Click your mouse on the Open button.

7. Position your cursor between the <HEAD> tags, then select the Edit menu Paste option to paste the code from the Active Channel Wizard between the tags.

8. Copy the second set of code from the Active Channel Wizard's window, as instructed.

9. Select the Edit menu Paste option to paste all the code from the Active Channel where you would like to have the Add Active Channel button appear on the page.

The resulting HTML file should now appear as follows:

```
<HTML>

<HEAD>

<TITLE>A test page for creating an Active Channel</TITLE><SCRIPT
LANGUAGE="JavaScript"> function isMsie4orGreater() {

    var ua = window.navigator.userAgent ;    var msie = ua.indexOf ("MSIE ") ;

    if (msie > 0){

      return(parseInt(ua.substring(msie+5, ua.indexOf(".", msie))) >= 4)

        && (ua.indexOf("MSIE 4.0b") < 0) ;  }   else {     return false ;

    } }</SCRIPT>

</HEAD>

<BODY>

<IMG SRC="xyz-co-main-img.jpg" ALT="main image" WIDTH="540"

 HEIGHT="111" BORDER="0"><BR>

<BR>

<IMG   SRC="bar.jpg"   ALT="divider"   WIDTH="477"   HEIGHT="22"
BORDER="0"><P>This is

a test page for creating an Active Channel CDF file.</P><A NAME="Active_Channel_Test"

 HREF="http://www.microsoft.com/ie/ie40/download/?/ie/ie40/download/redirect.htm">
```

275

```
<IMG SRC="IEAddChannel.gif" BORDER=0 WIDTH=136 HEIGHT=20></A>

<SCRIPT LANGUAGE="JavaScript">

  if (isMsie4orGreater()) { Active_Channel_Test.href = "http://www.saucierdesign.com/ac-test/ac-test.cdf" ; }

</SCRIPT>

</BODY>

</HTML>
```

After you copy the two sections of code, click your mouse on the Back to the Wizard button at the bottom of the screen and click your mouse on the Next button to continue to the next screen. The Active Channel Wizard gives you the option of adding some DHTML code to your test channel HTML file. When you are satisfied with the look of the test HTML file, you can upload your modified file (ac-test.htm) and the Add Active Channel Logo (IEAddChannel.gif) to the same location on your server.

To see the test Active Channel in action, you should subscribe to the channel, as shown in Figure 18.23. As shown in Figure 18.24, the test channel's logo now appears in the channel bar.

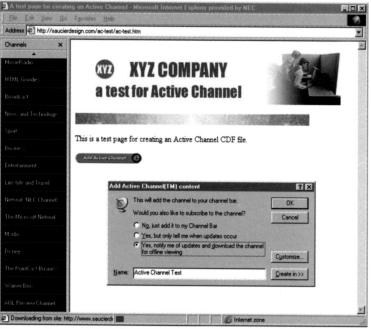

Figure 18.23 The test Active Channel in action.

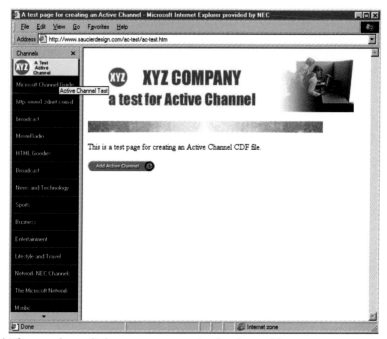

Figure 18.24 The test channel's logo now appears in the channel bar.

WHAT YOU MUST KNOW

As you have learned, push technology makes the user's efforts to obtain current information much easier, efficient, and interesting. By subscribing to channels, users can truly interact with Web site information. However, before you can create your own channels, you should first understand some basic concepts, such as the different options for push technology and the advantages and disadvantages of its use. This lesson introduced push technology. In Lesson 19, "Working with Shockwave and Flash," you will find out how to add interesting Shockwave animations to your Web pages. Before you continue with Lesson 19, however, make sure you understand the following key concepts:

✓ Push technology offers a solution to finding out about current Web site content without revisiting the Web site since push technology delivers the new content automatically to users who request the information.

✓ Push content is versatile. It can include text, audio, video, animation, Shockwave, DHTML, software, and more.

✓ Typical push content information includes current stock quotes, software upgrades, late-breaking news, sporting event scores, and much more.

✓ Push technology offers many advantages, such as users being able to view current information without frequent repeat visits to the Web site, display of push content in many versatile formats (screen savers, tickers, and the like), the possibility of offline browsing of information, ease of creation with the many available authoring programs, certain push technology programs (such as Netcaster and Active Channel) not requiring special server software, and the ability to obtain information when your computer is idle. Push technology also has several disadvantages. Some push technology programs' development software (such as Castanet and BackWeb) is expensive, some browser and platform incompatibilities exist, users can convert Web sites to channels with Netcaster and Internet Explorer 4, leading to the download of too much content or outdated content as well as downloading at a time that is not optimal.

✓ To create push content, you select your push platform, transform your Web pages to channels, and add special effects and other items to make your Web pages more interesting.

✓ Adding a push content to a Web page is relatively easy using special available authoring software and wizards, but some special server software may be required, depending on the type of push technology software you choose.

LESSON 19

WORKING WITH SHOCKWAVE AND FLASH

Many Web site designers now take advantage of Shockwave and Flash to add multimedia effects, such as animation with sound, to their Web sites. Both Shockwave and Flash are Macromedia technologies that let Web designers add multimedia elements to Web pages. Shockwave movies are the resulting files exported from Macromedia Director that display animation, special effects, and other types of applications for the Web. Flash movies are animations and other types of interactive Web elements exported from Macromedia Flash.

In this lesson, you will learn how to add a Shockwave and Flash file to your site. By the time you finish this lesson, you will understand the following key concepts:

- ◆ Web designers add Shockwave and Flash files to Web pages for several reasons, including to make Web pages more interesting and interactive, to add colorful navigational components, to enhance a site visually with animation, multimedia, and special effects, and to add more complex components, such as online games.

- ◆ Most Shockwave and Flash movies require a special plug-in that is easy to obtain since many browsers and operating systems include the plug-in. You can also export Flash and Shockwave movies as Java, which does not need a plug-in to view.

- ◆ Although they are similar in some features regarding multimedia, Shockwave and Flash do differ in several important ways. Director Shockwave Internet Studio is a full-featured multimedia authoring program that lets you create business presentations, CD-ROM/DVD-ROM works, games, and other interactive applications, in addition to Web content. Flash's main focus is multimedia animation for the Web and is easier to learn than Director.

- ◆ Flash and Shockwave offer Web site designers many advantages, such as they both make Web sites more interesting and interactive, both offer versatility, as well as cross-browser and cross-platform compatibility. Although some Flash and Shockwave movies require a plug-in, Flash and Shockwave offer options for playback without a plug-in that you can export as Java. Flash has a short learning curve and you do not need to do any programming to create Flash movies. Flash movies offer streaming content for fast downloads. Flash and Shockwave's disadvantages include their requirement of a plug-in for viewing, possible long download time for some Shockwave movies, Macromedia Director's high learning curve, and difficulties editing Flash movies with large amounts of text.

279

- To create and add a Shockwave movie to a Web page, you need to obtain the necessary artwork for your project (whether it may be using clip media or creating your own artwork), create your Shockwave movie using Macromedia Director, export the file to the proper Shockwave format, and embed the resulting file into an HTML file to view with a browser.

- To create and add a Flash movie to a Web page, you need to obtain the necessary artwork for your project (whether it may be using clip media or creating your own artwork), create your Flash movie using Macromedia Flash, export the file to the proper Flash format, and copy the code Flash generates to embed the resulting file into an HTML file to view with a browser.

- Adding Flash and Shockwave movies to a Web page is relatively easy, but some knowledge of Lingo programming concepts may be required for Shockwave's advanced techniques.

ENHANCING YOUR SITE WITH SHOCKWAVE AND FLASH

Macromedia first let Web site designers export files created with its multimedia authoring program, Director, as Shockwave files, which is Macromedia's playback format for the Web. However, Macromedia initially developed Director for playback on computer systems and it was not specifically planned for use on the Internet. In the past, users had to wait for several minutes, in some cases, before seeing the Shockwave file play. Later, Macromedia introduced Flash, a program specifically for creating Web content. Users do not have to wait to view a Flash file because Flash offers fast streaming content for viewing over the Internet.

Web designers add Shockwave and Flash files to Web pages for many reasons. For example, Shockwave and Flash components can make Web pages more interesting and interactive, since you can add colorful navigational components, mouseover menus with sound, scrolling menu bars, scene creation utilities, online games, and other interactive components to Web sites. Shockwave and Flash can also enhance a site visually with animation, multimedia, and special effects. In addition, you can use Shockwave to create more complex components, such as online games.

Most Shockwave and Flash movies require a special plug-in. To view Shockwave files, you need a Shockwave Player in many cases. Unlike most plug-ins, the Shockwave Player is easy to obtain since many browsers and operating systems, such as AOL, Windows 95/98, Macintosh OS 8, Netscape Navigator, and Internet Explorer include a copy of the Shockwave Player with installation. The initial releases of the Shockwave Player required longer download time for viewing of files. Fortunately today, the Shockwave Player works more efficiently no matter what the Internet connection speed is. Sometimes you will not need a plug-in at all to view a Shockwave file. Director also gives the option of exporting Web content as Java, which does not need a plug-in to view. Flash movies also generally require a plug-in for viewing. However, like Shockwave, many

browsers and operating systems now include the Flash Player. Flash movies will download quickly because Flash offers fast streaming Web content. Like Shockwave, Flash also lets you export Web content as Java. You can also use the Shockwave Player to view Flash movies. Both the Flash and Shockwave Player plug-ins are available at Macromedia's Web site at *www.macromedia.com*.

Although they are similar in some features regarding multimedia, Shockwave and Flash do differ in several important ways. The latest version of Director, Director Shockwave Internet Studio, creates much more than Web content. Director Shockwave Internet Studio is a full-featured multimedia authoring program that lets you create business presentations, CD-ROM/DVD-ROM works, games, and other interactive applications, in addition to Web content. Shockwave lets you incorporate sound, animation, and video to your work. In addition, Shockwave movies will run on both Macintosh and Windows platforms. Flash's main focus is multimedia animation for the Web and is now the standard among Web designers. With Flash, you can create stunning mouseovers, eye-catching animations and presentations, special effects, and much more. Another major difference is the learning curve for Flash and Director. Director takes much more time to learn, being a full-featured multimedia program, while Flash is easy to use, especially for the novice. As discussed before, download time is another difference between the two programs. Director's Shockwave files can take longer to load than Flash movies since Flash offers streaming content. The interface of Flash and Director also differ, as you will see later in this lesson. Unlike Director, Flash takes advantage of the vector-graphics language technology as opposed to bitmap images. Vector graphics are easily scalable to any size. In addition, file size is kept to a minimum because vector graphics do not map out images with every pixel as bitmap images. Like Shockwave, Flash movies will run on both Macintosh and Windows platforms. To decide whether to use Flash or Director for a Web project, you should determine your current needs. For example, if you just want a quick animation, then Flash would be a much better choice. Director is a good choice for more complex items, such as online games.

Shockwave and Flash differ in several ways from other Web technologies, such as DHTML, JavaScript, and Java. For example, Flash offers fast streaming Web content and downloads much faster than Java applets. Compatibility is another difference to note because Flash and Shockwave movies are cross-platform and browser compatible. DHTML still has many incompatibilities between Internet Explorer and Netscape. Ease of implementation is another area where Flash scores high compared to DHTML, JavaScript, and Java, all of which require programming. In addition, DHTML, Java, and JavaScript do not require a plug-in while many Flash and Shockwave movies require a plug-in for viewing. Furthermore, differences in capabilities exist for Flash and other technologies. For example, Flash works well for multimedia but you cannot use Shockwave or Flash for advanced Web programming, such as networking and database implementation as you can with Java.

Flash and Shockwave are popular components on Web sites. You can see many examples of how Flash and Shockwave enhance Web sites as you browse the Internet. A popular use of Flash is for splash pages, introductory animations, and animated banners. For example, the Balthaser Web site at *www.balthaser.com* displays an incredible introduction to the Web site that clearly communicates their business capabilities, as shown in Figure 19.1.

*Figure 19.1 The Balthaser Web site at **www.balthaser.com** displays an incredible introduction.*

The entire Balthaser Web site is a Flash presentation with 3D animation, and sound and pull-down menus to access other areas of the Web site. The Nicosia Creative Expresso LTD Web site at *www.niceltd.com* uses Flash to display a 3D animation of their logo with sound effect on the site's introductory home page and also for site navigation, as shown in Figure 19.2.

Figure 19.2 The Nicosia Creative Expresso LTD Web site.

Two other excellent examples of introductory page Flash animation is the wddg Web site at *www.wddg.com/final/* and the Chevy Impala Web site at *www.chevrolet.com/impala/*, as shown in Figures 19.3 and 19.4.

Figure 19.3 The wddg Web site's introductory page Flash animation at *www.wddg.com/final/*.

Figure 19.4 The Chevy Impala Web site's introductory page Flash animation.

Simple, yet effective, animation of text effects on a home page can be seen at the Digital Lava Web site at *www.digitallava.com*, as shown in Figure 19.5.

Figure 19.5 *The Digital Lava Web site's effective animation of text effects on a home page.*

Hot spots (or mouseovers) navigational bars is another popular use for Flash and Shockwave. For example, a user can click on one of the mouseover buttons on the Flash menu bar at the Out of Towers Web site at *www.outoftowners.com/intro.html* for more information about the movie, as shown in Figure 19.6.

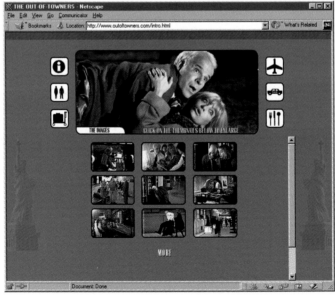

Figure 19.6 *The Out of Towers Web site Flash menu bar at* ***www.outoftowners.com/intro.html.***

Flash and Shockwave hot spots navigational bars can incorporate various effects to make navigation easy for users. For example, a user can choose which animation to play by clicking on one of the Flash scrolling hot spot menu items on the right at the HotWired Animation Express Web site at *www.hotwired.com/animation/*, as shown in Figure 19.7.

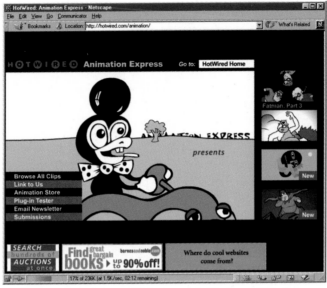

Figure 19.7 HotWired Animation Express Web site with Flash scrolling hot spot menu items.

Flash hot spots can include sound and animation effects. For example, the Harbinger Central Web site at *corvuscorax.org/~jnugent/flash/* uses Flash for its hot spots with sound effects, as shown in Figure 19.8.

Figure 19.8 The Harbinger Central Web site uses Flash for its hot spots with sound effects.

You can also use JavaScript with Flash to create interesting navigation interfaces for Web sites. For example, as you first open the CyberAtlas Web site at *cyberatlas.guggenheim.org/home/*, you are instructed to click and drag the right frame to reveal the navigational bar. After doing this, a Flash menu bar with several hot spot items appears, as shown in Figure 19.9.

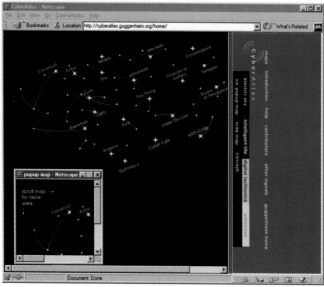

Figure 19.9 CyberAtlas Web site Flash/JavaScript menu bar at **cyberatlas.guggenheim.org/home/**.

The entertainment industry Web sites tend to incorporate Flash movies to attract attention to movies. For example, the Flash presentation for the movie, The General's Daughter, at *www.thegeneralsdaughter.com*, is stunning, to say the least, as shown in Figure 19.10.

Figure 19.10 The Flash presentation for the movie, The General's Daughter.

Flash presentations are not limited to just movies. For example, the First 9 Months presentation at *www.pregnancycalendar.com/first9months/* documents an entire pregnancy using Flash, as shown in Figure 19.11.

Figure 19.11 *The First 9 Months Flash presentation at* **www.pregnancycalendar.com/first9months/**.

Furthermore, the First 9 Months presentation also includes hot spot buttons for easy navigation as well as animations of the embryo. Another use for Flash and Shockwave is for interactive games, other interactive components, and creation utilities. For example, the Shockwave component at SCIFI.COM's Virtual Dr. Smith at *www.scifi.com/lostnspace/Smith/* lets users click on a button for the Lost in Space character's thoughts, as shown in Figure 19.12.

287

Figure 19.12 *The Shockwave component at SCIFI.COM's Virtual Dr. Smith.*

The Flash scene creator at the Patent Place Web site at *www.patentplace.com/main.asp*, as shown in Figure 19.13, lets you create your own scenes based on your selections for place, characters, and other components at *www.patentplace.com/scenes/create_default.asp*, as shown in Figure 19.14.

Figure 19.13 *The Flash scene creator at the Patent Place Web site at* ***www.patentplace.com/main.asp***.

288 *Figure 19.14* *The Flash scene creator submission page at the Patent Place Web site.*

Two fun examples of Shockwave games are the Balihighway Web site's Name That Tune game at *www.balihighway.com/movement/roadmvie.html* that plays while waiting for an animation to load, as shown in Figure 19.15, and the Austin Powers Web site's Let's Dance, Baby! Game at *www.austinpowers.com/Shock/index.html*, as shown in Figure 19.16.

Figure 19.15 *The Balihighway Web site's Name That Tune game.*

Figure 19.16 *The Austin Powers Web site's Let's Dance, Baby! Game.*

You can use Flash and Shockwave for many other types of Web components. The Shockwave.com Web site at *www.shockwave.com* has many more examples of what you can do with Shockwave and Flash, from hot spots to animated greeting cards, as shown in Figures 19.17 and 19.18.

*Figure 19.17 The Shockwave.com Web site at **www.shockwave.com.***

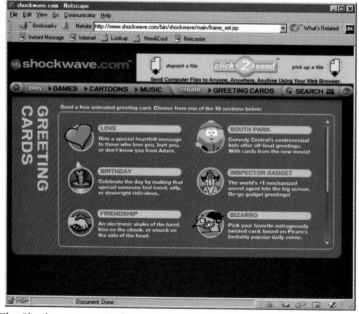

Figure 19.18 The Shockwave.com Web site's Animated Greeting Card Creator.

Flash and Shockwave offer Web site designers many advantages, such as they both make Web sites more interesting and interactive, both offer versatility, as well as cross-browser and cross-platform compatibility. Although some Flash and Shockwave movies require a plug-in, Flash and Shockwave offer options, that you can export as Java, for playback without a plug-in. Flash has a short learning curve and you do not need to do any programming to create Flash movies. Flash movies offer streaming content for fast downloads. Flash and Shockwave's disadvantages include their requirement of a plug-in for viewing, possible long download time for some Shockwave movies, Macromedia Director's high learning curve, and difficulties editing Flash movies with large amounts of text.

ADDING A SHOCKWAVE MOVIE TO A WEB PAGE

To create a Shockwave file requires several steps, which include obtaining the necessary artwork for your project (whether it be using clip media or creating your own artwork), creating your Shockwave movie using Macromedia Director, exporting the file to the proper Shockwave format, and embedding the resulting file into an HTML file to view with a browser. You should be aware of the palette issues for Director files concerning the artwork for your project and displays set for 256 colors. Generally, you should be sure that your artwork shares a global optimized palette or superpalette for best results with 256 color displays.

Now you are ready to create your first Shockwave movie. As you have learned, the first step for creating any Shockwave movie is to obtain the necessary artwork. For the purposes of this lesson, some image files for a movie to use for this exercise are included in the LESSON19 directory on the CD-ROM that accompanies this book. Copy all of these files to a directory on your hard drive. In this lesson, you will need to use Macromedia Director to create your Shockwave movie. For more information on Director, you can visit Macromedia's Web site at *www.macromedia.com.*

To create a Shockwave movie for a Web page with Director, perform the following steps:

1. Click your mouse on the Start button. Windows, in turn, will display the Start menu.
2. Within the Start menu, select the Programs option and then choose Macromedia Director. Windows, in turn, will cascade the Macromedia Director sub-menu.
3. Within the Macromedia Director sub-menu, click your mouse on the Director option. Windows, in turn, will open Macromedia Director.
4. Select the File menu Open option. Director, in turn, will display directories and lists of files.
5. Select the HIGHTECH.DIR file.
6. Click your mouse on the Open button.
7. Select the File menu Import option. Director, in turn, will display directories and lists of files.

8. Select the image files (PHOTO0.JPG, PHOTO1.JPG, PHOTO2.JPG, PHOTO3.JPG, PHOTO4.JPG, PHOTO5.JPG, PHOTO6.JPG, PHOTO7.JPG, PHOTO8.JPG, and the sound file (MUSIC.WAV), for the project.

9. Click your mouse on the Add button.

10. Click your mouse on the Import button. Director, in turn, will display a dialog box with options for color depth and palette. You can select whatever color display your system is currently set to for color depth and select Dither and Same Settings For Remaining Images for the palette for the purpose of this lesson.

11. Click your mouse on the OK button. Director, in turn, will display the imported files in what is known as the Cast.

12. Select the Window menu Tool Palette option to display the Tool Palette you will use later in this lesson. Director, in turn, will display the Tool Palette on the left and its three main components, the Cast, the Score, and the Control Panel, as shown in Figure 19.19.

Figure 19.19 Director's Cast, Score, Tool Palette, and Control Panel.

As you can see, the Cast displays all imported components available for the Director project. The Control Panel, as the name suggests, provides various controls for your movie, such as play, stop, forward and reverse, volume, frame rate, and more. The Tool Palette lets you create shapes, add text, buttons, and more. The Score is the area where you will place your imported files to create your movie. Several channels with icons are visible at the top of the Score for adjusting the tempo, palette, and transition, as well as for placement of the sound files and script. Below the channel icons are many other channels for adding cast members to the score for the movie. Each

cell for placement of cast members is a sprite and has its own number, as indicated from left to right in the Score. Many sprites together make up a Director animation. For example, one sprite could have an image of a ball in one position. The next sprite could have the same ball moving up a bit. The third sprite could have the ball moving upward even more. The rest of the sprites could show this ball in various positions, resulting in an animation. However, sprites are not just for animation. Any cast member in a cell is a sprite. Other options, such as the Text window and Paint window, are also available in Director. To add items to the Score, perform the following steps:

1. Select PHOTO0.JPG in the Cast and drag it to the stage in the center of the work area. Director, in turn, will add your file to the Score, as shown in Figure 19.20.

Figure 19.20 *The image as it now appears on the Stage and within the Score, as well as indicators for cell placements for the next group of steps.*

2. Select PHOTO1.JPG in the cast and drag it to the next position one channel below the previous image (channel 2, column 29), as indicated in Figure 19.20. You can see the cast member added to the score.

3. Repeat Step 2 for PHOTO2.JPG, PHOTO3.JPG, PHOTO4.JPG, PHOTO5.JPG, PHOTO6.JPG, PHOTO7.JPG, and PHOTO8.JPG, being sure to select the cast member and drag it to the next position one channel below the previous image.

4. Double-click your mouse on the cell for a transition in the transition channel on the same column where the second image (PHOTO1.JPG) first appears in the movie, as indicated in Figure 19.20. Director, in turn, will display the Frames Properties dialog box.

293

5. Select the Dissolve for Categories and Dissolve Pixels, Fast for Transitions.

6. Click your mouse on the OK button. Figure 19.2 shows the cast member added to the score.

7. Select the first cell for adding a sound in the sound channel on the same column where the second image (PHOTO1.JPG) first appears in the movie, as indicated in Figure 19.20. Figure 19.21 shows the cast member added to the score.

8. Double-click your mouse on the MUSIC.WAV file in the Cast. Director, in turn, will display the Sound Cast Member Properties dialog box. Within the dialog box, make sure the checkbox for the Loop option has a checkmark, then click your mouse on the OK button.

9. Drag the MUSIC.WAV file from the Cast to the cell.

10. Click your mouse on the last sprite cell for the sound and drag it to the end of the movie. Director, in turn, will display the Score, as shown in Figure 19.21.

Figure 19.21 The Score with several images, a transition, and background music added to the movie.

11. Click your mouse on the first cell under the seventh image (PHOTO6.JPG) in the Score.

12. Click your mouse on and drag the PHOTO7.JPG cast member to the cell.

13. Adjust the position in the Score for PHOTO7.JPG, if necessary, so it spans as many cells as PHOTO6.JPG.

14. Double-click your mouse on the cell for timing in the tempo channel on the same column where the PHOTO6.JPG and PHOTO7.JPG images

last appear in the movie. Director, in turn, will display the Frames Properties: Temp dialog box.

15. Select the Wait for Mouse Click or Key Press option, then click your mouse on the OK button. Director, in turn, will display the Score, as shown in Figure 19.22.

Figure 19.22 *The Score with the PHOTO6.JPG and PHOTO7.JPG images in place and the tempo set.*

16. Repeat Steps 12 and 13 for the column where PHOTO8.JPG last appears in the movie.

17. Click your mouse on the column in the white bar above the channel with the icon for tempo where PHOTO8.JPG first appears in the Score. Director, in turn, will let you add what is known as a marker. A marker is the frame you can advance to within the movie by clicking on a button.

18. Type in **contact** for the marker's label.

19. Select the entire PHOTO7.JPG sprite in the Score.

20. Select the Xtras menu Behavior Library option. Director, in turn, will display the Behavior Library Cast, as shown in Figure 19.23. Director includes some predefined common scripts to use for sprites in your movie. (If you are using a trial version of Director and do not have the Behaviors Library, you can also use Director's scripting language, Lingo, for scripting. As the name suggests, the Go To Next Marker script will advance to the next marker in the movie when the user clicks on a button. To add a simple script for this same task, click your mouse on the sprite cell in the script that corresponds to the last sprite cell for PHOTO7.JPG sprite in the Score. The script channel is right below the sound channels. You then

double-click your mouse on the cell. Director, in turn, will display the Score Script Window. Enter on the second line below exitFrame and close the Score Script window).

Figure 19.23 The Behavior Library Cast.

21. Select the Marker Go To Next behavior option and drag it to the PHOTO7.JPG sprite in the Score. Director, in turn, will display the Go To Next Marker dialog box. The default setting is mouseUp.

22. Click your mouse on OK.

23. Select the File menu Save and Compact option.

24. Use the Control Panel to play the movie.

The resulting movie should play music throughout the movie. The movie will display a transition after the initial screen, proceed to several screens of high tech photo images, stop at the screen with a Click Here button, and advance to the last screen upon clicking the button. Director does have a large learning curve so if your movie did not play in this manner, you can view the completed movie by opening the HIGHTECH-COMPLETE.DIR file in the LESSON19 directory on the companion CD-ROM that accompanies this book.

The last step you will perform is to export the resulting file as a Shockwave movie for embedding into a Web page. The code to embed the movie is as follows:

```
<EMBED SRC="hightech.dcr" WIDTH="320" HEIGHT="240">
```

To export and embed the resulting Shockwave file, perform the following steps:

1. Select the File menu Save As Shockwave Movie option.

2. Click your mouse on the Save button.

3. Click your mouse on the Start button. Windows, in turn, will display the Start menu.

4. Within the Start menu, select the Programs option and then choose Windows NotePad from Accessories. Windows, in turn, will open the Windows NotePad ASCII text editor.

5. Select the File menu Open option. Windows NotePad, in turn, will display directories and lists of files.

6. Select the SW-CODE.TXT file.

7. Click your mouse on the Open button.

8. Select all the code in the SW-CODE.TXT file.

9. Select the Edit menu Copy option.

10. Select the File menu Open option. Windows NotePad, in turn, will display directories and lists of files.

11. Select the SW-TEST.HTM file.

12. Click your mouse on the Open button.

13. Position your cursor between the <BODY> tags and select the Edit menu Paste option to paste all the code from the SW-CODE.TXT file between the tags. Windows NotePad, in turn, will display the code, as shown in Figure 19.24.

Figure 19.24 The SW-TEST.HTM file with the code as it appears in Windows NotePad.

14. Save your file.

15. Open the SW-TEST.HTM file in Netscape or Internet Explorer. The browser, in turn, will display the Shockwave movie, as shown in Figure 19.25.

Figure 19.25 The Shockwave movie as it appears in your browser.

ADDING A FLASH MOVIE TO A WEB PAGE

To create a Flash movie file requires several steps, which include obtaining the necessary artwork for your project (whether it be using clip media or creating your own artwork), creating your Flash movie using Macromedia Flash, exporting the file to the proper Flash format, and copying the code Flash generates for embedding the resulting file into an HTML file to view with a browser.

Now you are ready to create your first Flash movie. As you have learned, the first step for creating any Flash movie is to obtain the necessary artwork. For the purposes of this lesson, some image files for a movie to use for this exercise are included in the LESSON19 directory on the CD-ROM that accompanies this book. If you have not done so already, copy all of these files to a directory on your hard drive. For this lesson, you will need to use Macromedia Flash to create your Flash movie. For more information on Flash, you can visit Macromedia's Web site at *www.macromedia.com*.

To create a Flash movie for a Web page with *Flash*, perform the following steps:

1. Click your mouse on the Start button. Windows, in turn, will display the Start menu.

2. Within the Start menu, select the Programs option and then choose Macromedia Flash. Windows, in turn, will cascade the Macromedia Flash sub-menu.

3. Within the Macromedia Flash sub-menu, click your mouse on the Flash option. Windows, in turn, will open Macromedia Flash.

Flash's interface, as shown in Figure 19.26, is different in some ways from Director. The Control Panel, Stage, and Tool Box are present but the Timeline, which resembles Director's Score at first glance, is different. The Timeline is made up of one or more layers with frames spanning across the Timeline. All components you add to a movie will reside in the frames of the layers.

Figure 19.26 Flash's Stage, Tool Palette, and Control Panel.

4. Select the File menu Open option. Flash, in turn, will display directories and lists of files.

5. Select the HIGHTECH.FLA file.

6. Click your mouse on the Open button.

7. Select the File menu Import option. Flash, in turn, will display directories and lists of files.

8. Select the sound file (MUSIC.WAV) for the project.

9. Click your mouse on the Open button. Flash, in turn, will add the music file to the first frame.

10. Select the frame in Layer 1 containing the music clip on the Timeline and drag it so it spans to Frame 70.

11. Double-click your mouse on any frame of the music clip in Layer 1 to access Frame Properties.

299

12. Select the Sound tab and choose the music file's name from the drop-down list for sound.

13. Click your mouse on the OK button. Flash, in turn, will activate the music file, as shown in Figure 19.27.

Figure 19.27 The music file activated on the Timeline.

To add items to the Timeline, you should create a separate layer for each item in your movie to make things easier. Thus, to add an item, you will click on the frame in the layer that will be the first position on the Timeline for its appearance.

To add items to the Score, perform the following steps:

1. Select the Insert menu Layer option. Flash, in turn, will add a new layer above the layer for the sound clip.

2. Select the first frame in Layer 2.

3. Select the File menu Import option. Flash, in turn, will display directories and lists of files.

4. Select the first image file (PHOTO0.JPG) for the project.

5. Click your mouse on the Open button. Flash, in turn, will display a dialog box about importing images in a sequence.

6. Click your mouse on No. The image file is in the first frame of Layer 2 and should span across the Timeline to Frame 70 as the music clip. (If it does not, you will need to select and drag the item to make the adjustment.)

7. Select the Insert menu Layer option. Flash, in turn, will add a new layer above the layer for the first image clip.

8. Select the first frame in Layer 3.

9. Select the File menu Import option. Flash, in turn, will display directories and lists of files.

10. Select the second image file (PHOTO6.JPG) for the project.

11. Click your mouse on the Open button. Flash, in turn, will display a dialog box about importing images in a sequence.

12. Click your mouse on No. The image file is in the first frame of Layer 3 and should span across the Timeline to Frame 70, as done in the previous files.

13. Hold the SHIFT key down and click on the first and last frame of the new image.

14. Move the selected item to Frame 35. Flash, in turn, will display the Timeline, as shown in Figure 19.28.

Figure 19.28 The two images in place on the Timeline.

15. Select the Insert menu Layer option. Flash, in turn, will add a new layer above the layer for the second image clip.

16. Click your mouse on Frame 75 in Layer 4.

17. Select the Text Tool in the Tool Box on the left.

18. Click your mouse on the Color Icon to change the text color to white below the Tool Box.

19. Change the font size to 26.

20. Place your cursor on the Stage to add text.

21. Enter Call us today for all your high tech needs!

301

22. Click your mouse on the Select Tool (the arrow icon) from the Tool Box and position the text in the center of the Stage.

23. Click your mouse on the first frame of the text item in Layer 4 and move the text item so it starts at Frame 75.

24. Use the Control Panel to play the movie.

The movie should play sound throughout the entire movie. The first image will appear, the second image will appear, followed by the second image with the text. To view the completed movie, you can open the HIGHTECH-COMPLETE.FLA file in the LESSON19 directory on the companion CD-ROM.

The last step you will perform is to export the resulting file as a Flash movie for embedding into a Web page. As you will see, Flash offers many options for export. For the purpose of this lesson, you will export the movie as a movie to view with the Flash Player. Flash generates the HTML file for you. The code to embed the movie resembles the following:

```
OBJECT classid="clsid:D27CDB6E-AE6D-11cf-96B8-444553540000"

codebase="http://active.macromedia.com/flash2/cabs/swflash.cab#version=4,0,0,0"

ID=hightech-complete WIDTH=320 HEIGHT=240>

<PARAM NAME=movie VALUE="hightech-complete.swf"> <PARAM
NAME=quality VALUE=high> <PARAM NAME=bgcolor VALUE=#000000>
<EMBED src="hightech-complete.swf" quality=high bgcolor=#000000
WIDTH=320 HEIGHT=240 TYPE="application/x-shockwave-flash"
PLUGINSPAGE="http://www.macromedia.com/shockwave/download/
index.cgi?P1_Prod_Version=ShockwaveFlash"></EMBED>

</OBJECT>
```

To export and embed the resulting Flash movie, perform the following steps:

1. Select the File menu Export Movie option.
2. Enter hightech2 for the filename.
3. Select Flash Player for the Save as Type option.
4. Click your mouse on the Save button. Flash, in turn, will display the Export Flash Player dialog box.
5. Enter 80 for JPEG Quality.
6. Select Flash 3 for the Version type.
7. Click your mouse on the OK button. Flash, in turn, will export your movie.

8. Select the File menu Publish option to automatically generate an HTML file with the code in place. Flash, in turn, will place your HTML file with the embedded movie in your project directory.

9. Open the HIGHTECH.HTML file in Netscape or Internet Explorer. Netscape or Internet Explorer, in turn, will display the Flash movie, as shown in Figure 19.29.

Figure 19.29 The Flash movie as it appears in your browser.

WHAT YOU MUST KNOW

As you have learned, Shockwave and Flash movies are easy to add to a Web site and can make an otherwise static Web site more interesting and interactive as well as enhance a site visually with animation, multimedia, and special effects. However, before you can add Shockwave and Flash movies, you should first understand some basic concepts, such as the differences between Director and Flash, the uses of Shockwave and Flash movies, and the advantages and disadvantages of their use. This lesson introduced Shockwave and Flash. In Lesson 20, "Working with Video," you will learn how easy it is to add video clips to your Web pages. Before you continue with Lesson 20, however, make sure you have learned the following key concepts:

✓ Web designers add Shockwave and Flash files to Web pages for several reasons, including to make Web pages more interesting and interactive, to add colorful navigational components, to enhance a site visually with animation, multimedia, and special effects, and to add more complex components, such as online games.

✓ Most Shockwave and Flash movies require a special plug-in that is easy to obtain since many browsers and operating systems include the plug-in. Some Flash and Shockwave movies exported as Java do not need a plug-in to view.

✓ Although they are similar in some features regarding multimedia, Shockwave and Flash do differ in several important ways. Director Shockwave Internet Studio is a full-featured multimedia authoring program. Flash's main focus is multimedia animation for the Web and is easier to learn than Director.

✓ Flash and Shockwave offer Web site designers many advantages, such as they both make Web sites more interesting and interactive, both offer versatility, as well as cross-browser and cross-platform compatibility. Although some Flash and Shockwave movies require a plug-in, Flash and Shockwave offer options for playback without a plug-in that you can export as Java. Flash has a short learning curve and you do not need to do any programming to create Flash movies. Flash movies offer streaming content for fast downloads. Flash and Shockwave's disadvantages include their requirement of a plug-in for viewing, possible long download time for some Shockwave movies, Macromedia Director's high learning curve, and difficulties editing Flash movies with large amounts of text.

✓ To create and add a Shockwave movie to a Web page, you need to obtain the necessary artwork for your project (whether it may be using clip media or creating your own artwork), create your Shockwave movie using Macromedia Director, export the file to the proper Shockwave format, and embed the resulting file into an HTML file to view with a browser.

✓ To create and add a Flash movie to a Web page, you need to obtain the necessary artwork for your project (whether it may be using clip media or creating your own artwork), create your Flash movie using Macromedia Flash, export the file to the proper Flash format, and copy the code Flash generates to embed the resulting file into an HTML file to view with a browser.

✓ Adding Flash and Shockwave movies to a Web page is relatively easy, but some knowledge of Lingo programming concepts may be required for Shockwave's advanced techniques.

LESSON 20

WORKING WITH VIDEO

Web site designers have been able to take advantage of video clips now for several years but only recently has the use of video clips become more popular. Depending on the type of Web site, adding video clips to Web pages can greatly enhance a Web site's effectiveness. You can add video clips in several formats and use video in a variety of ways to communicate ideas. Download time has been a problem in the past for video. However, the emergence of various streaming video options lets video clips download quickly for viewing.

In this lesson, you will learn how to add video to your site. By the time you finish this lesson, you will understand the following key concepts:

- Web designers add video to Web pages for several reasons, including to demonstrate how to perform an action or series of steps, incorporate animation on a Web page, display such information as weather, new music videos, movie previews, news, and much more.

- Several formats are available for common Web video and include AVI, QuickTime (MOV), and MPEG.

- Streaming video technology allows faster download time and has increased the popularity of video on the Web overall. Several streaming video options are available today and include RealVideo, VivoActive, VDOLive, Vxtreme, and NetShow.

- Adding video clips to Web sites offers several advantages, including ease of implementation, no special plug-in required to view AVI and QuickTime files, fast download time with streaming video technology, and cross-browser and cross-platform compatibility, in most cases. Video also has several disadvantages, including requirement of a plug-in for streaming video clips, streaming video's compromise of quality for speed, slow downloading of certain file formats (such as AVI), server storage difficulties for large files, and MPEG videos not displaying well on some systems.

- While many Macintosh systems come with a video capture board, PC owners generally have to buy a separate video capture card to have video capture capability.

- Several video editing programs include Adobe Premiere, Ulead's VideoStudio, MGI Software Corp.'s VideoWave, Avid Technology's Avid Cinema for PC, and IMSI's Lumiere Video Studio.

305

- To add video, you will select a video file or create your own, convert the video file to a proper format and size for the Web, add the appropriate code to your HTML file, and upload the HTML file, the video file, and any other files to your server.

- Adding video to a Web page is easy and generally requires only a few lines of code.

ENHANCING YOUR SITE WITH VIDEO

Several formats are available for common Web video and include AVI, QuickTime (MOV), and MPEG. Other formats exist for streaming video, such as RealVideo, which you will learn about later in this lesson. AVI, which stands for Audio/Video Interleaved, is the standard video format for Windows. You will commonly use this format for Windows-based multimedia presentations. Web designers do not use the AVI file format as much as QuickTime or MPEG for Web video due to problems with audio playback with the video and less than adequate compression for Web site viewing. On the other hand, AVI is cross-browser and cross-platform compatible, does not require special software to view on the Web with a PC, and offers better quality clips for viewing on the Web than streaming video. However, AVI does require a special software called Video for Windows Apple Macintosh utilities to work on Macintosh systems. Creating AVI files is easy since AVI requires no special software. Most standard Windows video capturing and editing programs generate the AVI file format. QuickTime is another cross-browser and cross-platform compatible format that is extremely popular since QuickTime offers better compression over AVI, does not require special software to create a clip or view on the Web with a Macintosh system, and offers high quality clips for Web viewing. Like AVI, Macintosh-based QuickTime does require special software called QuickTime for Windows to view QuickTime files on a PC. Most Mac and PC video capturing and editing software programs let you easily create QuickTime files. MPEG (Motion Picture Experts Group), a file format originally developed for video on CD-ROMs, video games, and the like, is still another option for Web video. The MPEG file offers TV quality full motion video at 30 frames per second (fps). MPEG's main advantage is its high quality videos for the Web at a slightly larger file size than AVI or QuickTime files. However, MPEG video is expensive to digitize and playback. You will need special hardware that costs $4,000 or more to create MPEG videos. Another disadvantage concerns playback. Playback of MPEG videos can vary in quality on PCs and on Macintosh systems, and viewers cannot view MPEG videos at all without a special QuickTime MPEG extension.

Streaming video technology allows faster download time and has increased the popularity of video on the Web overall. Several streaming video options are available today and include RealVideo (*www.real.com*), VivoActive (*www.vivo.com*), VDOLive (*www.vdonet.com*), Vxtreme (*www.vxtreme.net*), and NetShow (*www.microsoft.com/Netshow/*). You can start viewing streaming video clips after a few seconds of loading with a special viewer plug-in that is generally available free of charge. Special compression software on servers allows the transfer of the

streaming video clip to the user's viewer. While streaming video offers fast download time, you compromise speed for quality. The quality of streaming video is generally inferior to QuickTime or AVI. Another drawback is that users need to download a special viewer plug-in to watch the video clip. Some browsers now include the popular Real Player for viewing Real videos, but generally users have to download the special viewer plug-in. Still another disadvantage for streaming video is downloading and, in many cases, paying for a special encoder utility to create the streaming video clips. However, RealNetworks offers its basic RealProducer G2 for free to create streaming videos. RealNetwork's other encoder utilities, RealProducer Pro G2 and RealProducer Plus G2, are also available with more features for a price.

If you like the idea of streaming video but not of the user downloading a special viewer plug-in, you may want to consider Emblaze VideoPro (*www.emblaze.com*). For an estimated price of $295, Emblaze VideoPro lets you easily create streaming video for the Web without the hassles of a required plug-in. You also do not need any special server software to use Emblaze.

You can use video in many ways to enhance a Web site's functionality and promote better communication. For example, you can use video to demonstrate how to accomplish an action or series of steps for education and training. The VTC Online University Web site at *www.vtco.com/vtconline/*, as shown in Figure 20.1, uses QuickTime videos to demonstrate how to use some popular applications, such as MetaCreations Poser.

Figure 20.1 The VTC Online University Web site.

You can see another example of video training at the Seishin Aikido Web site at *www.seishindo.com/gallery/gallery.htm*, as shown in Figure 20.2.

***Figure 20.2** The Seishin Aikido Web site displays QuickTime videos on karate techniques.*

Clicking on one of the links for large or small video clips under each small image displays a QuickTime video of karate instruction in a separate browser window. Another popular use of video is to display the work of animators or 3D artists. For example, the *www.3dtalent.com* Web site, as shown in Figure 20.3, displays QuickTime videos of 3D artist portfolio samples.

***Figure 20.3** The **www.3dtalent.com** Web site displays QuickTime videos of 3D artist portfolio samples.*

You can also use video to display or add an animation effect to a Web page. The Norad Santa Web site at *www.noradsanta.org/english/* plays MPEG video clips of Santa's travels for children, as shown in Figure 20.4.

Figure 20.4 *The Norad Santa Web site plays MPEG video clips of Santa's travels for children.*

Pixar's Web page for the Animation Film Festival's short clips at *www.pixar.com/shorts/geri/geri.html* displays an animation as a QuickTime video clip, as shown in Figure 20.5.

Figure 20.5 *Pixar's Web page for the Animation Film Festival's short clips.*

You can also convert video clips to GIF animations made up of several frames from the video. The tiny video clip under The Visual Magic Magazine title at *www.visualmagic.awn.com*, as shown in Figure 20.6, shows a GIF animation of video frames.

Figure 20.6 The tiny video clip under the Visual Magic Magazine title is a GIF animation.

Many Web sites, such as the MTV Web site at *www.mtv.com*, use video clips to display music videos. Each QuickTime Video clip appears in a new browser window, as shown in Figure 20.7.

*Figure 20.7 The MTV Web site at **www.mtv.com** uses QuickTime video clips.*

Some music archive sites, such as SONICNET at *www.sonic.com*, as shown in Figure 20.8, let users sample music video clips using Real Player.

Figure 20.8 Some music archive sites let users sample music video clips using RealPlayer.

Many movie viewers' Web sites now take advantage of the technology to display video clips of movie previews. For example, Sony's Web site at *www.sony.com* displays many video previews in QuickTime format, as shown in Figure 20.9.

311

*Figure 20.9 Sony's Web site at **www.sony.com** now displays many video previews in QuickTime format.*

Many Web sites for actual movies, such as the Patch Adams Web site at *www.patchadams.com*, offer movie previews in one or two formats, as shown in Figure 20.10.

Figure 20.10 *The Patch Adams Web site offers both QuickTime and RealVideo clips.*

News and current weather information are also common uses for Web video. For example, the New England Cable News Web site at *www.necnews.com*, as shown in Figure 20.11, offers users some video clips of both past and current news segments in RealVideo format.

Figure 20.11 *The New England Cable News Web site offers users RealVideo clip news segments.*

Weather can also be a good use for video. For example, see the QuickTime weather videos for the Weather Channel at *www.apple.com/quicktime/showcase/news/weatherchannel/*, as shown in Figure 20.12.

Figure 20.12 *Some QuickTime weather videos for the Weather Channel.*

Adding video clips to Web sites offers several advantages. For example, video clips are easy to add to Web sites. Both QuickTime and AVI files only require a few lines of code as you will learn later in this lesson. You do not need a special plug-in to view AVI and QuickTime files. Although Mac and PCs may need certain software to run AVI and QuickTime files, the software is generally included with operating systems, such as Windows and other software application setup utilities. Streaming video requires a few lines of code and conversion of your clip to the streaming file format. In most cases, you can create streaming video clips with an easy-to-use encoder utility. Streaming video also offers fast download time. Another advantage is cross-browser and cross-platform compatibility. Except for MPEG, as noted earlier, you can view most common video formats with most browsers and on both PCs and Macintosh systems. Video also has several disadvantages. For example, streaming technology requires a special plug-in to view the video clip and, in some cases, greatly compromises quality for speed. You must also use a special encoder utility that can be expensive, in some cases, to create streaming video. Another problem with video clips is that certain file formats, such as AVI, take a long time to download and the audio may not be in synch with the video itself. Large video files make storage difficult on many servers. Another disadvantage concerns playback. Playback of the high quality MPEG videos can vary in quality on PCs and on Macintosh systems, and viewers cannot view MPEG videos at all without a special QuickTime MPEG extension.

PREPARING THE VIDEO FILE FOR THE WEB

You have two options for obtaining video for the Web. First, many video resources are now available on CD-ROM. You can also download videos from the Internet. For example, the Sci Fi Channel's Free Zone at *www.scifi.com/freezone/*, as shown in Figure 20.13, has many video clips you can download.

Figure 20.13 *The Sci Fi Channel's Free Zone at **www.scifi.com/freezone**.*

Second, you can shoot your own video and digitize it for the Web. If you choose to create your own video for the Web, you should avoid using the zoom feature and making any unnecessary movements with your camera, such as panning and tilting. Be sure to leave adequate space to crop your video. You should also try to get as close to your subject as possible. High quality audio is important too since you will compress the video for the Web. You should use an external microphone to get the best quality audio possible.

For video capture, you probably need at least a 200-MHz Pentium with 32MB or RAM and a video capture card. You could possibly get by with a lesser system but, for best results, a more powerful system is recommended. Many Macintosh systems come with a video capture board. However, PC owners generally have to buy a separate video capture card to have video capture capability. Some video cards, such as the ATI All in Wonder Pro, include video capture capabilities for under $300. After you read the manual and are set up with a video capture card, you will need a software program for capturing and editing the video clip. Generally, most video capture cards come with such software. However, Adobe Premiere, as shown in Figure 20.14, has become the standard for video editing and is also quite expensive at $795.

Figure 20.14 *The popular Adobe Premiere lets you edit video for the Web.*

Several less expensive video editing programs are available and include Ulead's VideoStudio for $99.95 (a trial copy of this software is included on the accompanying CD), MGI Software Corp.'s VideoWave for around $100, Avid Technology's Avid Cinema for PC for $84.95, and IMSI's Lumiere Video Studio for $79.95.

Adobe Premiere is a good choice for capturing and editing Web video and modifying video settings, as shown in Figure 20.15.

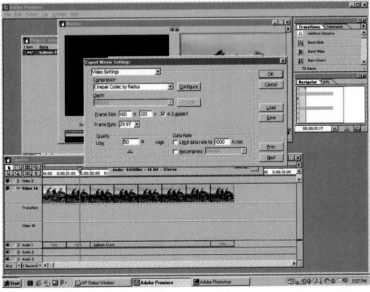

Figure 20.15 *Adobe Premiere lets you modify various video settings.*

No matter what program you use to edit your captured video clip for the Web, you should modify several settings to make your Web video files as small as possible. For example, you should change the actual physical size of the video to 160 x 120. You can set the size for a larger view, but this will increase the file size. You should also set the video rate to 10 fps (frames per second). Video playback on the Web will be adequate at this setting. If you plan to upload your video as a regular AVI or QuickTime video file, then be sure to set the compression. Cinepak compression is compatible with Macs and PCs. Quality should be set at about 50%, which is fine for Web video. If you plan to use streaming video, set the video compression setting for uncompressed video and the quality for 100%. Audio settings you should change include the format and rate. A setting of 16-bit mono for format and 22kHz for the rate are the recommended choices. You do not have to worry about the audio compression setting for QuickTime files since QuickTime automatically adjusts the compression for you. However, you should set the AVI files' audio setting for uncompressed audio.

CREATING A REALVIDEO CLIP

Creating a RealVideo clip is easy with RealVideo's RealProducer. You can download a free copy at *www.real.com/products/tools/index.html*. After using RealProducer to capture a video clip or import an existing 160 x 120 video clip, you simply change a few settings, such as the modem speed for the target audience, audio format, video quality, and file type, as shown in Figure 20.16.

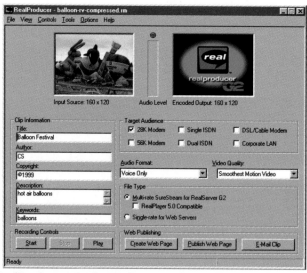

Figure 20.16 The RealProducer encoding software with options for various video settings.

Click your mouse on the Start button. RealProducer, in turn, will convert your file to a RealVideo file. RealProducer also creates a Web page for you with all the code to view the newly created file in place. Just click on the Create Web Page button and the Web Page Wizard will help you with various selections, such as embedded or pop-up player, RealPlayer Control layout Options, AutoStart, and caption. You can use the resulting file for displaying your streaming video clip or

you can copy and paste the code from this file to the Web page you want the clip to appear on. To view an example of a RealVideo file, open the REAL-VIDEO.HTM file included in the LESSON 20 directory on the CD-ROM that accompanies this book.

ADDING A VIDEO CLIP TO A WEB PAGE

You can add an AVI or QuickTime video in two ways to your Web site. First, you can let users click on a link to download a video for viewing. The tag looks similar to the following example for a QuickTime movie:

```
<a href="filename.mov">Download QuickTime movie</a>
```

The tag looks similar for an AVI movie:

```
<a href="filename.avi"> the AVI movie</a>.
```

To view an example of the download method for both AVI and QuickTime files, you can open the DOWNLOAD-VIDEO.HTM file included in the LESSON 20 directory on the CD-ROM that accompanies this book. The second way to add a video clip to a Web page is to use the <EMBED> tag that lets the user play the video. However, using the <EMBED> tag does not guarantee the video will play on the Web page. Some users have certain AVI and QuickTime plug-ins that will make the video play in a new browser window. The <EMBED> tag to play a 160 x 120 QuickTime video looks similar to the following:

```
<EMBED SRC=" filename.mov " WIDTH="160" HEIGHT="138">
```

As you can see, the <EMBED> tag height setting adds an extra 18 pixels for the controls that will appear below the video clip. The <EMBED> tag to play a 160 x 120 AVI video looks something like this:

```
<EMBED SRC=" filename.avi " WIDTH="164" HEIGHT="155">
```

Again, the <EMBED> tag width and height settings add extra pixels for the video controls. To view an example of the download method for both AVI and QuickTime files, you can open the EMBED-VIDEO.HTM file included in the LESSON 20 directory on the companion CD-ROM that accompanies this book. You can also add several attributes to control the playing of the video, as follows:

```
<EMBED SRC=" filename.mov " WIDTH="164" HEIGHT="155"
PLUGINSPAGE="http://www.apple.com/quicktime/" LOOP="false">
```

The above code includes various attributes for playback. If you set the controller attribute to *true*, viewers can play, pause, and stop the movie. If you set the controller attribute to *false*, be sure to adjust the width and height for the video to 160 x 120 since the controls will not be present below **317**

the video clip. The autoplay attribute set to *true* will let the video play automatically as the user enters the page. If you set the attribute to false then the user must click to play. You can also use the pluginspage attribute to specify the URL to go to if the user does not have the required plug-in to play the video. In addition, you can set the loop attribute to *true* to have the video play continuously or to *palindrome* to have the video play through once, and then play in reverse continuously. If you set the loop attribute to false, the video will only play once.

Now you are ready to add your first video clip to your Web page. In this lesson, you will add a QuickTime file called BALLOON-COMPRESSED.MOV. All the files you need to use for this exercise are in the LESSON20 directory on the CD-ROM that accompanies this book. Copy all of these files to a directory on your hard drive. The first step in adding the QuickTime file to your Web page is to add the code to your HTML file. For the purposes of this lesson, the code to embed the QuickTime file is provided for you. An example of how the code looks that you will add to your HTML document is as follows:

```
<EMBED SRC=" balloon-compressed.mov " WIDTH="164" HEIGHT="155"
PLUGINSPAGE="http://www.apple.com/quicktime/" LOOP="false">
```

To add the above code to your HTML document, perform the following steps:

1. Click your mouse on the Start button. Windows, in turn, will display the Start menu.

2. Within the Start menu, select the Programs option and then choose Windows NotePad from Accessories. Windows, in turn, will open the Windows NotePad ASCII text editor.

3. Select the File menu Open option. Windows NotePad, in turn, will display directories and lists of files.

4. Select the video-code.txt file.

5. Click your mouse on the Open button.

6. Select all the code in the video-code.txt file.

7. Select the Edit menu Copy option.

8. Select the File menu Open option. Windows NotePad, in turn, will display directories and lists of files.

9. Select the video-code.txt file.

10. Click your mouse on the Open button.

11. Select the Edit menu Paste option to paste all the code from the video-code.txt file between the <BODY> tags. Windows NotePad, in turn, will display the code, as shown in Figure 20.17.

Figure 20.17 The VIDEO-TEST.HTM file with the code as it appears in Windows NotePad.

12. Open the VIDEO-TEST.HTM file in Netscape or Internet Explorer to see the QuickTime file in the browser window, as shown in Figure 20.18.

Figure 20.18 The VIDEO-TEST.HTM file as it appears in Netscape.

ADDING VIDEO TO A WEB PAGE USING FRONTPAGE 2000

Adding video to a Web page is easy with FrontPage 2000. To add an AVI video clip using FrontPage 2000, perform the following steps:

1. Click your mouse on the Start button. Windows, in turn, will display the Start menu.

2. Within the Start menu, select the Programs option and then choose Microsoft FrontPage. Windows, in turn, will open the FrontPage Editor.

3. Click your mouse on the File menu Open Web option. FrontPage, in turn, will display the Open Web dialog box.

4. Enter a Folder name and click your mouse on Open.

5. Select the Insert menu Picture option, then select Picture from options and the Video option. FrontPage, in turn, will display a list of files.

6. Select the BALLOON-COMPRESSED.AVI file, then click your mouse on the OK button. FrontPage, in turn, will display the video clip on the Web page.

7. Right-click your mouse on the video while in Page View. FrontPage, in turn, cascades a menu from which you can choose Picture Properties.

8. Select the Video tab. FrontPage, in turn, will display various setting options for the video clip, as shown in Figure 20.19.

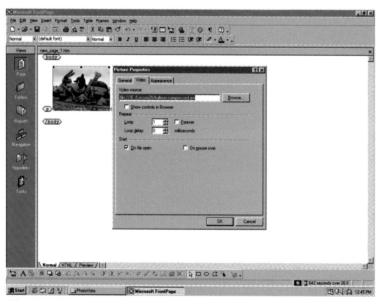

Figure 20.19 *The FrontPage 2000 Picture Properties window settings for video.*

9. Select 1 for the Loop setting and place a mark in the On file open checkbox for the Start option.

10. Click your mouse on the OK button.

11. Publish and upload your page to your server.

12. Save your file.

13. Select the File menu Preview in browser option to view your video file in a browser, as shown in Figure 20.20.

Figure 20.20 *The FrontPage 2000 video clip as it appears on the page in Internet Explorer.*

WHAT YOU MUST KNOW

As you have learned, video is easy to add to a Web site and can make a Web site more interesting and enhance communication, if used effectively. However, before you can add video, you should first understand some basic concepts, such as video file format types, streaming video, and the advantages and disadvantages of adding video to Web pages. This lesson introduced video. In Lesson 21, "Maintaining and Using Site Statistics," you will learn how to use site statistics for your Web site. Before you continue with Lesson 21, however, make sure you understand the following key concepts:

✓ Web designers add video to Web pages for several reasons, including to demonstrate how to perform an action or series of steps, incorporate animation on a Web page, display such information as weather, new music videos, movie previews, news, and much more.

✓ Several formats for common Web video include AVI, QuickTime (MOV), and MPEG.

321

✓ Streaming video technology allows faster download time and has increased the popularity of video on the Web overall. Several streaming video options are available today and include RealVideo, VivoActive, VDOLive, Vxtreme, and NetShow.

✓ Adding video clips to Web sites offers several advantages, including ease of implementation, no special plug-in required to view AVI and QuickTime files, fast download time with streaming video technology, and cross-browser and cross-platform compatibility, in most cases. Video also has several disadvantages, including requirement of a plug-in for streaming video clips, streaming video's compromise of quality for speed, slow downloading of certain file formats (such as AVI), server storage difficulties for large files, and MPEG videos not displaying well on some systems.

✓ While many Macintosh systems come with a video capture board, PC owners generally have to buy a separate video capture card to have video capture capability.

✓ Video editing programs include Adobe Premiere, Ulead's VideoStudio, MGI Software Corp.'s VideoWave, Avid Technology's Avid Cinema for PC, and IMSI's Lumiere Video Studio.

✓ To add video, you will select a video file or create your own, convert the video file to a proper format and size for the Web, add the appropriate code to your HTML file, and upload the HTML file, the video file, and any other files to your server

✓ Adding video to a Web page is easy and generally requires only a few lines of code.

LESSON 21

MAINTAINING AND USING SITE STATISTICS

In Lesson 3, you learned about the counter's role in determining how much traffic a Web site receives. As you also learned, counters are limited and unreliable as to how many users really visit your Web site. Most counters also provide no details about users except a number that gives a rough idea about the number of visits to your Web site. While counters are fine for personal Web sites, both small business and commercial Web sites require more than just a counter to measure Web traffic. Fortunately, today, many options are available to study a Web site's traffic in detail and help you improve your Web site.

In this lesson, you will learn how to use Web site statistics to find out more about users and how to use the results to improve your Web site pages. By the time you finish this lesson, you will understand the following key concepts:

- ◆ Web statistics is the analysis of traffic a Web site receives by using a Web site's log file, an ASCII text file that retains various bits of information about a user's visit to a Web site. The useful information Web statistics provides includes which pages are most popular, when and how often Web pages are accessed, the type of browser used, occurrence of errors during the visit, the URL that the visitor was sent from to your Web site, and much more.

- ◆ Several reasons to measure Web traffic include to study a business and develop strategies, to acquire marketing and advertising statistics, and to use statistics as justification for added business expenditures.

- ◆ Many Web statistic services and software programs are available for use and include shareware and freeware and more sophisticated commercial programs. Web site analysis software programs take raw data, such as the log file, and display the information as easy-to-understand charts, graphs, and tables.

- ◆ Most Web statistic services and software programs provide information such as visitor count, average page views per visitor, average length of page view, overall length of a site visit, average number of hits per visitor, peak hours and days, geographical areas, most popular pages, and the most recent page requests.

- ◆ You can revise your Web site pages and components based on the Web tracking software's results. For example, you may have to add, revise, or remove certain components or revise Web components for different user systems or displays.

WHAT ARE WEB SITE STATISTICS

You can use both Web statistics and cookies to obtain valuable information about users. As you learned in Lesson 16, cookies store various types of information (such as users' online purchases), personalize Web sites, track Web site navigation, retrieve information for target marketing, and more. Web statistics also obtain valuable information. Web statistics means the analysis of traffic a Web site receives by using a Web site's log file, which is an ASCII text file that retains various bits of information about a user's visit to a Web site. The useful information Web statistics provides includes which pages are most popular, when and how often Web pages are accessed, the type of browser used, occurrence of errors during the visit, the URL that the visitor was sent from to your Web site, and much more. As shown in Figure 21.1, the sample log file contains many entries with the visitor's host name, date and time, the URL of site pages and graphics, and more.

Figure 21.1 A sample Web site log file.

The following is a sample entry line:

> 207.87.178.66 - - [02/Jun/1999:13:01:57 -0400] "GET /rei/re-score.htm HTTP/1.1" 200 1609

As you can see, the host is 207.87.178.66. The first hyphen (-) means you could not retrieve a user name for the visitor. The second hyphen means the user's log name is not available. Next, the date stamp follows with the date and time of access. The next item is the retrieval method, which can be GET, POST, PUT, or HEAD. The retrieval method in this entry line is GET. After the retrieval method, a code displays the result of the access attempt. The code in the above status line is 200 and means access was successful. A code value of 304 indicates the file was reloaded from cache. Codes of 4XX or 5XX generally mean errors of some type. For example, a 400 code

indicates an invalid request. A 401 or 403 code means the user was forbidden to access the file. If the file was not found, the code would be 404. Server error codes are 500 for internal server errors, 502 for bad gateway, and 503 for unavailable service. The last item in the entry line indicates the number of bytes the log file retrieves from the accessed file. Log files are difficult to read in raw form. Fortunately, many Web analysis software programs and services are available, as you will learn about later in this lesson.

Log files generally reside in a subdirectory called logs (or other similar names) or at various locations on your server. If you cannot find a log file, you should contact your system administrator for assistance.

Each time a user accesses a file at your Web site is known as a hit. For example, one Web page with four graphics files and one sound file generates six hits. One hit equals the Web page itself. The four graphics represent another four hits. The sound file adds one hit for a total of six hits. Hits do not provide accurate site popularity ratings since one page can have many graphics and other Web components. You should go by actual page views for a better idea of site popularity. Page views include all log file entries for one Web page, including the page itself and its components.

Web statistics, cookies, and counters are not the only way to get an idea of Web traffic and who makes up your Web site's audience. You can also install a guest book at your Web site. A guest book will provide a lot of input as to what types of people come to your Web site. Some helpful resources for guest books include *www.freecode.com*, *www.worldwidemart.com/scripts/*, and *www.davecentral.com*.

REASONS TO MEASURE WEB TRAFFIC

Several reasons to measure Web traffic include to study a business and develop strategies, to acquire marketing and advertising statistics, and to use statistics as justification for added business expenditures. Studying Web traffic can help companies develop business strategies. For example, Web statistics provide information about where users go when they visit your Web site. By knowing what pages are most popular on your Web site, you can add more information on the same topic to keep users coming back to your site or expand on a topic to attract new users to the site. If certain Web site pages receive few visits, then you may want to delete the information from the site or modify it in some manner to attract the audience. Web statistics also provide other information, such as how long visitors remain at a Web page and what time of the day your Web site is the most popular. By knowing how long visitors tend to remain on a Web page, you can get an idea if you should revise the page content or remove the Web page from the Web site altogether. If you know when most users tend to use your Web site, then you can add new material right before peak viewing times. You can also find out what type of users visit your Web site. For example, if a domain has an EDU extension, then users may be from a university or other educational organization. GOV extensions represent government agencies and ORG extensions are for non-profit organizations. Sometimes you may see domains that include an abbreviation for the state the user is from, as indicated in bold in the log file entry below:

> barney.itg.state.mn.us - - [03/Jun/1999:00:16:09 -0400] "GET /techbooks/ HTTP/
> 1.0" 200 5522

You also may see domains with extensions of au representing Australia, or extensions for other foreign countries, indicating users from foreign countries that show an interest in your Web site. You can also use Web statistics for Web marketing and advertising. You can, for example, show potential advertisers how popular your Web site is and persuade them to place a banner ad on the Web site. If the statistics show that one section of your Web site is more popular than another section, you can target potential advertisers for the popular section only. Obtaining information about users' occupations, hobbies, and other personal information can also be useful for advertising and marketing. Microsoft and Netscape are developing ways to ensure user profiles will be available in the future for Web statistics. Currently, you can obtain this information by having users fill out a form and store the information in a database for analysis. Another use of Web statistics is for justifying business expenses. For example, Web site statistics that show a Web site that is receiving heavy traffic can justify the cost of more server disk space and the like.

WEB STATISTICS SOFTWARE AND SERVICES

Many Web statistic services and software options are available for use and include shareware freeware, freeware, and more sophisticated commercial programs. Web site analysis software programs take raw data, such as the log file, and display the information as easy-to-understand charts, graphs, and tables. The low-end programs may display a simple list. High-end programs can display information in many ways and some can access databases. Most Web statistic services and software programs provide the following types of information: visitor count, average page views per visitor, average length of page view, overall length of site visit, average number of hits per visitor, peak hours and days, geographical areas, most popular pages, and the most recent page requests.

Some general features to look for in Web analysis software include real-time reporting, ability to view in several formats, whether it be a spreadsheet or Web page, ease of use, and ability to handle larger Web sites. You should also be aware that some Web analysis software programs work on the server, while other analysis programs and services require you to download your log file for analysis.

A variety of online Web analysis services are available. For example, Web Site Garage's Hitometer, as shown in Figure 21.2, is a utility that you pay to use online at *www.websitegarage.com*.

Hitometer offers complete analysis of your Web site's traffic, including hits on a daily, weekly, and monthly basis as well as the user's browser, platform, screen display setting, JavaScript usage, keyword used in search, top domains visiting your site, most commonly accessed pages, choice of search engine, and more. As shown in Figures 21.3, 21.4, 21.5, 21.6, and 21.7, Hitometer displays results for hits by month, user browser/platform, time and date, video characteristics, and top domains visiting the site in easy-to-understand charts and graphs.

Figure 21.2 The Web Site Garage's Hitometor Utility.

Figure 21.3 A sample Hitometer chart for Hits by Month.

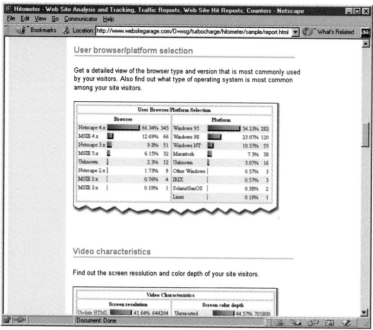

Figure 21.4 A sample Hitometer chart for User browser/platform.

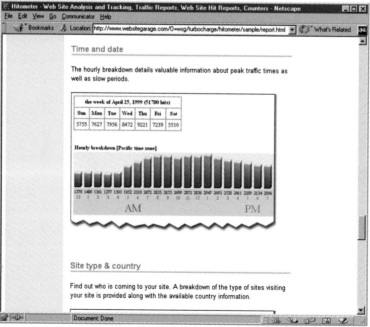

Figure 21.5 A sample Hitometer chart for time and date.

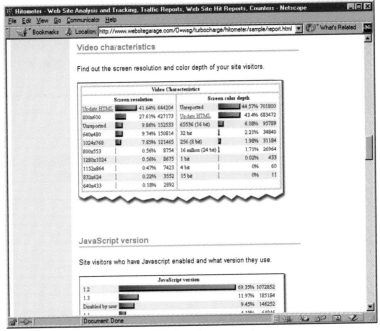

Figure 21.6 A sample Hitometer chart for video characteristics.

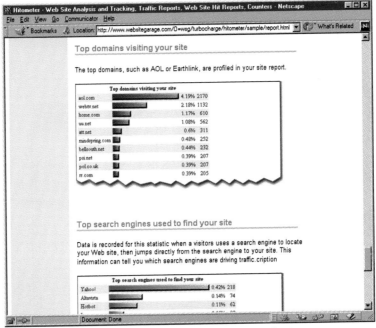

Figure 21.7 A sample Hitometer chart for top domains visiting the Site.

Other Web tracking services are more sophisticated, as well as expensive, and include NetCount, BPA International, and Internet Profile (I/Pro) Netline and I/Audit. Web rating services are also available and are similar to TV's Nielson ratings. The Web rating services, such as RelevantKnowledge, MBInteractive, and Media Metrix, offer valuable information about Web sites' audiences.

Several shareware/freeware Web statistics programs are available for analyzing logo files, such as *wwwstat*, available for free at *www.ics.uci.edu/pub/websoft/wwwstat/*. As shown in Figures 21.8 and 21.9, *wwwstat* displays results as text charts and lists.

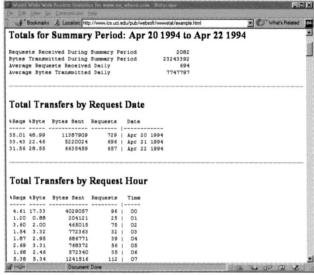

Figure 21.8 A sample wwwstat text chart for summary, date, and hour.

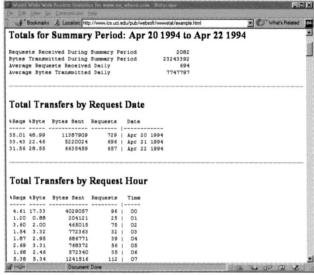

Figure 21.9 A sample wwwstat text chart for total transfers by Client Domain.

Analog 2.0, available at *www.statslab.cam.ac.uk/~sret1/analog*, uses both text and graphics to display its results, as shown in Figure 21.10

Figure 21.10 Sample Analog results for monthly activity.

Commercial software varies in price from generally a few hundred dollars to thousands of dollars. An example of a low cost program fine for smaller businesses is WebTrends. WebTrends uses log files to analyze traffic. One problem with log files is. Log files can get rather large. Today, some Web analysis programs do not use log files at all. For example, Andromedia's Aria performs dynamic analysis on users and does not use log files at all. However, Aria is much more expensive than Webtrends and costs $9,895. Other commercial Web tracking software products include net.Genesis net.Analysis, Marketwave Hit List, and Accrue Insight. FirstPlace Software's WebPosition Gold is another low cost commercial software program that not only analyzes Web traffic but provides several other tools that analyze your Web site to better position it in the search engines, as well as for automatic submission into the major search engines, and much more. WebPosition Gold is easy to use and includes a set up wizard utility, as shown in Figure 21.11, to help you enter information needed for using its tools. WebPosition Gold also helps you with such items as Meta Tags and Descriptions (the tags found at the top of your Web pages that search engines use for placement and classification) and provides helpful hints specific to the major search engines about how to get the best positioning possible. You can download a free trial copy of WebPosition Gold at *www.webposition.com*.

Figure 21.11 WebPosition Gold's set up wizard lets you easily enter information to use the tools.

REDESIGNING BASED ON RESULTS

After you use Web tracking software, you can revise your Web site pages and components based on the results. For example, if you find users are leaving a certain Web page quickly, you may want to revise or remove a component found on that Web page that may not be working properly or is taking too long to download. The Web tracking results could also show that a certain Web page is very popular and has a cool DHTML, a Flash animation, or effect on it. You can consider adding some effects to other Web pages on your Web site. Another example of using Web statistics to redesign Web pages, but you need to be aware of certain information about users systems, browsers, and display settings. For example, if you find most of your audience uses older systems with displays with 256 colors, you may decide to redesign certain graphics and animations for better display at this color setting and remove components, such as video clips, that require more powerful systems for best results. Likewise, if the opposite is true and your main audience has more powerful systems, then you should consider adding Shockwave animation, video, and other components.

WHAT YOU MUST KNOW

As you have learned, Web statistics can provide valuable information to help you redesign your Web site to fit your targeted audience. However, before you start redesigning your Web site, you should first understand some basic concepts, such as the reasons to measure Web site traffic, the different software options and services available for Web site statistics, and how to use the results for redesigning. This lesson introduced Web site statistics. In Lesson 22, "Design Considerations for Animated Web Sites," you will learn how to decrease the time it takes your Web site to

download and how to design Web pages for various screen display sizes. Before you continue with Lesson 22, however, make sure you understand the following key concepts:

✓ Web statistics is the analysis of traffic a Web site receives by using a Web site's log file. The useful information Web statistics provides includes which pages are most popular, when and how often Web pages are accessed, the type of browser used, occurrence of errors during the visit, the URL that the visitor was sent from to your Web site, and much more.

✓ Several reasons to measure Web traffic include to study a business and develop strategies, to acquire marketing and advertising statistics, and to use statistics as justification for added business expenditures.

✓ Many Web statistic services and software programs are available for use and include shareware and freeware, and more sophisticated commercial programs.

✓ Most Web statistic services and software programs provide information such as visitor count, average page views per visitor, average length of page view, overall length of a site visit, average number of hits per visitor, peak hours and days, geographical areas, most popular pages, and the most recent page requests.

✓ You can revise your Web site pages and components based on the Web tracking software's results. For example, you may have to add, revise, or remove certain components or revise Web components for different user systems or displays.

LESSON 22

DESIGN CONSIDERATIONS FOR ANIMATED WEB SITES

Web sites with animation, sound, video, and other enhancements can be interesting and promote user interactivity. However, Web sites with all the bells and whistles can also take too long to download and discourage users. Fortunately, a wealth of techniques and options are available to help keep download time to a minimum.

In this lesson, you will learn how to decrease the time it takes your Web site to download and how to design Web pages for various screen display sizes. By the time you finish this lesson, you will understand the following key concepts:

- Bandwidth, which is the transfer rate of data to the user's browser, has hindered the development of Web sites with multiple multimedia effects and enhancements.

- Many techniques and options are available to help keep Web site graphics and animation download time to a minimum and include use of tables, color reduction and optimization of graphics, use of thumbnails, reuse of images, optimal placements of scripts, and selection of fast-loading type of Web technologies, when appropriate.

- Several online Web software tools are available to perform various tests on your Web sites, such as Web Site Garage, SiteScan Survey, Pehtoori (the HTML Validation Service), Link Alarm, and Site Inspector.

- Two design considerations include designing to fit screen resolution of most monitors and using components that are compatible with most browsers and systems.

BANDWIDTH ISSUES

Bandwidth, which is the transfer rate of data to the user's browser, has hindered the development of Web sites with multiple multimedia effects and enhancements. It was not long ago that the norm was the 14.4K modem. Today, many users still use 28.8K modems for surfing, but bandwidth must still be a concern to Web site designers. However, with technological advances such as 56K modems, fast cable modems, T1 lines, (DSL) Digital Subscriber Line, ISDN (Integrated Services Digital Network), and the like, bandwidth will be less of a concern in the future. However, today you must still design Web sites with bandwidth limitations in mind.

Many techniques and options are available to help keep Web site graphics and animation download time to a minimum. The following Tips will help you create Web pages that load as quickly as possible.

Use tables for putting graphics together to reduce the size of a GIF animation. Depending on what your animation is like, tables can help reduce its overall file size. For example, you may have an image you want to animate, but only a small part of the image will actually be the animation. You can manually cut up the image into different pieces using a program like PhotoShop, or automatically, using a special utility like Ulead SmartSaver Pro. If you use PhotoShop, you must put the resulting graphics back together in your HTML Editor using table cells. Programs like Ulead SmartSaver Pro create the HTML file with the graphics already in the table cells. By slicing up your image into sections, the small part of the image that animates will now be in a table cell by itself. The rest of the image in the other table cells does not become part of the actual animation file, thus reducing file size.

Reduce the color palette of your GIF animation. You can greatly reduce the size of your GIF animation by reducing the number of colors in its color palette. For example, if you have a 256-color image and decrease its colors to 64, the size of the animation will be significantly smaller. However, too much color reduction may have an effect on image quality. Obviously, some complexities exist for animated GIF creation. Fortunately, several software options are available that help with palette and overall GIF animation optimization, such as Equilibrium's Debabilizer, Digital Frontier's HVS ColorGIF, Ulead's GIF Animator, as well as online GIF optimizing services, such as GIF Wizard and GIF Cruncher.

Optimize your GIF animation. You can optimize individual GIF animation frames using one or more of three methods. These methods include the minimum bounding rectangle method, frame differencing, and LZW optimization. Software programs that use one or several of these methods include GIF Wizard, Ulead SmartSaver, Macromedia's Fireworks, Ulead's GIF Animator 3.0, and BoxTop Software's GIFMation. The minimum bounding rectangle method is an optimization method where the first animation frame is full-size and other frames include only the parts that change. Frame differencing is similar to the minimum bounding rectangle method except it saves only the pixels that change in the animation frames. LZW optimization is a type of lossless compression for GIF and TIFF images. It removes unnecessary image details and color changes your eyes cannot see.

Reuse images throughout a Web site. Reusing images, if possible, is another way to decrease download time since the browser downloads and places the image in the PC's cache. For example, if you use an image on your home page and then use the same image on four other pages of your

Web site, the image has to download just once. Thus, download time is kept to a minimum since one image downloads instead of five separate images.

Specify HEIGHT and WIDTH in your HTML code for your animated GIF images. You should always specify HEIGHT and WIDTH in your HTML code for your animated GIF images. If you do not specify HEIGHT and WIDTH in your HTML code, then the browser will wait for the graphic to load before loading the text. You should also beware that setting the HEIGHT and WIDTH in your HTML code to a size smaller than the graphic will not reduce download time since the image's file size will remain the same as it was before.

Be sure to always check your image's resolution before uploading it to a server. You should always be sure your image's resolution is 72 dpi.

Specify a low-res image to display as a high-res image loads. You can create a low-res variation of a JPG or GIF image to appear while waiting for the high-res image to finish downloading. When you do this, the page appears to load much faster to the user. In reality, the extra image actually adds to the total download time. To add a low-res variation, you simply add an attribute to the image tag like the following:

```
<IMG src="image-high-res.gif" lowsrc="image-low-res.gif">
```

Be sure to use JPGs for colorful photographic images. While you could compress your photographic images as GIF images, JPEG compresses colorful images with generally better results since JPG images offer 24-bit color compared to GIF images' 256 colors.

Substitute thumbnail images for larger images on a Web page. If at all possible, you many want to display thumbnail images on a Web page that the user can click on for a full-size view.

Show only important parts of an image. Be sure your images display only the most important details by cropping unnecessary parts of the image.

Use interlaced JPG and GIF images. You can save your images as interlaced JPG and GIF images that will display a preview of the images as they load.

Offer a scaled-down version of your Web site to users. If you created a site that includes many graphics, animation, Java, DHTML, and other components, you may want to consider creating a version of the Web site without the extra components for the few users with 14.4 modems.

Use separate and multiple tables to display graphics and information. If you have a table that contains many types of Web elements, you should break it into several separate tables, if at all possible. If you leave all elements in one table, then a user's browser must load the entire table before it displays the elements. The same is true if you have many nested tables within other tables since it increases download time. You should use separate tables as much as possible.

Place scripts within the <HEAD> tags. You usually place the <SCRIPT> tags within the <HEAD> tags of your HTML document. By placing the script within the <HEAD> tags, the script will load before the page displays.

Use JavaScript or DHTML rather than Java or CGI. Both CGI scripts and Java applets take longer to load than DHTML or JavaScript.

Set up push channels that do not download during peak hours. Download of information will be much faster during hours when users are not using the Internet.

Recommend the use of the latest browsers. Using the latest browser versions will enhance a Web site's performance in many cases. Be sure to recommend that a user upgrade his or her browser to the latest version.

Use Java applets only if they are truly functional. Because all Java applets require the download of the Java Virtual Machine, they increase download time. Be sure your Java applets actually serve a purpose on a Web page. For example, if your Java applet displays an animation, you may want to consider recreating the animation as a GIF animation or use a different technology, such as JavaScript or DHTML.

Use only fast-loading audio and video. Many options are now available for streaming audio and video for quick downloads. You can also select a fast-loading technology for your audio or video clip, for example, MIDI files are small in size.

USING ONLINE WEB SOFTWARE TOOLS

Several online Web software tools are available to perform various tests on your Web sites, including Web Site Garage, SiteScan Survey, Pehtoori (the HTML Validation Service), Link Alarm, and Site Inspector.

Web Site Garage, as shown in Figure 22.1, at *www.websitegarage.com*, offers several utilities that maintain and improve your Web site.

*Figure 22.1 The Web Site Garage Web site at **www.websitegarage.com**.*

337

Web Site Garage's Tune Up, as shown in Figure 22.2, is a utility that you pay to use online. You do not have to install any software program on your system. Web Site Garage also offers a free test for one Web page of your site.

Figure 22.2 The Web Site Garage's Tune Up utility.

As shown in Figure 22.3, Tune Up runs diagnostics that check for browser compatibility, Register-It! Readiness, download time, dead links, link popularity, and HTML check.

Figure 22.3 A sample Web Site Garage's Tune up test.

Web Site Garage's GIF Lube, as shown in Figure 22.4, is another utility that you pay to use online. GIF Lube optimizes your graphics and provides some options for special effects, animation settings, and image resizing.

Figure 22.4 The Web Site Garage's GIF Lube utility.

Web Site Garage's Hitometer, as shown in Figure 22.5, is a third utility that you pay to use online. Hitometer offers complete analysis of your Web site's traffic, including hits on a daily, weekly, and monthly basis, as well as the user's browser, platform, screen display setting, JavaScript usage, and choice of search engine.

Figure 22.5 The Web Site Garage's Hitometer utility.

SiteScan Survey at *www.gifwizard.com*, as shown in Figure 22.6, is a free test from GIF Wizard that tests for optimization of your graphics and animation.

*Figure 22.6 The SiteScan Survey test at **www.gifwizard.com**.*

SiteScan Survey lets you know how long it takes your Web site page to download, the efficiency of current graphics and animation compression, it alerts you to graphics that need more optimization, and offers recommendations. As shown in Figure 22.7, the sample SiteScan Survey displays the overall efficiency of current graphics regarding optimization and offers recommendations for better optimization.

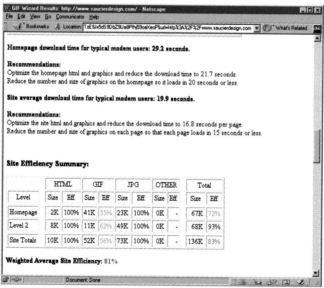

340 *Figure 22.7 A sample SiteScan Survey test.*

The free SiteScan Survey test promotes GIF Wizard, which is an online service you pay for that optimizes your Web graphics and animations and includes a special Ad-O-Matic tool specifically for banner ads.

Online tools, such as Link Alarm at *www.linkalarm.com*, as shown in Figure 22.8, check links. Pehtoori, the HTML Validation Service at *t2r.uwasa.fi/pehtoori/index-en.html* checks your HTML code for errors.

*Figure 22.8 Link Alarm's online tool Web site at **www.linkalarm.com**.*

Site Inspector at *siteinspector.linkexchange.com*, as shown in Figure 22.9, also checks your HTML code as well as Web site download time, browser compatibility, and more.

*Figure 22.9 The Site Inspector online tool web site at **siteinspector.linkexchange.com**.*

Other online utilities are available at the Web Developer's Web site at *www.webdeveloper.com/html/html_online_utils.html.*

OTHER DESIGN CONSIDERATIONS

Two other design considerations include designing to fit screen resolution of most monitors and using components that are compatible with most browsers and systems. Designing Web pages that will display optimally on all systems is not an easy task. For example, users browse the Internet with a wide range of systems, from Web TV or tiny computer monitors to high-end computer systems with large monitors. Much controversy exists over what is the best size to make Web pages. A good rule of thumb, when possible, is to create Web pages not larger than 580 x 350 pixels. Many Web site designers now create their Web pages for 640 x 480 or even 800 x 600. You should also keep in mind that most users dislike scrolling very far on pages to access information. Be sure to remove extra unnecessary spaces. You should try to use only components that are compatible with most browsers and systems. For example, JavaScript, CGI, and Java are compatible with more browsers and platforms than ActiveX or VBScript. Some components require plug-ins or more download time. If you can create the same effect with a Web technology that does not require a plug-in or loads faster, you may want to create the effect using that technology instead.

WHAT YOU MUST KNOW

As you have learned, adding animation, sound, video, and other enhancements to your Web pages can make your Web site more interesting and appealing as well as add to the Web site's overall download time. Many techniques and options are available to help keep download time to a minimum. You have now completed all the lessons in this book and are on your way to creating some captivating Web sites. Before you put this book down, however, make sure you understand the following key concepts:

- ✓ Bandwidth, which is the transfer rate of data to the user's browser, has hindered the development of Web sites with multiple multimedia effects and enhancements.

- ✓ Many techniques and options are available to help keep Web site graphics and animation download time to a minimum and include use of tables, color reduction and optimization of graphics, use of thumbnails, reuse of images, optimal placements of scripts, and selection of fast-loading type of Web technologies, when appropriate.

- ✓ Several online Web software tools are available to perform various tests on your Web sites, such as Web Site Garage, SiteScan Survey, Pehtoori (the HTML Validation Service), Link Alarm, and Site Inspector.

- ✓ Two design considerations include designing to fit screen resolution of most monitors and using components that are compatible with most browsers and systems.

Index

What's On the *Web Animation and Interactivity*

Companion CD-ROM

The companion CD-ROM that accompanies this book contains all the Lesson files, as well as a trial version of Microsoft FrontPage 2000.

As you browse ... beled lesson3 to lesson20. All of the files ... side in the appropriate directory on th... y all of these files to a directory on yo... ample of how the program- ming code to i... ɔu an idea of the inner workings of the ...

DATE DUE